WILLIAM BLAKE

The Seer and His Visions

Milton Klonsky

ORBIS PUBLISHING LIMITED
London

Acknowledgments

The author would like to express his gratitude to the following:
Bruce Harris, publisher, for having inspired me to do this book;
Maria Carvainis, editor, for her perspicacity and assiduity
throughout its preparation; Ken Sansone and Murray Schwartz
for having designed and produced it; and David V. Erdman, Martin
Butlin, Robert Essick, and Edwin Wolf 2nd for their kindness
in reading the manuscript and suggesting many improvements.

This edition published by
Orbis Publishing Ltd., London
1977.

Hardback edition ISBN 0 85613 097 4
Paperback edition ISBN 0 85613 029 X

Published in Canada by General Publishing Company Limited.
Printed in Japan by Dai Nippon Printing Co., Ltd., Tokyo.

WILLIAM
BLAKE

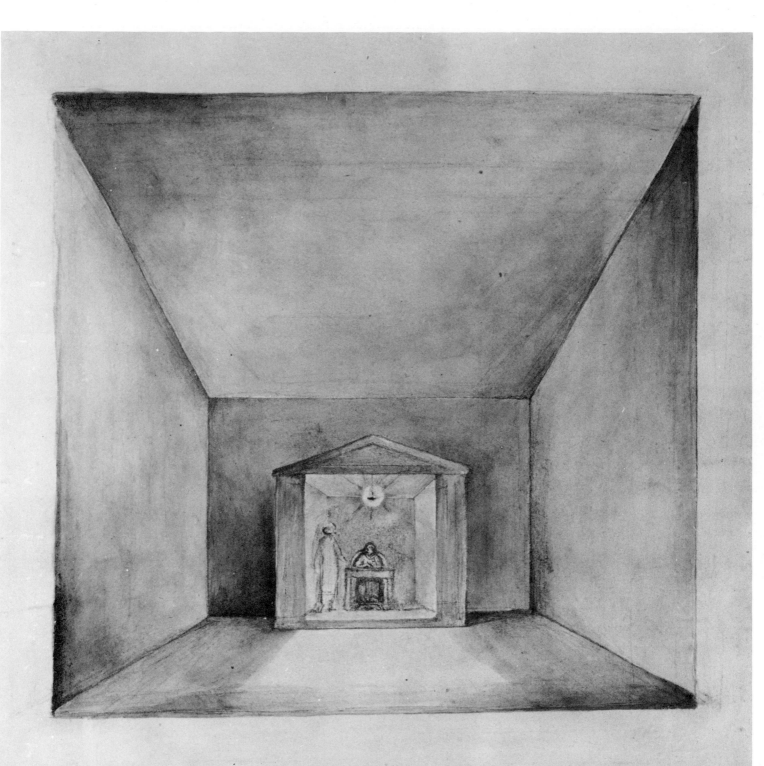

A Vision, sepia wash drawing, undated and unsigned

CONTENTS

INTRODUCTION

I N *The Marriage of Heaven and Hell*, celebrated in 1793 as both holy sacrament and revolutionary manifesto, Blake engraved and etched upon "the minds of men" with the "corroding fires" of his infernal acid these apocalyptic sentences:

> If the doors of perception were cleansed every thing would appear
> to man as it is, infinite.
> For man has closed himself up, till he sees all things thro' narrow
> chinks of his cavern.

Thro' such "narrow chinks" we still peep out, even at Blake's words themselves, blearing them o'er with the pale cast of cant as vaguely and generally referring to a Higher Truth, to which we assent while nodding. And then rest assured, as before, within the Sleep of Reason. For it is not, so Blake insisted, by mathematical abstractions or metaphysical generalities, but only in what he called "minute particulars," specific and irreducible nitty-gritty quiddities, that the "infinite," as it itself is, can be perceived.

And to make it still more specific, such perception must be personal. Whatever the seer sees—whether envisioned in a religious trance, or in a poetic or prophetic rapture, or even, as nowadays, in the spell of psychedelic drugs—has to be seen by himself alone. There can be no other eye-witness.

For better or for worse, Blake's words from *The Marriage of Heaven and Hell* were deeply etched upon my own mind one day about ten years ago, at a beach on Fire Island, New York, when for the first (and also the last) time I "tripped" on LSD. From the start I had been forewarned not to expect any instant hallelujah or Jekyll-into-Hyde metamorphosis; but after what seemed an endless minute-by-minute countdown, during which I felt nothing but a slight tilt of vertigo, my initial dread slowly gave way, I admit, to relief that the acid had apparently been cut too thin to take effect. In this still queasy and uncertain mood I detached myself from my friends, who had kept vigil around me like Job's comforters, and wandered out alone to the beach.

The sun was then at its height, blazing down upon the dunes from a bare blue sky without a wisp of cloud for shade. As far as I could see on either side no one else was there—I had the whole beach to myself—and for good reason; it was so hot that the sand, reflecting the sun's rays from innumerable diamond-faceted particles, "boundless as a nether sky," seemed to glow and kindle here and there with sparks of real fire. Some lines of Blake, dimly remembered, came to mind:

> *Turn away no more;*
> *Why wilt thou turn away?*
> *The starry floor,*
> *The wat'ry shore,*
> *Is giv'n thee till the break of day.*

For by then, twisting and turning, as if on a spit, from side to front to side to back to side again to keep from being scorched, I had become more and more aware that a similar kind of corrosive scorching was going on inside me, "melting apparent surfaces away," as Blake put it, "and displaying the infinite which was hid." Flayed, that is, from within and without, in a panic I got up and ran, stumbling at times and staggering headlong, then even crawling, unable to stand up again, on all fours until I reached the surf.

The first cold shock of the water went through me tingling with such ecstatic, such baptismal, joy—or was it anguish?—that I felt as if reborn. The ocean, which had appeared from a distance to be a clear, translucent emerald green, now that I stood inside it and looked closer seemed like a soup, almost a stew, in which floated scraps and pods of rubbery brown seaweed, tassels of hairy-looking filaments, odd calcareous fragments, maybe the bones of fish, maybe broken shells or teeth, bits of shredded cork, micalike scales, flecks of spume or phlegm, unnameable jellies, and brimming throughout with swarms of evanescent infinitesimal motes, but whether light or plankton, organic or inorganic, real or illusory, hardly mattered, for everything in that soup, I knew, would ultimately be dissolved and annihilated. From the horizon, swelling out, an unceasing succession of waves salaaming waves salaaming waves salaaming waves, uplifting me momentarily as they went by, one after the other, prostrated themselves upon the shore. Their pulse, rising and falling, became indistinguishable from my own. How long I remained there, without will or consciousness, spellbound in that jump-rope rhythm, I can't say, but long enough so that when I did leave, my teeth had already begun to chatter and my body felt numb with cold.

It was while I lay sprawled out once more on the beach, this time basting myself with handful after handful of hot sand, shivering uncontrollably, that it happened. The loneliness of my self-inflicted ordeal was so intense that, just to hear the sound of a human voice, even if only my own voice, I recited aloud what had to be, under the circumstances, Blake's inevitable lines:

> To see the world in a grain of sand
> And heaven in a wild flower . . .

and then stopped. No, I thought, that wasn't right . . . and a pulsebeat later the words flashed back—it was *a* world, *a* heaven—expanding inside my mind:

> To see a World in a Grain of Sand
> And a Heaven in a Wild Flower,
> Hold Infinity in the palm of your hand
> And Eternity in an hour.

The "blue Mundane Shell" (as Blake imagined it) of the sky—a "hard coating of matter that separates us from Eternity"—cracked open for me at that moment, and I perceived the sun with acid clarity as *a* star, one of billions, so many billions that the grains of sand I then held in my palm would comprise only a handful; and in the same split second, the shell of my own time-hardened and encrusted ego, of which the material universe, as Blake thought, was merely the sensual reflection, also cracked, and something within me but not quite me—Ka, or Atman, or Spirit, or Pneuma, or whatever—that had been brooding coiled up in itself, stirred awake. Of course I had always believed that the sun was a star, but now I saw it as if for the first time in its "minute particularity." In its next-to-nothingness as well, and on that scale my own life, not only mine but all life, seemed so paltry, so drained of purpose, value, or significance that I actually began to cry, without shame or self-restraint, the way I used to cry as a child.

Within a few minutes—the sun was that intense—I had switched once more from freezing to burning. Only now, instead of quenching myself in the surf, I decided to get back, and as quickly as possible, to my friends and whatever cold comfort they had to offer. My "trip," I knew, would last from five to six hours, depending on how long the acid inside me could be "stopped out"; but suppose it were to take fifty years, sixty, a whole lifetime? What then? As if existence itself were another more subtly corrosive kind of acid, consuming and flaying us, almost unawares, from within and without, to whose pangs we gradually become accustomed until the end. It occurred to me then, as I lurched and plodded off the beach, that this is what Blake must have meant when he wrote: "Time is the mercy of Eternity; without Time's swiftness/Which is the swiftest of all things, all were eternal torment."

Naturally, in time, it had a stop, some ten or so years ago. Looking back now I can recall neither visions nor apparitions, disembottled genii nor spirits out of the vasty deep—unless, perhaps, that of Blake himself, whom I invoked to preside over the scene. What I saw instead ("As the Eye," said Blake, "such the Object") was the world as I had always conceived it to be, the only "real" reality of matter reduced to minuter and minuter particles in a space-time expanding to infinity-eternity, no more no less, according to the scientific dispensa-

tion of Newton & Einstein, but which I had never perceived · so "im-mediatively" and "into-it-ively" until then. In sum:

> . . . *the very world, which is the world*
> *Of all of us—the place where, in the end,*
> *We find our happiness, or not at all!*

as Wordsworth once described it. Whether the doors of perception be open or shut, our common world, in that sense, which is the world of common sense, was "the very world" Blake lived in as well . . . and yet not entirely.

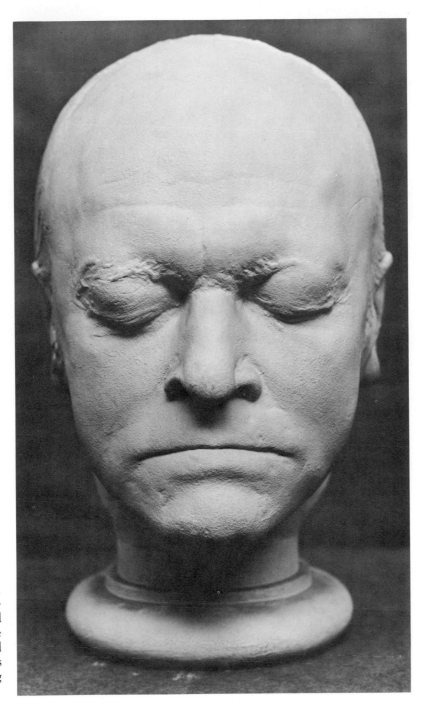

Life Mask of Blake, J. Deville, 1823. Blake's wincing expression must have been caused when the grease and then the plaster were first applied, and he then set his face in this manner to await the hardening and removal of the cast.

For he also—or so he claimed—saw visions and spoke face to face with spooks . . . and what can we make of *that?* Starting in early childhood, at the age of four, when God (who even then must have had for him the ghastly visage of Urizen) poked his head through a nursery window to set him screaming with terror, and continuing throughout his life, into his old age,

when he would keep regular 9 to 5 A.M. visitation hours for any ghost who might care to chat for a while or pose for his portrait, Blake lived on familiar terms with the spirit world. Invisible to anyone else, yet visible to him as numinous presences, he observed and described them in their "minute particularity." "Spirits," he wrote, "are not as the modern philosophy supposes, a cloudy vapour or a nothing: they are organized and minutely articulated beyond all that the mortal and perishing nature can produce." Being by definition incorporeal, their presence cannot be perceived with or in the "vegetative and corporeal" eye, as he put it, but only "with-in" the imagination "heightened to Vision" . . . and never evident except when "self"-evident. Like the leptons and muons, quarks and antiquarks, "strange" or "charmed," of nuclear physics, they were mind-stuff, the stuff that dreams and concepts are made of, close to the margin of nonentity, and crossing over from time to time.

A literary journalist and barrister named Henry Crabb Robinson, who came to know Blake intimately in his last years and kept a detailed record of their conversations, attempted to cross-examine him on his beliefs. Crabb Robinson relates: "At the same time that he asserted his own possession of this gift of vision, he did not boast of it as *peculiar* to himself; All men might have it if they would." Blake was thereby reaffirming the reply once made by Moses (in Numbers 11:29) to the demand that he punish two lowly upstarts, named Eldad and Medad, who had dared to prophesy in the camp of the Israelites: "Would God that all the Lord's people were prophets, and that the Lord would put his spirit upon them!" The down-to-earth lawyer, however, remained unconvinced and wrote in his diary: "Shall I call him Artist or Genius—or Mystic or Madman? Probably he is all."

Blake's visions and visitations have sometimes been explained (though not explained away) by reference to his own rare poetic faculty, cultivated by him since childhood, for envisioning images of such intense cathectic power that they were projected before his eyes as apparitions. Their actual presence could no more be doubted by Blake

> He who Doubts from what he sees
> Will neer Believe do what you Please
> If the Sun & Moon should doubt
> Theyd immediately Go out

than, say, a dreamer, without waking up, could doubt his own dreams in the course of dreaming them.

What Blake "saw," in any case, were not hallucinations, for he was always aware of the distinction between his own self-inspired visions and the delusions of sense-perception. In a letter in verse to his friend and patron Thomas Butts, in 1802, Blake made this explicit:

> A frowning Thistle implores my stay.
> What to others a trifle appears.
> Fills me full of smiles or tears;
> For double the vision my Eyes do see,
> And a double vision is always with me.
> With my inward Eye 'tis an old Man grey;
> With my outward a Thistle across my way.

Had he mistaken the thistle by the roadside for "an old Man grey," that would have been the sort of twilight garden-variety hallucination with which we are all familiar, but clearly Blake saw it for what it was. Only in his imagination, "heightened to Vision," did that frowning and thistle-like old man exist. Further on in the letter Blake proceeds to illuminate his compound visionary credo:

> Now I a fourfold vision see,
> And a fourfold vision is given to me;
> 'Tis fourfold in my supreme delight
> And threefold in soft Beulah's night
> And twofold Always. May God us keep
> From Single vision & Newton's sleep.

His "soft Beulah's night," where vision, annealed by passion, becomes threefold, is Blake's erotic realm of the creative unconscious, presided over by the Daughters of Inspiration. Twofold vision, with him "Always," we have already encountered in the personification of the thistle; and single vision, exemplified by the hypnosis of Newtonian science, occurs when we

see with, not thro', our eyes. But fourfold vision, his "supreme delight," is only attained when the phenomenal world has been transcended by the Divine Imagination and reunited with Spirit.

Taken all together, Blake's fourfold method of envisioning reality seems to reflect, mirrored within his "inner eye," the fourfold hermeneutics devised by cabbalists and scholastic commentators upon the Bible, whereby the literal-historical, the allegorical, the tropological (or moral), and, finally, the anagogical (or spiritual) levels of meaning in Scripture are successively revealed. And, upon further reflection, there exists in his cosmology something else too: the various cabbalist and Neoplatonist and alchemical mystagogues, from strands of whose doctrines Blake largely spun his own mythopoeic system, held that God's Word (Scripture) was not only prior to his Work (Nature), but had formed it and lay concealed within its outer material husks as essential "ideas" or divine "sparks." Nature, sometimes referred to in this sense as God's "other" Book, was thus conceived as a vast rebus of image-ideas, reflecting and reflecting upon one another in multiple facets of meaning. Moreover, the "word" of man, as in a poem, was a particle of *the* Word of God, and so, *pars pro toto*, shared in its sacredness, just as a picture, like a talisman, images his Work, and is likewise sacred.

Based on this mystical cosmology, there emerged during the Renaissance the tradition of picture-poetry—or "Emblem poetry," as it came to be called—and it is to this tradition that Blake, with his fourfold visionary aesthetics, squarely belongs. But to his own age, the Age of Reason, Emblem poetry had come to seem in itself emblematic of the superstition and obscurantism of a benighted past. What had intervened, inexorably, and it appeared permanently, was the science of Newton and its philosophical wedge, the dualist psychology of Locke and Descartes:

> *Two Horn'd Reasoning, Cloven Fiction,*
> *In Doubt, which is Self contradiction,*

cleaving existence between the mind within and the world without, and thereby annulling the unified mystical world-view upon which picture-poetry had been based.

Against Newton's mechanist universe, ruled by Urizen, Blake opposed the Divine Imagination, personified and apotheosized by him as the God-Man Albion:

> *That might controll*
> *The starry pole,*
> *And fallen, fallen light renew!*

Naturalized an Englishman by Blake, Albion, "in whose Sleep, or Chaos, Creation began," was Blake's patriotic counterpart to the Hebrew Adam Kadmon of cabbalist legend. At the beginning of *Jerusalem* (subtitled *The Emanation of The Giant Albion*) Blake wrote, "You [the Jews] have a tradition, that Man anciently contain'd in his mighty limbs all things in Heaven & Earth: this you recieved from the Druids." But if so, Blake received it back again, and much more besides, from the cabbala. He was undoubtedly familiar with its nuclear ideas and symbols as adapted by Jacob Boehme, Robert Fludd, and Paracelsus, among others; but a bill of "minute particulars" might be drawn from his own works to show that he was also acquainted, perhaps at first hand, with the most famous version of the cabbala, the sixteenth-century *Zohar* (literally, "Radiance").

"In every word [of Scripture]," states the *Zohar*, "there are many lights." Specifically, every word has 70 "facets," corresponding to the 70 known languages of the 70 nations of the earth; and every separate letter of every word also has 70 "facets"; and, furthermore, for each of these 70 x 70 light-revealing "facets" in every word there are 600,000 "entrances," or possible interpretations, a number equivalent to the 600,000 eye-witnesses said to have been present at Sinai with Moses when the Word was first revealed, and so were able to see for themselves, according to their own "inner light." ("As a man Is," wrote Blake, "so he sees.") Finally, the entire body of Scripture, the words, the letters, and even the shapes of the letters, comprised the secret name of God, not a tittle of which could be altered or removed without tearing a hole in the material fabric of the universe.

Human Alphabet, page 74 (detail), Blake's MS NOTEBOOK (ROSSETTI MANUSCRIPT), pencil drawing, c. 1787. In 1803, while Blake was studying Hebrew, he attempted a similar anthropography based on Hebrew letters. Reading clockwise from the left: a huddled figure, with head between knees, perhaps an M or else an S in reverse; an M or an N; a Y–a Y-shaped figure, with the outspread arms of the child on his shoulders forming a kind of T (see *Frontispiece*, SONGS OF EXPERIENCE, page 35); a P; and an O.

"As Poetry admits not a Letter that is Insignificant," Blake insisted, "so Painting admits not a Grain of Sand or a Blade of Grass Insignificant—much less an Insignificant Blur or Mark." For to him any picture, or picture-poem, if inspired by the Divine Imagination, was as holy as holy writ. Thus, in *Jerusalem*, the cabbalist vision of the multiplicity of possible entrances into the infinite was refracted by Blake and revealed in its "minute particularity":

> There is a Grain of Sand in Lambeth that Satan cannot find,
> Nor can his Watch Fiends find it; 'tis translucent & has many Angles,
> But he who finds it will find Oothoon's* palace; for within
> Opening into Beulah, every angle is a lovely heaven.

Through the Blakean dispensation, all men, not just the 600,000 eye-witnesses at Sinai, even we ourselves, can find the way by their own "inner light" to Oothoon's palace, see visions, dream dreams, and converse with spirits.

Should there be any doubt, we need merely conjure up the spirit of Blake himself (as a "Memorable Fancy") and present him seated center-stage in the Imagination before us, arms, of course, akimbo, and with one knee folded, or crossed—4-fold, that is—over a leg planted firmly on the ground, and allow him to speak out, *ex cathedra*, as follows:

> I assert for My Self that I do not behold the outward Creation & that
> to me it is a hindrance & not Action; it is as the dirt upon my feet,
> No part of Me. "What," it will be Questioned, "When the Sun rises,
> do you not see a round disk of fire somewhat like a Guinea?" O no,
> no, I see an Innumerable company of the Heavenly host crying,
> "Holy, Holy, Holy is the Lord God Almighty." I question not my
> Corporeal or Vegetative Eye any more than I would Question a
> Window concerning a Sight. I look thro' it & not with it.

Blake was (in Marianne Moore's phrase) a "literalist of the imagination," though not in any cross-eyed sense of envisioning "imaginary gardens with real toads in them," for both gardens *and* toads were to him imaginary . . . and thereby more, not less, "real." "What seems to Be," he wrote, "Is, To those to whom / It seems to Be. . . ."

It all depends, of course, on *what* seems to be and *to whom*. To many of Blake's

*"Oothoon, with four ecstatic *o*'s, speaks for herself as the personification of sexual joy and freedom in Beulah land. In a similar fashion, reminiscent not only of cabbalist abracadabra, but also of primitive name-magic, Blake's malevolent demiurge "Urizen" is contained and revealed in the letter *z*, the shape of the zigzag thunderbolt with which, as a storm god, he inscribes himself upon the sky. The name Oothoon was derived from that of the character Oithona in Ossian's *Fingal*; whereas Urizen has been variously interpreted as a play on "Your Reason," or as stemming from the Greek root of *horizon*, "to limit." But it may well be a scatological pun on Uranus (from the Greek *ouranos*, "heaven"), which would have appealed to Blake's raunchy and subversive wit. The planet Uranus, discovered by Sir William Herschel in 1781, was first named *Georgium Sidus* ("The Star of George") in honor of George III.

contemporaries, his visions and visitations seemed to be unmistakable proof of madness. The poet Robert Southey, for one, recalling his first and only meeting with Blake, which occurred in the summer of 1811, declared that "his madness was too evident, too fearful. It gave his eyes an expression such as you would expect to see in one who was possessed." Not long afterward, Southey related his observations to Crabb Robinson, who duly noted them at the time in his diary, apparently in full agreement. But a quarter century later, when Crabb Robinson came to know the "fearful" madman personally, he wrote: "In the sweetness of his countenance & gentility of his manner he added an indescribable grace to his conversation"; and, further, that his "observations, apart from his visions and references to the spiritual world, were sensible and acute."

Still, it was not these "sensible" views, whatever they were, but Blake's visions and, especially, his "references to the spiritual world," that fascinated Crabb Robinson, and to them he returned again and again in his relentlessly rational cross-examinations. Blake was then about sixty-eight years old, within a year of joining that world himself, and he no longer attempted to rationalize what was ir- and/or supra-rational and could only be witnessed—but never proved or demonstrated—by the witness alone.

"As he spoke of frequently Seeing Milton," Crabb Robinson writes in his diary, "I ventured to ask, half ashamed at the time, which of the three or four portraits in Hollis's *Memoirs* [of Milton] is the most like. He answ^d 'They are all like, At different Ages. I have seen him as a youth And as an old man with a long flowing beard. He came lately as an old man.'" Blake, in Crabb Robinson's account, then tells what happened:

> He came to ask a favor of me. He said he had committed an error in his Paradise Lost, which he wanted me to correct, in a poem or picture; but I declined. I said I had my own duties to perform. "It is a presumptuous question," I [Crabb Robinson] replied. "Might I venture to ask—What that could be?" He wished me to expose the falsehood of his doctrine, taught in the Paradise Lost, That Sexual intercourse arouse [*sic*] out of the Fall. Now that cannot be, for no good can spring out of Evil.

On another occasion, a few days afterward, Blake described a similar encounter with the spirit of Voltaire, informing Crabb Robinson:

> I have had much intercourse with Voltaire. And he said to me, "I blasphemed the Son of Man and it shall be forgiven me, but they (the enemies of Voltaire) blasphemed the Holy Ghost in me, and it shall not be forgiven to them." I asked him in what language Voltaire spoke. His answer was ingenious and gave no encouragement to cross questioning. To my sensations it was English. It was like the touch of a musical key—he touched it probably French, but to my ear it became English.

The detail about the "musical key" that nonplussed Crabb Robinson, who had thought to trap Blake by questioning his knowledge of French,

> *The Questioner, who sits so sly,*
> *Shall never know how to Reply.*
> *He who replies to words of Doubt*
> *Doth put the Light of Knowledge out.*

was a neat thrust, most likely inspired by some spirit on the spot—jabbing this pointed detail, like a bare bodkin, into his solidly planted and down-to-earth metaphysical fundament.

"He who does not imagine in stronger and better lineaments," wrote Blake, "and in stronger and better light than his perishing and mortal eye can see, does not imagine at all." He must previously have told the tale of Voltaire's visitation to others besides Crabb Robinson, re-imagining it afresh each time in the telling and, as in this case, touching up the lineaments to make them "stronger and better."

But even if imagined, and therefore "imaginary," these emissaries from the far-out peripheries of the visionary fourth dimension were not any less "real" to Blake. "And as all of us on earth are united in thought," he wrote as long ago as 1788 (in his annotations to Lavater's *Aphorisms*), "for it is impossible to think without images of somewhat on earth—So it is impossible to know God or heavenly things without conjunction with those who know God

& heavenly things; therefore all who converse in the spirit, converse with spirits." (That *therefore!*) Blake's argument for the existence of spirits resembles in form Anselm's ontological proof of God (that the conception of a Supreme Being necessarily entails his reality), just as his equation of seeming and being to authenticate vision stems from Bishop Berkeley's famous dictum, *Esse est percipi* ("To be is to be perceived"); but, in both cases, there is a prestidigitational fast-shuffle in the enthymeme. As inhabitants of Blake's mental realm, where seeming is being and art & life amalgamate, these spirits have a marginal existence; though how they might then differ, if at all, from the mythic personae and "Giant Forms" of his prophetic books, such as Los or Urizen or Enitharmon or Luvah, Crabb Robinson forgot to ask.

"I never in all my conversations with him," wrote Blake's friend, the artist John Linnell, some three years after his death, "could feel the least justice in calling him insane; he could always explain his paradoxes when he pleased, but to many he spoke so 'that hearing they might not hear.'"

What Crabb Robinson heard, *sans doute*, was what he had told himself . . . he would hear; yet it was also, paradoxically, the case. In another letter addressed by Blake to Thomas Butts (dated April 25, 1803), he speaks of having "composed an immense number of verses on One Grand Theme [possibly his *Milton* or *Vala*], Similar to Homer's Iliad or Milton's Paradise Lost, the Persons & Machinery intirely new to the Inhabitants of Earth. . . . I have written this Poem from immediate Dictation," he continues, "twelve or sometimes twenty or thirty lines at a time, without Premeditation & even against my Will; the Time it has taken in writing was thus render'd Non Existent, & an immense Poem Exists which seems to be the Labour of a long Life, all produc'd without Labour or Study." Since all who converse *in* the spirit, as he said, converse *with* spirits, the eighteenth-century poetic device of personification was for him no "mere" figure of speech. As a mystical poet-painter—that is, clairaudient as well as clairvoyant—while under the spell of creation he would first hypostatize ideas into real entities, which were then personified, a hypertrophy of the trope, as 'twere, so that to be inspired was, literally, to be inspirited. The ideas themselves might have been "mad"—or the spirits that personified them—but not Blake. Judging, moreover, from the many deletions and revisions in the surviving manuscript of *Vala*, which was never published, these spirits, like mortal and corporeal authors, must have had second thoughts, and then seconded their second thoughts, before leaving well enough alone.

"I am under the direction of Messengers from Heaven," he told the faithful Butts, "Daily and Nightly." But what sort of "Messengers"? Were they, for instance, like the seraphic scouts of Jehovah through whom, in the old days, he despatched his communiqués to the prophets? Or did they resemble instead the personal *daimon* of Socrates, the warning voice that, he claimed, had attended and guided him throughout his life? They must have shared the characteristics of both. But if more like the latter, then what Blake envisioned was not one but legions, a pandemonium of such *daimons*, innumerable as motes within the beam of his own inner light, whose imagined actions were his thoughts. Speaking for themselves, they declared in *Vala* that "in the Brain of Man we live & in his circling Nerves / . . . this bright world of all our joy is in the Brain of Man." However, the "Brain," hypostatized and capitalized, was not Blake's alone but Everyman's—Albion's—for we are all one in spirit as well as one Spirit. "Man is All Imagination," he wrote. "God is Man & exists in us & we in him."

To such a pledge of spiritual allegiance, one for all and all for one, Crabb Robinson himself might have piously assented; but as a lawyer he could not help but balk at the enormous consequences concealed within the small-print minutiae. "We who dwell on Earth," wrote Blake in *Jerusalem*, "can do nothing of ourselves; every thing is conducted by Spirits, no less than digestion or sleep"; and further, but in a different context, "For every Natural Effect has a Spiritual Cause, and Not / A Natural; for a Natural Cause . . . is a Delusion of Ulro [materialism] & a ratio of the perishing Vegetable Memory." But, if so, this would merely invert the materialist determinism of Newtonian science, replacing it with an equally binding, though spellbinding, spiritual determinism, and thus reanimate the once haunted animist universe of our savage ancestors. No wonder Crabb Robinson, baffled in his attempt to rationalize Blake's ideas, kept pointing a revolving forefinger at his head. "He incidentally denied [physical] causation," he notes in his diary, "Every thing being the work of God or Devil." Yet Blake was no predestinarian or zomboid fatalist either, for the impulses that lead us to act one way or the other, like the improvisations of art, he believed to be freely inspired and self-evident.

He appears to us now (if such can be imagined) a kind of existential hieroglyph, a figure in whom the ancient prayer of Socrates, that the inner and outer man be one, has been realized. He not only believed but also lived his visionary ideas, and as he saw himself so can he be seen thro' by us. For Blake to have become Blake, that is, the chance coincidences of his life, like the "minute particulars" of his poems and pictures, could not have been otherwise. "Look over the events of your own life," he suddenly confronts the reader (in his marginalia to Watson's *Apology*), "& if you do not find that you have done such miracles & lived by such you do not see as I do."

Of all these seemingly miraculous coincidences, the most crucial, as it turned out, was the date of his birth: 1757. For that was the year in which the mystical theologian Emanuel Swedenborg claimed to have been transported to heaven in a vision and while there to have personally witnessed the commencement of the Last Judgment, as foretold by the book of Revelation. In 1771 Swedenborg, in his corporeal being, traveled to London to organize a branch of his church, dying there a year later at the age of eighty-five. Though none of his works were translated into English until 1788, Blake must have learned, long before then, that the beginning of Swedenborg's millennium coincided with the date of his own birth. It was a "fact" that would have aroused anyone's sense of wonder, but especially Blake's. When the London branch of Swedenborg's New Church was founded in 1788, he and his wife attended several of the meetings, though they never became members. Among other things, Blake ridiculed Swedenborg for his pious orthodoxy in accepting Good and Evil as static and eternally opposed, rather than dynamic and conjugally united. As he wrote in his *Milton:*

> O Swedenborg! strongest of men, the Samson shorn by the Churches,
> Shewing the Transgressors in Hell, the proud Warriors in Heaven,
> Heaven as a Punisher, & Hell as One under Punishment. . . .

And besides, he once told Crabb Robinson (no doubt with a sidelong glance), Swedenborg was "wrong in trying to explain to the rational faculty what the reason cannot comprehend."

But of the truth of Swedenborg's prophecy that the Kingdom of God was at hand, Blake remained convinced. In further confirmation, another mystical author, Jacob Boehme, whom Blake revered, had also predicted that a seventh "Enochian Age"—from Adam to Seth to Enos to Cainan to Mahalaleel up to Enoch, the so-called "Prophetical Mouth"—would see the fulfillment of the Word, and this age Blake identified with his own. There were signs and portents everywhere he looked, both within

> Even I already feel a World within
> Opening its gates, & in it all the real substances
> Of which these in the outward World are shadows which pass away . . .

and without,

> Spurning the clouds written with curses, [the son of fire]
> stamps the stony law to dust, loosing the eternal horses
> from the dens of night, crying:

> EMPIRE IS NO MORE! AND NOW THE LION
> & WOLF SHALL CEASE.

In the American War of Independence and the overthrow of the monarchy in France, Blake imagined still greater things to come in the spirit world.

The Marriage of Heaven and Hell (even the title parodies that of Swedenborg's famous book, *Heaven and Its Wonders and Hell*) was conceived in, and by, this confident expectation of world revolution and divine revelation. Though not published until 1793, it was apparently composed in 1790, when he wrote: "As a new heaven is begun, and it is now thirty-three years [the life span of Christ and Blake's own age in 1790] since its advent, the Eternal Hell revives. And lo! Swedenborg is the Angel [of the Resurrection] sitting at the tomb: his writings are the linen clothes folded up. Now is the dominion of Edom*, & the return of Adam into Paradise. See Isaiah xxxiv & xxxv Chap." Instead, as we know, the Second Coming never came, and

*Edom (meaning "red" in Hebrew) refers to Esau, the eponymous ancestor of the Edomites, who was tricked by Jacob into selling his birthright for a mess of red lentils. He will now, asserts Blake, reclaim it. In the prophetic books, Blake's personified spirit of rebellion, both political and religious, was named "red Orc."

the growing threat of revolutionary France brought about the imprisonment or deportation of its Jacobin sympathizers in England.

Not long after the celebration of *The Marriage of Heaven and Hell*, however, something astonishing, almost uncanny, did occur, which must have reminded Blake that the ways of the Lord surpasseth the understanding even of prophets. For there then appeared in London a strange, demented, tragic figure, Richard Brothers, proclaiming himself a "nephew of God" and "Prince of the Hebrews." A former naval officer, he had resigned from his commission in 1792

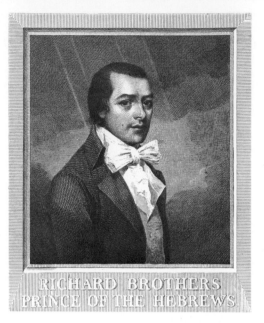

Richard Brothers, Prince of the Hebrews, engraved portrait by William Sharp, 1795. Under Brothers's portrait, Sharp wrote: "Fully believing this to be the Man whom GOD has appointed;—I engrave his likeness."

to protest the war being organized against the French Republic, and, afterwards, sent urgent letters to the king and his ministers appealing to them to repent and desist. This war, he prophesied, would be the final conflict between Good and Evil foretold in Revelation 19:19: "And I saw the beast [with "seven heads and ten horns," representing the crowned heads of Europe, one of them, presumably, on the neck of George III], and the kings of the earth, and their armies, gathered together to make war against him that sat on the horse [the Word of God], and against his army." By 1794, with the war already under way, he began to preach among the people that the apocalyptic Day of Wrath was at hand, and also published a tract, entitled *A Revealed Knowledge of the Prophecies and Times*, in which he predicted the imminent destruction of the British and all other empires. This was to be succeeded by a new political-religious dispensation, when the Jews both "visible" and "invisible" (those who identified themselves as such and others who, unknown to themselves, were descendents of the ten lost tribes) would return to the Promised Land. A universal brotherhood—led, naturally, by Brothers—would then be established on earth, with its capital in Jerusalem.

By the charismatic force of his own self-persuasion, turned outward, Brothers gathered a large and enthusiastic following—including Blake's friend, the engraver William Sharp, a former Swedenborgian—inducing his adherents to believe that he was the prophet chosen by the Lord to blow the ram's horn for year 1 of the millennium. When, for instance, he warned his brotherhood in the summer of 1794 that an earthquake was about to devastate London, crowds are reported to have fled the city in panic. The authorities, by this time, came to regard him as a social as well as political menace. Arrested in March of 1795, on the charge of disturbing the peace and making "fond and fantastical prophecies," he was pronounced insane and sentenced to be confined in a lunatic asylum, remaining there for eleven years until his release in 1806, by which time he was almost forgotten.*

*Brothers would be diagnosed nowadays as "paranoid schizophrenic." According to Morton S. Paley (from whose essay, "William Blake, The Prince of the Hebrews, and the Woman Clothed with the Sun," the facts in my own account have been drawn), Brothers maintained faith in his mission until the day of his death, on January 24, 1824. Paley also points out the close similarity between Blake's conception in his prophetic books of a "spiritual fourfold London," which he called Golgonooza, and Brothers's own grandiose plans for rebuilding the holy city, as outlined in his *A Description of Jerusalem*, published in 1801.

In Brothers Blake must have recognized, with a double take, his own spiritual doppelganger; and this, in turn, upon further reflection, would have been redoubled thro' his eyes—becoming fourfold, that is— with the realization that Brothers, too, had been born in the annus mirabilis of 1757. His fate also must have seemed to Blake a warning by the spirits. Three years after Brothers's imprisonment, Blake wrote gloomily: "To defend the Bible in this year 1798 would cost a man his life. The Beast & Whore [of Revelation] rule without control"; and further down (on the back of the title page of Bishop Watson's *Apology*, which he was then annotating), Blake added: "I have been commanded from Hell not to print this, as it is what our Enemies wish." As he knew, his own "prophecies" might be regarded as no less "fond and fantastical" by the authorities had they wished to do so—or had they heard about them, for Blake's very obscurity here protected him—since he too had often been stigmatized as mad. From 1795 to 1808, a period of thirteen years, Blake was to publish no more of his "prophetic" books.

In a letter sent in 1800 to the sculptor John Flaxman, a devotee of Swedenborg, he relates how

> . . . terrors appear'd in the Heavens above
> And in Hell beneath, & a mighty & awful change threatened the Earth.
> The American War began. All its dark horrors passed before my face
> Across the Atlantic to France. Then the French Revolution commenc'd in
> thick clouds,
> And My Angels have told me that seeing such visions I could not subsist on
> the Earth....

The Blake who had once plumed himself with the red cockade of revolution on the streets of London was to choose, a decade later, as an epigraph for *Vala*, this quotation from Ephesians (6:12): "For our contention is not with the blood and the flesh, but with dominion, with authority, with the blind world-rulers of this life, with the spirit of evil in things heavenly."

Those "blind world-rulers" ("blind" to us because we are blind to them) exist within the mind of Everyman—and any one man—as moral commandments; as historical forces within society; and, as eternal decrees within the realm of the spirit. Old Nobodaddy *is* King George III *is* the superego dominating our lives. "Are not Religion & Politics the Same Thing?" he asks (in *Jerusalem*, 57:10), a truism as self-evident to him in eighteenth-century London as it had once been to the prophets in ancient Israel. Since "Thought is Act"—and reciprocally, in such a mental universe, Act must be Thought—the politics Blake envisioned was not that of "the reasoning historian, turner and twister of causes and consequences, such as Hume, Gibbon and Voltaire," but a spiritual politics. As he writes in *A Descriptive Catalogue:* "Acts themselves alone are history. . . . Tell me the Acts, O historian, and leave me to reason upon them as I please. . . . His opinions, who does not see spiritual agency, is not worth any man's reading; he who rejects a fact because it is improbable, must reject all History and retain doubts only." These squint-eyed rationalists, peering through the narrow chinks of "single vision," asserts Blake, "cannot see either miracle or prodigy: all to them is a dull round of probabilities and possibilities; but the history of all times and places is nothing else but improbabilities and impossibilities; what we should say was impossible if we did not see it always before our eyes."

Yet, as we know, one man's undoubted "miracle" may be another's seeming "coincidence." Looked at thro' our own eyes, what strikes us nowadays as almost miraculously coincidental is the close resemblance between Blake's views denying physical causation (for which he was deemed mad) and the theory of "acausal synchronicity" devised by Carl Jung, in collaboration with the physicist Wolfgang Pauli, to explain certain age-old but still baffling psychic phenomena. Jung's and Pauli's abstract principle has merely been personified by Blake into spiritual agency, in accord with the poetic conventions of his time; and the same may be said of Jung's "archetypes" as Blake's "Giant Forms," Jung's "collective unconscious" as Blake's "Divine Imagination." Toward the end of his life Jung came to believe that "Meaningful coincidences—which are to be distinguished from meaningless chance-groupings—seem to rest on an archetypal foundation"; and, after transmuting Jung's psychological precepts into his own occult and spiritualist terms, Blake would have agreed to this as self-evident. Finally, the concept of a "group-mind," postulated by some modern biologists to account for the highly complex and coordinated social activities among various species of insects and marine rhizopods, in which each member seems to share a "psychic blueprint," has often been cited by parapsychologists to advance the possibility of ESP and telepathy and precognition among

humans. This obviously corresponds to Blake's own conception of man as microtheos, sharing in the mystical body of the collective God-Man, Albion. "What is now proved," he wrote (as one of the infernal proverbs of *The Marriage of Heaven and Hell*), "was once only imagin'd."

Looking over the events of his own life, there is one, at the outset of his career, that has sometimes been seen as objective proof that he must have been gifted with precognition; though Blake, who necessarily viewed it from the inside, subjectively, would have declined any such gift, attributing this power instead to his tutelary spirits. Through the prism of one event, however, we can observe in retrospect the young Blake in the act of realizing—or, rather, "imagining"— himself as an artist.

At the age of fourteen, in 1772, he was taken by his father, who owned a small business as a hosier in London, to be apprenticed to the celebrated engraver William Wynne Ryland. Blake had been enrolled four years earlier at one of the conventional art schools of the period, where he was taught how to draw by sketching plaster casts of antique statuary and copying prints of old masters. But his father, upon hearing him tell of having seen seraphic beings flitting through the hayfields or perched up in the trees like stars, had become increasingly concerned for the worldly prospects of his otherworldly son. If he were accepted as an apprentice by Ryland, it was hoped, these apparitions might fade in time from his mind, and meanwhile he could practice his art and also learn the profitable trade of engraving.

Right after his first interview with Ryland, however, Blake peremptorily refused to join his workshop, telling his father that the man had a hanging look and was doomed to die one day on the scaffold. Ryland was then official engraver to King George III, a social as well as artistic favorite at the court, and such a fate seemed inconceivable. Yet some ten years later, just as the young Blake had foretold, Ryland was convicted of forging banknotes on the East India Company, denied a pardon by the angry king, and hanged. How Blake responded to this fulfillment of his prophecy is not recorded; but in 1798 (in his annotations to Watson's *Apology*), he wrote: "Every honest man is a Prophet; he utters his opinion both of private & public matters. Thus: If you go on So, the result is So. He never says, such a thing shall happen let you do what you will. A Prophet is a Seer, not an Arbitrary Dictator." The warning voice of his own *daimon*, he must have imagined, had whispered Ryland's fate into his inner ear.

Apprentice Drawing of Edward III for Gough's SEPULCHRAL MONUMENTS OF GREAT BRITAIN, c. 1774

Apprentice Drawing of Richard II for Gough's SEPULCHRAL MONUMENTS OF GREAT BRITAIN, c. 1774

Had Blake been apprenticed to him at so early an age, he would have been trained in Ryland's highly fashionable style of mezzotint engraving by "stipple," or dots, which reproduced the syrupy tones and twilight shadings of chiaroscuro ("that infernal machine called Chiaro Oscuro," Blake so abominated) in paintings by Sir Joshua Reynolds, G. B. Cipriani, Angelica

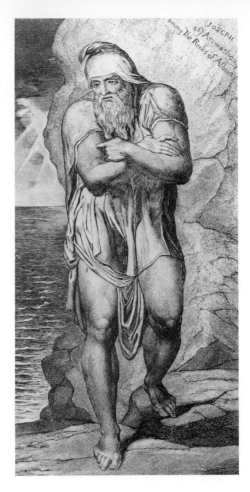

Joseph of Arimathea among the Rocks of Albion, engraving by Blake from a drawing by Salv[i]ati after Michelangelo, 1773

Kauffmann, *et al.* Ryland, a former pupil of Boucher, meant his prints to be framed in the elegant drawing rooms of the period above the Chippendale and Sheraton. But such a modish and rococo "Blake," of course, could never have become Blake. Instead, after his father had paid the requisite sum of 50 guineas, he was taken on as apprentice by the old-fashioned engraving firm of James Basire and Sons (I, II & III) from 1772 to 1779. Though Basire's provided engravings for various publishers of that time, the firm was chiefly employed as official engraver to the Society of Antiquaries and also to the Royal Society of London, for whom precision and clarity of line rather than tonal values were most important. This severely linear style, though outmoded, was in accord with Blake's own precocious enthusiasm for the prints and drawings of Albrecht Dürer, Marcantonio Raimondi (the engraver for Raphael), Hendrik Goltzius, Giulio Romano, and Michelangelo—especially Michelangelo—and from it he never deviated. "Nature has no outline," he later declared, "Imagination has."

During his second year at Basire's a quarrel erupted between two newly enrolled apprentices and the feisty, cocksure, disputatious and redheaded adolescent who was Blake. Once more we can discern in this the fine hand of his attendant spirits; for, as a result, Basire decided to restore peace in his workshop by sending him off, alone, to Westminster Abbey— where he sometimes remained for the night as the sole living person within its walls*—to make preparatory sketches for a book on the *Sepulchral Monuments of Great Britain.* Up to the end of his life he was to recall the time spent there alone, sketching and meditating amid the Gothic vaults and tombs and effigies, as sacred, a religious and an artistic second birth.

It was then, he declared, that he saw revealed "the simple and plain road to the style at which he aimed, unentangled in the intricate windings of modern practice." Both the sixteen-year-old and the sixty-year-old Blake saw the vision of the Gothic style thro' the same eyes: "Grecian is Mathematic Form: Gothic is Living Form, Mathematic Form is eternal in the

*Curiously—and by a "coincidence" that seems as predestined as his long, womblike sojourn inside Westminster—Blake's mother's name was Catherine, his only sister's name was Catherine, and his wife's name turned out to be Catherine. In alchemical lore (of which Blake became an adept), an athanor, from the Arabic *at-tannur,* meaning "oven," was the alembic in which the elixir was prepared; but the true athanor, regarded as a microcosmos, was the human body itself. In Blake's spiritual fourfold city of art, Golgonooza, based on the divine human body, he named the womb of generation "Cathedron."

Reasoning Memory: Living Form is Eternal Existence," he wrote (in *On Homer's Poetry & On Virgil*) in 1820. Coincident with this discovery must have come the further revelation, in medieval illuminated manuscripts, of the flamboyant and self-expressive, even self-willed, Gothic line, which was to germinate over the years into the luxuriant exfoliations of his own picture-poems. A firm and determinate "bounding line" (so to speak) was then drawn in his mind between the prevailing eighteenth-century conception of art as "imitation," ruled by the repressive and backward-looking daughters of Memory, and art as "inspiration," released by the prophetic agents of the Divine Imagination.

About this time, as it happened, Blake made still another discovery—actually a self-discovery—that was to prove as important to him as a poet as his insight into the Gothic style had been to him as an artist. Once his work on the *Sepulchral Monuments* was finished, Blake was assigned by Basire to do several of the illustrations for Jacob Bryant's *A New System, or An Analysis of Ancient Mythology*, which sought to trace the descent of the gods and demigods of the ancient world to the survivors of the Deluge in Noah's Ark. Though Bryant's fantastic chronology, which relied mainly on the murky genealogical system of dating in the Bible, was by modern standards no more than guesswork, a shot in the "dark backward and abysm of time," his analysis of the common motifs underlying the pantheons of Egypt, Greece, India, Babylon, and Scandinavia, anticipated in the eighteenth century the comparative mythology of Frazer's *The Golden Bough*.

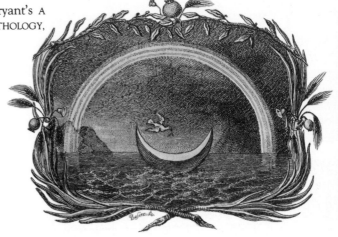

Moon-ark and Dove of Peace, from Jacob Bryant's A NEW SYSTEM, OR AN ANALYSIS OF ANCIENT MYTHOLOGY, engraving, attributed to Blake, c. 1774–76

What it meant to the young Blake, reared in the bibliolatry of a devoutly Protestant household, was expressed by him more than three decades later (in *A Descriptive Catalogue*), when he wrote: "The antiquities of every Nation under Heaven, is no less sacred than that of the Jews. They are all the same thing, as Jacob Bryant and all antiquaries have proved. . . . All had originally one language and one religion: this was the religion of Jesus, the Everlasting Gospel." And, to this belief in a perennial and primordial religion, he came to add—with his usual patriotic fervor—the notion, which was shared, incidentally, by Brothers, that the Druids, who had built the mysterious temple of Stonehenge on the plains of Salisbury, were none other than that chosen and original race descended from the ten lost tribes of Israel. From which it followed that Britain was "the Primitive Seat of the Patriarchal Religion." ("Can it be?" he asks in self-bemused astonishment in *Jerusalem*, "Is it a Truth that the Learned have explored?")

When, in his preface to *Milton*, he vowed:

> *I will not cease from Mental Fight,*
> *Nor shall my Sword sleep in my hand*
> *Till we have built Jerusalem*
> *In England's green & pleasant Land.*

he meant it literally, allegorically, morally, and anagogically. That "Mental Fight" had in fact already begun while he was still an apprentice. In his marginalia—notes and comments, inscribed throughout his life in the books he considered important, that were sometimes asides addressed to the reader, to the world at large, to his attendant spirits, or to the author as a

direct retort, as if all were present at the same time looking over his shoulder—he wrote around 1808 on a page of Reynolds's *Discourse VIII*:

> I read Burke's Treatise [on the Sublime] when very Young; at the same time I read Locke on Human Understanding & Bacon's Advancement of Learning, on Every one of these books I wrote my Opinions, & on looking them over find that [they] are exactly Similar. I felt the Same Contempt & Abhorrence then that I do now. They mock Inspiration & Vision. Inspiration & Vision was then, & now is, & I hope will always Remain, my Element, my Eternal Dwelling Place.

The ideas he held then, engraved into his being, never really changed, but were only etched deeper by time; and in discovering them at so early an age, he was simultaneously uncovering his own essential lineaments. Like Blake's mythic alter ego, the poet-engraver Los, "he became [as he wrote in *Vala*] what he beheld: He became what he was doing: he was himself transform'd." Basire's, in that sense, was for him the sort of infernal "Printing house," described in *The Marriage of Heaven and Hell*, "in which knowledge is transmitted from generation to generation," and where "Unnamed forms [later to be named by him as the "Giant Forms" of the prophetic books] cast the metals into the expanse" of corrosive acid. The seven years he spent there had the effect, within and without, of "melting apparent surfaces away, and displaying the infinite which was hid."

The twenty-two-year-old engraver who finally emerged in 1779 from his long apprenticeship was unmistakably Blake. For a time he enrolled at the Royal Academy as an art student, supporting himself by doing commercial engravings on a free-lance basis for various publishers. The two English artists he then most admired and emulated were the Irish-born enthusiast James Barry, reputed like himself to be a seer of visions, and J. H. Mortimer, a historical painter in the grand style of medieval subjects, both of whom worked outside the official canons of taste decreed by Sir Joshua Reynolds. And for the latter reason alone, they

Self-portrait, page 67 (detail), Blake's MS NOTEBOOK (ROSSETTI MANUSCRIPT), pencil drawing, 1809–10

Portrait of Catherine Blake, pencil drawing on the reverse side of a page proof, c. 1802

would have appealed to Blake's rebellious spirits. In 1782, against his father's wishes, Blake married—"beneath him" and "on the rebound" it was rumored—to the illiterate daughter of a greengrocer, Catherine Boucher, or Butcher, who signed the marriage register with an "X." However, she was subsequently trained and educated well enough by Blake to assist him at his work, becoming the Enitharmon to his Los.*

Upon his father's death, in 1784, Blake received a small inheritance, and with it he went into partnership with a former fellow-apprentice at Basire's, James Parker, to open an engraver's and print-seller's establishment on the same street as the family's hosiery business. But the living was meager, and besides, his spirits had other plans for Blake. Sharing the same quarters with him and his wife at the time was his beloved younger brother Robert, whom he was teaching to paint and engrave. In 1787 when Robert fell sick and died of consumption at the age of nineteen, Blake dissolved his partnership with Parker and moved with his wife to a house in another neighborhood. The business that had begun as a direct result of a death in the family also ended with one, and Blake was afterward to recall with bitterness these interim years, when he worked "as a slave bound in a mill among beasts and devils."

During the early 1780s he formed what turned out to be lifelong friendships with several other artists: the sculptor John Flaxman, the Swiss painter Henry Fuseli, the portrait painter George Romney (who thought Blake's "historical drawings rank with those of Michael Angelo"), and the engraver Thomas Stothard. Through Flaxman he was introduced into the intellectual salon run by the bluestocking wife of the Reverend Anthony Mathew. At a few of these gatherings Blake is said to have recited—or crooned, rather, to tunes of his own devising—the early poems assembled under the title "*Poetical Sketches*, by W. B." It was the Reverend Mathew, together with Flaxman, who sponsored the printing in 1783 of this volume of juvenile verse, which, though never offered for sale, was the only book by Blake ever to be printed commercially during his life.

At the time of his brother Robert's death, Blake was almost entirely unknown to the public, either as poet or painter, and seemed likely to remain so. His self-realization as both at once, in the picture-poems of *Songs of Innocence and of Experience* and the prophetic books, had to await the invention of so-called "illuminated printing." The secret of this process, he claimed, was revealed to him in a vision by the spirit of his deceased brother. Though some doubt exists about priority (for a similar method was discussed by Blake's friend the engraver George Cumberland, in correspondence dated 1784), Blake was the first to perfect it, producing, in 1788, the tiny plates for the tracts *All Religions Are One* and *There Is No Natural Religion*. And there is a passage in *An Island in the Moon*, written between 1784 and 1787, which suggests that, even without supernatural revelation, most of the technical problems had already been solved by then.** Following a break in the text, with one or more missing pages apparently torn out by Blake himself to protect his secret, it continues:

*Los, "the fourth immortal starry one," is Sol spelled backward (as it would be when engraved in mirror writing on a plate intended to be etched and printed); and Sol, or the Sun, whose *materia* is sulfur, when joined in marriage with the Moon, whose *materia* is quicksilver, forms the central symbol of alchemy. As he wrote in *Vala*:

> His head beam'd light & in his vigorous voice was prophecy.
> He could controll the times & seasons & the days & years;
> She could controll the spaces, regions, desert, flood & forest,
> But had no power to weave the Veil of covering for her sins.

The name Enitharmon may be a conflation of (z)enith-(h)armon(y). Out of it, H. M. Margoliouth suggests, Blake then derived the names of her parents, Enion and Tharmas.

**Blake was also experimenting about this time with a new way of painting in tempera, which he called "fresco," binding his colors not with gum, as was customary, but with a diluted solution of ordinary carpenter's glue. The secret formula for this too, he claimed, had been revealed to him in a vision, and by none other than Saint Joseph himself, the sacred carpenter.

Blake's propensity for invoking the members of the Holy Family, whenever it suited his purpose, once brought about the following exchange with his friend Fuseli, who had remarked of one of his pictures, "Now someone has told you this is very fine?" Blake: "Yes, the Virgin Mary appeared to me and told me it was very fine. What can you say to that?" Fuseli: "Say? why nothing, only her Ladyship has not an immaculate taste."

As it turned out, neither did Saint Joseph have an infallible technique, for those pictures painted in "fresco" with glue as a binder have by now cracked and darkened, many of them beyond restoration. Fortunately Blake (or maybe Saint Joseph) later reconsidered the use of glue, and changed the binder to a gelatinlike substance made of scraps of parchment.

> "—thus Illuminating the Manuscript."
>
> "Ay," said she, "that would be excellent."
>
> "Then," said he, "I would have all the writing Engraved instead of Printed, & at every other leaf a high finish'd print—all in three Volumes folio—& sell them a hundred pounds apiece. They would print off two thousand."

Which would add up to a weighty 200,000 pounds of pie-in-the-sky—a figure yeasted with irony, for by Blake's own accounts from 1802 to 1827, the year of his death, he earned from all his illuminated books and the sale of pictures between 50 and 100 pounds a year, *in toto* about 1,531 pounds for a lifetime's effort.

Plate 2, THERE IS NO NATURAL RELIGION, relief etching, touched with watercolors, 1788

Plate 2, ALL RELIGIONS ARE ONE, relief etching, 1788

In a *Prospectus to the Public*, issued in 1793, Blake first announced his new method of printing, "in a style more ornamental, uniform, and grand, than any before discovered . . . which combines the Painter and the Poet . . ." And he also remarks: "The Labours of the Artist, the Poet, the Musician, have been proverbially attended by poverty and obscurity . . . owing to a neglect of means to propagate such works as have wholly absorbed the Man of Genius. Even Milton and Shakespeare could not publish their own works"; but, he adds, now that a way has been found to do so, ". . . the Author is sure of his reward." In this *Prospectus*, Blake offered his *Songs of Innocence* ("with 25 designs") and *Songs of Experience* (also "with 25 designs") for 5s apiece; *The Marriage of Heaven and Hell* ("with 14 designs") for 7s 6d; and *The Gates of Paradise* ("a small book of Engravings") for 3s. Each "highly finish'd" print, moreover, reproduced on "the most beautiful wove paper that could be procured," was to be illuminated by the artist in several colors.

Yet for all that—and at that price—there were few buyers. By 1818, when the cost of a copy of *Songs of Innocence*, for instance, had risen over the years to 3 pounds 3s, Blake ruefully advised a potential patron that producing illuminated books was "unprofitable enough for me, tho' Expensive to the Buyer." Whatever else his spirits had going for them, they weren't very good at business. As Crabb Robinson observed in 1826, when he ordered a copy of the *Songs* for 5 guineas: "He spoke of his horror of money and of turning pale when it was offered him. . . . And this was certainly unfeigned."

For he knew its weight. Blake, in order to survive, had had to push that Sisyphean boulder uphill all his life, starting anew at the bottom of failure time after time. During his early years, when the patronage of art in England was under the sway of Sir Joshua Reynolds, he must have found the going especially steep and rough. Writing in 1808 (in his marginalia to Reynolds's *Discourses*), he recalls having "spent the Vigour of my Youth & Genius under the

Oppression of Sr Joshua & his Gang of Cunning Hired Knaves Without Employment & as much as could possibly be Without Bread . . ."; and when, further on, he says of the two visionary English artists whose work he had most admired in those days, that "Barry was Poor & Unemploy'd, except by his own Energy; Mortimer was call'd a Madman . . ." he might have been talking not only about, but to, himself. In the degradation of art—and artists—by money he saw the debasement of Albion.* "Where any view of money exists," he wrote (on his allegorical engraving of the Laocoön) circa 1820, "Art cannot be carried on, but War only. . . ."

An anonymous friend of Blake's, cited by Alexander Gilchrist in his *Life,* recalls Blake as having suffered a contemptuous rebuff during his youth from Sir Joshua himself:

> Once I remember his talking to me of Reynolds, [and] he became furious at what the latter had dared to say of his early works. When a very young man he had called on Reynolds to show him some designs, and had been recommended to work with less extravagance and more simplicity, and to correct his drawing. This Blake seemed to regard as an affront never to be forgotten. He was very indignant when he spoke of it.

The wound continued to fester, especially since he was reminded of it over the years by the rankling criticism, repeated and parroted so often that it came to be taken for granted, that his technical skills as an artist-engraver were inferior to his designs and conceptions.

"I know," he declares (in his *Public Address* of 1810), "my Execution is not like Any Body Else. I do not intend it should be so; none but Blockheads Copy one another." And then: ". . . the Lavish praise I have received from all Quarters for Invention & drawing has Generally been accompanied by this: 'he can conceive but he cannot Execute'; this Absurd assertion has done me, & may still do me, the greatest mischief."

What Blake chiefly resented was the disparagement by critics of the austere, linear style of engraving he had learned at Basire's and still "religiously" practiced. This style, employed by Dürer and Giulio Romano and Marcantonio, which rendered tones by means of parallel lines of varying thickness and by elaborate webs of cross-hatching, had long been superseded by the method of burnishing and scraping a roughened plate called mezzotint—known internationally as *la manière anglaise*—and by the still more modern etching technique of aquatint. During Blake's youth the two most celebrated engravers in England were William Woollett (1735–85) and Sir Robert Strange (1721–92), who used a hybrid style combining drypoint, line engraving, and etching, but whom Blake condemns nevertheless and confounds with the practitioners of *la manière anglaise.*

"What is Call'd the English style of engraving," he writes, "such as proceeded from the Toilettes of Woolet [sic] & Strange (for theirs were Fribble's Toilettes) can never produce Character & Expression. I knew the Men intimately from their Intimacy with Basire my Master & knew them both to be heavy lumps of Cunning & Ignorance. . . ." Against Woollett, especially, then twenty-five years dead, his rage and scorn were obsessive: "Woollett I know did not know how to grind his graver," he writes. "I know this. . . ."

It is that stutteringly reiterated and apodictic "I know . . . I know . . ." that certifies for us that what Blake knows he knows for a certainty by the glow of his own inner light. With the prophetic fury of a cockney Ezekiel or Jeremiah *qua* artist, as astonishing in his time as in ours, he denounces all the works of the blasphemous mezzotinters and no less perfidious tribe of aquatinters as "slobberings," "bunglishness," "blundering blurs," "Venetian & Flemish ooze,"

*Blake's biographer, Alexander Gilchrist, relates that, sometime during his youth, an officious go-between at the court once showed a portfolio of Blake's visionary prints and drawings to George III. Whether this was meant to assist the artist, or to help effect a sort of homeopathic cure of the demented king, goes unmentioned. "'Take them away!'" writes Gilchrist, "was the testy mandate of disquieted royalty." An echo of this abrupt rejection by George III may perhaps be heard in an untitled poem by Blake that begins:

> *I rose up at the dawn of day—*
> *Get thee away! get thee away!*
> *Pray'st thou for Riches? away! away!*
> *This is the Throne of Mammon grey.*

"paltry blots,"* and more besides. Their sins in denying outline, as Blake saw them, were sins against the Divine Imagination; for art and morality, good works and good deeds, were inseparable and interchangeable. In A Descriptive Catalogue he makes this explicit:

> The great and golden rule of art, as well as of life, is this: That the more distinct, sharp, and wiry the bounding line, the more perfect the work of art; and the less keen and sharp, the greater is the evidence of weak imitation, plagiarism, and bungling. . . . What is it that distinguishes honesty from knavery, but the hard and wiry line of rectitude and certainty in the actions and intentions? Leave out this line, and you leave out life itself; all is chaos again, and the line of the almighty must be drawn out upon it before man or beast can exist.

But in stressing "the bounding line" in art as in life, yet erasing the "keen and sharp" distinction between them, as it exists in this very world, Blake's paradoxical "golden rule" was regarded instead as the measure of his own madness.

A Descriptive Catalogue, though it had the opposite effect, was intended mainly to refute just that charge—that he himself was insane and his works "but an unscientific and irregular Eccentricity, a Madman's Scrawls." He now appealed directly to the public from "the judgment of those narrow blinking eyes, that have too long governed art in a dark corner." As a pamphlet of some 38 pages, along with several related leaflets and handbills, it was given away free as part of the 2s 6d admission charge to an exhibition, in the summer of 1809, of sixteen "Poetical and Historical Inventions, painted by William Blake in water colors, being the ancient method of fresco painting restored." Blake undoubtedly perceived the dead hand of Sir Joshua Reynolds still raised against him from the spirit world, for his Descriptive Catalogue— more a polemic than a catalogue, and less a description of the pictures than a religious and philosophical tract—criticizes throughout those artists most esteemed by Reynolds, such as Titian and Rubens and Correggio, and even condemns oil painting itself, which (he declares) "deadens every colour it is mixed with . . . and in a little time becomes a yellow mask over all it touches." (Further on, he adds: "This is an awful thing to say to oil Painters; they may call it madness, but it is true.") One idea in A Descriptive Catalogue suggests another, sometimes only distantly or even metaphorically related, which immediately raises its voice above it, and then, in turn, may be drowned out by a following idea, before the first can be heard again. Written in the ejaculatory style of his marginalia, but now across the whole page of everything he believes and knows, it is as though the conclamant and sometimes discordant voices of all his attendant spirits were alternately haranguing, explaining, protesting, denouncing, scolding, cajoling, lecturing, pleading and prophesying.

The exhibition itself (not one painting was sold), like A Descriptive Catalogue that accompanied it, turned out to be a fiasco. One nameless reviewer, writing about the show in September of 1809, described Blake as "an unfortunate lunatic, whose personal inoffensiveness secures him from confinement," and went on:

> The poor man fancies himself a great master, and has painted a few wretched pictures, some of which are unintelligible allegory, others an attempt at sober characters by caricature representation, and the whole "blotted and blurred," and very badly drawn. These he calls an Exhibition, of which he has published a Catalogue, or rather a farrago of nonsense, unintelligibleness, and egregious vanity, the wild effusions of a distempered brain. . . .

*"Blots," paltry or otherwise, was no mere epithet. In a well-known treatise on etching entitled A New Method, published in 1784, the engraver Alexander Cozens demonstrated the use of "blots" executed in aquatint to create "Original Compositions in Landscape." Blake may have had this technique in mind when (in A Father's Memoirs of His Child, by Benjamin Malkin, published in 1806) he spoke of "blots, called masses; blots without form, and therefore without meaning. These blots of light and dark, as being the result of labour, are always clumsy and indefinite; the effect of rubbing out and putting in, like the progress of a blind man, or of one in the dark, who feels his way, but does not see it."

In Blake's *Public Address* of 1810 (which was never made public), he refers bitterly to this article, complaining to his ghostly audience that "the manner in which my Character has been blasted these thirty years, both as an artist & a Man, may be seen particularly in a Sunday Paper cal'd the Examiner" and then passes without a break, and in the same sentence, to his other grievances, the ingratitude of friends and the contumely of patrons, the spite of his rivals, the decline of honest drawing in favor of spurious color in art, English engravers vs. European, puffed-up reputations in newspapers . . . which reminds him, and he suddenly erupts once more: *"It is very true, what you have said for these thirty two Years. I am Mad or Else you are so; both of us cannot be in our right senses. Posterity will judge by our Works."* [Italics added.]

And in that, of course, he was right: "Posterity" (meaning ourselves) has done even better, and made his works into a touchstone by which we judge our own works. The aspersion of madness against him, though it still persists, has come to seem increasingly beside the point. No doubt, among the heterogeneous swarms of spirits attending him he must have had (and who hasn't?) one or two or several spirits, with a bit too much white around the eyeball; but to call an ecstatic and visionary artist such as Blake "mad" would be like saying of an accountant that he was "calculating."

Yet even with that in mind, the virulence of his hatred against all those whom he considered "spiritual enemies," especially Reynolds, sometimes teeters on paranoia. In the case of Sir Joshua—that "doll" (as Blake dubbed him) of the king and nobility—he continued to stick pins into his effigy long after the man himself had died in 1792. Around 1808, a year before his exhibition, Blake conjured up the spirit of Reynolds for a "Mental Fight," head-to-head and with no thoughts barred, when he came to annotate the *Discourses*.

Dr. Johnson had once remarked of Reynolds that he was "the most invulnerable man he knew; whom, if he should quarrel with him, he should find the most difficulty how to abuse"; but Blake, no respecter of persons—least of all Sir Joshua's—refers to him throughout as "hypocrite," "liar," "villain," "Damned Fool!" "sly dog," and so forth. On the title page of the *Discourses,* he states flatly: "This Man was Hired to Depress Art"; and then, should there be any doubt, adds: "This is the Opinion of Will Blake: my Proofs of this Opinion are given in the following Notes." Next to a passage in the dedication "To the King," where Reynolds declares that it was his duty for years "To give advice to those who are contending for royal liberality," Blake exclaims, "Liberality! we want not Liberality. We want a Fair Price & Proportionate Value & a General Demand for Art." Elsewhere, of a statement by Reynolds (in *Discourse III*) that "the whole beauty of the art [of painting] consists . . . in being able to get above all singular forms, local customs, particularities, and details of every kind," Blake pounces, "A Folly! Singular & Particular Detail is the Foundation of the Sublime"; and, again, a bit further on, where Reynolds mentions "a rule, obtained out of general nature," he asks, "What is General Nature? is there Such a Thing? what is General Knowledge? is there such a Thing? Strictly Speaking All Knowledge is Particular."

The *Discourses,* in fact, served as a foil for him to set off the "minute particulars" of his own ideas and, at the same time, to respond to Reynolds's old charge, unforgotten and unforgiven, that he was lacking in skill as an artist. From the start, though attached to no statement by Reynolds in his Introduction, this is blazoned upon the page as a kind of heraldic philosophic device: "Invention depends Altogether upon Execution or Organization; as that is right or wrong so is the Invention perfect or imperfect. Whoever is Set to Undermine the Execution of Art is set to destroy Art. Michael Angelo's Art depends on Michael Angelo's Execution Altogether." And later on (in *Discourse IV*), and again without reference to any one remark by Reynolds, he asserts: "I know"—that incandescent gleam of certainty!—"that The Man's Execution is as his Conception & No Better." For how, in Blake's mental realm of being, where "Thought is Act," could it be otherwise? Just as a dream may be said to be fully realized and enacted in the dreaming, so any work of the imagination is already realized in the imagining.

Elsewhere, in the very process of commenting on the *Discourses*, Blake exhibits this thought (about the identity of thought and act) itself in action. Next to an editorial footnote that the colors in certain of Reynolds's pictures were fading, he remarks sarcastically, "I do not think that the Change is so much in the Pictures as in the Opinions of the Public"; and then, next to an account of Reynolds's death and state funeral, which was attended by the king and queen and all the potentates of England, Blake distilled the rage and resentment of a lifetime into a drop, no larger than a tear, of venom:

When Sr Joshua Reynolds died
All Nature was degraded;
The King drop'd a tear into the Queen's Ear
And all his Pictures Faded.

The alchemical ingredients of this verbal sorcery may be analyzed as follows: Nature, "mortal & perishing," as Blake saw it, though be-all and end-all to the "single vision" of Reynolds, was of course diminished, or "degraded," by the death of the man who had worshipped her in his art as a goddess. The tear ("For a tear," wrote Blake in *The Gray Monk*, "is an intellectual Thing") shed by the king into the queen's ear—a sort of mock Annunciation in which the demented George III plays the part of the Holy Ghost—suffices to wash out all the pictures of Reynolds from her mind.

Any work of the imagination, such as a poem or a picture, must necessarily be composed of mind-stuff, but Blake saw the larger creation as well, this very world, as no different in kind. The acts that made up the lives of the prophets, in the Bible and in the world, spoke through them as thoughts, miming the voice of God. In Ezekiel's use of human dung as fuel with which to cook his food, for instance, was prefigured the famine that would occur in Jerusalem during its siege by the Chaldeans; in the cuckolded Hosea's divorce of his wife, the exile of Israel for its infidelity in lusting after strange gods; and in the shepherd Amos's poverty, the Lord's condemnation of the rich and powerful for their greed and oppression. All had been "set as a sign" by God to reveal, and so impose, by a kind of magic-working charade, His judgments upon the people. The Word and the Work, as thought and act, interpenetrate.

So then, to get back: the "Sr Joshua Reynolds" whose name has also been "set as a sign" and magically spelled out by Blake, once existed as the flesh-and-blood Reynolds, Joshua (1723–1792); but within the context of Blake's epigrammatic poem he has been transfigured into a mythic character on the same transcendent plane as his Orc and Ozoth, Tiriel and Zazel, Tirzah and Rahab, and all the rest. At the time Blake came to annotate the *Discourses*, he had already begun the immense "Intellectual Allegory" (as he called it) of *Milton* and *Jerusalem*. In conception and execution the gnomic epigram he improvised on Reynolds is related to these as micro- to macrocosm, a bit of moon rock brought down to earth by means of which we can assay the moon itself.

Side by side with his pantheon of "Giant Forms" in the prophetic books, Blake also introduced a set of historical personae, such as Milton and Newton and Bacon and Locke, and, even under their proper names, a sub-cast of various minor characters whose sole importance was that they had once played a part in his own life. All of them act and react with one another, unite with or annihilate one another, shift identities and become one another like the phantoms of a dream, yet a dream within a larger dream, his own expanded into the 6,000-year-old dream of Albion. Mundane events in his personal life thus become symbolic of cosmic events in eternity. Blake himself may suddenly appear among his own creations, as in *Vala*, when he and his wife Catherine, apotheosized as Los and Enitharmon, are glimpsed in a domestic scene at work together:

And first he drew a line upon the walls of shining heaven,
And Enitharmon tinctur'd it with beams of blushing love.

Or in *Milton*, when he becomes Palamabron (one of the many sons of the fourfold Los) and resumes his quarrel with a quondam benefactor, William Hayley, there cast as Satan, whom Blake regarded as a "corporeal friend" but "spiritual enemy":

Then Palamabron, reddening like the Moon in an Eclipse,
Spoke, saying: "You know Satan's mildness and his self-imposition,
Seeming a brother, being a tyrant, even thinking himself a brother
While he is murdering the just: . . ."

By his envisioning of himself in this way, as the blake-smith and poet Los, we can thus see Blake as he saw himself thro' his own eyes.

As his spiritual ancestor and predecessor in such a self-transubstantiation, there was the half-mythic patriarch and prophet Enoch, seventh in descent from Adam, who (as it says in Genesis 5:24) "walked with God: and he was not; for God took him." According to cabbalist

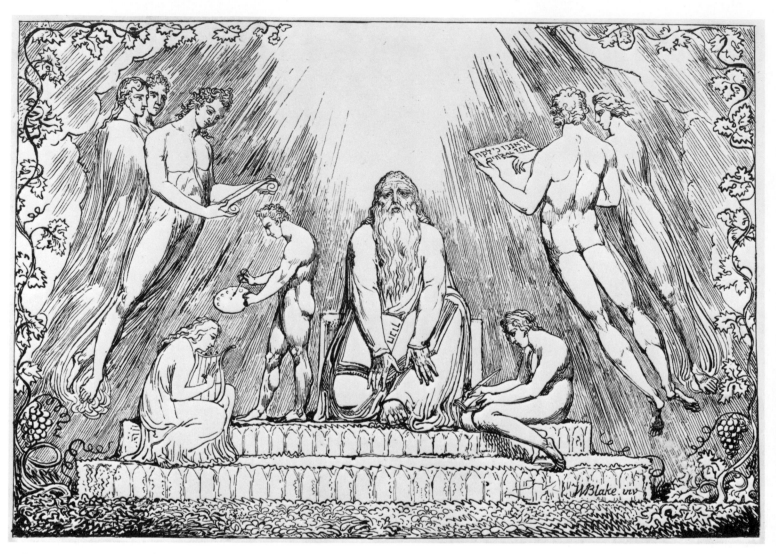

Job in Prosperity, the only lithograph ever made by Blake, c. 1807. The book held by Job in his lap is inscribed "Enoch" in Hebrew letters, and the words on the scroll displayed by the angels at the right are from the text of Genesis 5:24.

tradition,* Enoch (like Jacob Boehme) was a shoemaker by trade. With each stitch of his awl, joining uppers and lowers—symbolizing heaven and earth—he meditated upon a spirit that he had seen in a vision, the Archangel Metatron. His last stitch-thought was made at the age of 365 (one year for each day of the solar year, so that Enoch has often been identified with the Babylonian sun god Enmeduranna), at which time he was taken up alive by God to heaven and transformed into the Archangel Metatron he had envisioned during his labors on earth.

In the manner of Enoch the shoemaker, Blake as an engraver also combined "uppers and lowers," relief and intaglio, on copper plates that were etched and then printed in black and white. But which, relief or intaglio, was black, which white? He could, and did, engrave them either way, sometimes using black line in relief, etching away the whites, as in the designs for *Songs of Innocence,* and sometimes using white line on a black ground (similar to the wood engravings of his contemporary Thomas Bewick), as in the quicksilvery illustrations for *Jerusalem.* But the choice, in either case, was as much mystical as aesthetic. For Blake not only believed but also lived and enacted his ideas, reaffirming them within and without in each line he engraved. As Enoch became Metatron, he became Los.

Still another cabbalist tradition, of which Blake must have been aware, holds that the sacred Torah, containing the name of God, had originally been burned into being with "black

*That heaven and earth mirror each other, a concept as vital to Neoplatonist mysticism as to cabbalism, was also expressed by the alchemist *Emerald Tablet* of Hermes Trismegistus as its first dictum: "In truth, certainly, and without doubt, whatever is below is like that which is above, and whatever is above is like that which is below, to accomplish the miracles of one thing." Blake never doubted this principle. "There Exist in that Eternal World," he wrote in his *Vision of the Last Judgment,* "the Permanent Realities of Every Thing which we see reflected in this Vegetable Glass of Nature."

fire upon white fire," but in reverse, as in an engraving, so that the "white" is really the written Torah and the "black" the oral Torah transmitted from generation to generation. Concerning this, the author of *On the Kabbalah and Its Symbolism*, Gershom Scholem, remarks:

> Everything that we perceive in the fixed forms of the Torah, written in ink on parchment, consists, in the last analysis, of interpretations or definitions of what is hidden. *There is only an oral Torah:* that is the esoteric meaning of these words, and the written Torah is a purely mystical concept. It is embodied in a sphere that is accessible to prophets alone. . . . The mystical white of the letters on the parchment is the written Torah, but not the black of the letters inscribed in ink.

So Blake, in that incantatory and repetitive mantra of a poem, *The Everlasting Gospel,* written about 1818, contrasts in opposing visions the exoteric black and the esoteric white:

> *Thine loves the same world that mine hates,*
> *Thy Heaven doors are my Hell Gates. . . .*
>
> *Both read the Bible day & night,*
> *But thou read'st black where I read white.*

If we read the "black" of Blake, in the above, as self-evident, taking him at *his* word, then to see it as he saw it, we would have to read the Word-within-the-Word of the Bible as "white," or (as he had already stated some twenty-five years before, in *The Marriage of Heaven and Hell*) "in its infernal or diabolical sense."

What that "sense" was, in its Manichean black-white opposition to things-as-they-are, he must have discovered, possibly while still quite young, in the cosmogonic myths devised by the gnostic heretics of the second and third centuries. Though none of the once widespread gnostic texts have survived, Blake would have found a description of them in books of that era by their Catholic adversaries, especially in the church father Irenaeus's *Against Heresy*. But from whatever source, their mystical nihilism became etched upon his mind, shaping his own essential and existential lineaments. As to this gnostic influence, Crabb Robinson reports that

> On my obtaining from him the declaration that the Bible was the work of God, I referred to the commencement of Genesis: "In the beginning God created the Heaven & the Earth." But I gained nothing by this, for I was triumphantly told that this God was not Jehovah, but the Elohim, & the doctrine of the Gnostics repeated with sufficient consistency to silence one so unlearned as myself.

Blake is often equivocal in his references to Jehovah, but in many of the gnostic myths the jealous and tyrannical God of the Jews (as the Gnostics considered him) was identified with their own evil demiurge, called Ialdaboath, who created the world in his own image. Above and against Ialdaboath they elevated the Son of Man, Christ, as the Saviour who would "raise the sparks" of divinity once again in mankind, or, as Blake put it, "fallen, fallen light renew!" "Thinking as I do," he wrote, in his *Vision of the Last Judgment*, "that the Creator of this World is a very Cruel Being, & being a Worshipper of Christ, I cannot help saying: 'the Son, O how unlike the Father!' First God Almighty comes with a Thump on the Head. Then Jesus Christ comes with a balm to heal it."

Blake's misanthropic "Old Nobodaddy," Urizen, who appears in *Jerusalem* "muttering low thunders" and boasting "Now I am God from Eternity to Eternity," has as a prototype the gnostic archon Ialdaboath; and Blake's mysterious Eno, described as a Daughter of Beulah, or Inspiration, who

> . . . took a Moment of Time
> And drew it out to seven thousand years with much care & affliction
> And many tears, & in every year made windows into Eden,

has for hers the procreative Ennoia (or Sophia Prunikos), the first emanation of the true God, the Nameless One. It was Ennoia, in the gnostic account of creation, who gave birth to Ialdaboath in thought, and afterward regretted her act. As related by Irenaeus, "He [Ialdaboath] boasted . . . and said, 'I am Father and God and there is none above me.' To which

his mother [Ennoia] retorted, 'Do not lie, Ialdaboath; there is above thee the Father of all, the First Man, and Man the Son of Man.'" So Blake, in his *Milton*, tells of how this "King of Pride"

> . . . *making to himself Laws from his own identity,*
> *Compell'd others to serve him in moral gratitude & submission,*
> *Being call'd God, setting himself above all that is call'd God; . . .*

In rejecting this jealous and self-justifying deity, Blake also annulled his authoritarian fiat that compels us, by reason, to accept the laws of creation as the only possible laws, to see the sun, that is, only by its own light. Instead he envisioned other creations with other laws, and saw the sun not with, but thro', his eyes, and by his own "inner light."

Where that led him, following the gleam, we already know: to the visionary perception of Old Nobodaddy–Urizen–Ialdaboath, enthroned within each individual as conscience and superego and within society as judge and executioner, an all-pervasive monodeism (as he described it in *The [First] Book of Urizen*) with

> *One command, one joy, one desire,*
> *One curse, one weight, one measure,*
> *One King, one God, one Law,*

his ill will being done on earth as it is in heaven. In his own time, having proclaimed himself the prophet of Divine Imagination, Blake suffered the usual fate of prophets. His epic myths of creation, opposing creation itself, were almost entirely ignored, or else scoffed at, as mere delphic gibberish; his apocalyptical religious politics were viewed as crackpot either way, an offense to the right and a scandal to the left; his picture-poems, except for *Songs of Innocence and of Experience*, as inspired but formless and flawed in technique. Many of his works were destroyed after his death or allowed to disappear; *Vala*, for instance, remained in manuscript and unpublished until it was rediscovered by W. B. Yeats in 1889. Not before our own doom-haunted age, in fact, following World War II, has Blake's faith in his vision come to seem justified.

Writing in 1920, T. S. Eliot criticized Blake's "crankiness" and "eccentricity," while conceding that, for its "naked honesty," his work had "the unpleasantness of great poetry." And then concluded: "What his genius required, and what it sadly lacked, was a framework of accepted and traditional ideas which would have prevented him from indulging in a philosophy of his own, and concentrated his attentions upon the problems of the poet." But whatever the "problems" he had in mind, Blake's were not Eliot's; and in any case, the man who once declared himself to be royalist in politics, Anglo-Catholic in religion, and classicist in literature—and was a prude and a bigot to boot—could never have accepted Blake's revolutionary, millenarian, romantic, and libertine "solutions."

In agreement with Eliot, the onetime apostle of modern art in the 1920s Roger Fry criticized Blake's technical facility as an artist as well, especially his drawing, and in words that seem to reecho the hollow voice of Sir Joshua Reynolds *d'outre-tombe*. Fry describes the figures so often depicted by Blake, with their space-flight or dream-space weightlessness, as having "the wavy unresistance of seaweed," in which "his lines wave about in those meandering nerveless curves which were so beloved by the Celtic craftsmen long before. He shows in this . . . a strange atavism which may not be unconnected with his mental malady." Fry, in fact, after disposing of Blake as deranged, would have preferred to categorize all of Blake's work as "surrealism," as if that was that, but it bulked too huge and proved too anomalous even for that compendious grab bag.

"It was words like 'the deep,' 'the Lord of Hosts,' 'the firmament,'" declares Fry, "with their vast and vague cosmic references, that stirred his spirit and forced him to refashion his conception into its own cosmogony, with its Thels and Gorgonoozas [*sic*]"—the perfervid effluvia of the foregoing, no doubt, must have wafted his own spirit toward thoughts of gorgonzola— "and Enotharmons [*sic*]." A similar distaste, soured by confusion, has been felt by almost everyone when first confronted with the brain-cluttering unpronounceable names and unscrambleable genealogies of Blake's personae. Entering his mythic world is like being immersed in an oceanic soup or stew of the imagination swarming with the minute particulars of someone else's nightmare. For this reason the attempt has sometimes been made by scholiasts

to demythologize Blake, just as the Bible itself has been so reduced by modern theologians, and to extract from the prophetic books an essential *kerygma* (so to speak) of inspired poetic fragments and philosophical concepts. Howbeit, one might as easily remove the mythological infra- and superstructure from Blake's work without killing the spirit as transcribe the multiple and multilingual puns of Joyce's *Finnegans Wake* into plain prose.

How to define and where to assign Blake, in what genre or tradition, still perplexes critics. He somehow remains outside any circle of reference we attempt to draw him into, existing in an epicycle apart and his own. As a painter, he seems to belong to the same totemic clan as those magic-working shaman artists of prehistory who once drew their own giant forms on the cave walls of Lascaux and Altamira; and as a poet, to the conclave of anonymous scribes and rhapsodic bards who invented the creation myths of the ancient religions. Yet he is no less in the present, perhaps more so to us now than to his own contemporaries, and, at the same time, futuristic as well. For the prophetic books have turned out to be just that, a kind of metaphysical science fiction in which, miraculously or coincidentally, many of the formative ideas of the twentieth century, Nietzsche's as well as Heisenberg's, Freud's as well as Reich's, were at least glimpsed momentarily in his vision. ("The Nature of Visionary Fancy, or Imagination," he wrote in his *Vision of the Last Judgment*, "is not well known.") We might even have to accept him on his own terms, see him as he saw himself.

And the way he saw himself (as we have seen), with his fourfold vision raised to its height, was as W.B.[4], incorporated into the divine body of the fourfold God-Man Albion, alias Adam Kadmon:

> *Then those in Great Eternity met in the Council of God*
> *As one Man, for contracting their Exalted Senses*
> *They behold Multitude, or Expanding they behold as one,*
> *As One Man all the Universal family; . . .*

as he stated in *Vala*. It is of course an ancient concept, sacred to Christianity, and envisioned also by the prophet Isaiah centuries before then. But Blake, being Blake, deliberately banished Old Nobodaddy and all other transcendent deities from their spheres above us. "Man can have no idea of anything greater than Man," he wrote, "as a cup cannot contain more than its capaciousness."

Within fairly recent times, the emergent but still inchoate existence of a spiritual Anthropos, in whom we live and move and have our being, was posited in Teilhard de Chardin's quasi-mystical evolutionary theory of a universal noosphere; also, the "collective unconscious" of this Anthropos was explored and analyzed symbolically by C. G. Jung and others; and, of course, the biography (or autobiography) of H.C.E., or "Here Comes Every-body," was spoken in tongues by James Joyce in *Finnegans Wake*. ("With pale blake," said Joyce in tribute, "I write tintingface.") The 6,000-year-old dream of Albion asleep has its obvious counterpart in the endlessly flowing "stream of consciousness" of Finnegan awake, but there is a crucial difference between them: for where Joyce's labyrinthine opus has no exit, but begins again where it seems to end, cyclically, Blake's reaches its climax in the ultimate redemption and awakening of Albion.

And this in itself, with fewer than twenty-five annual heartbeats remaining before the millennial year 2000, may account for the almost noumenal power of Blake's vision nowadays. For though the real existence of all men in "One Man" still seems no more than metaphysical science fiction, the possible annihilation of mankind as a whole, through nuclear warfare or some other disaster, has come to be universally accepted. If not in life, then in death—"the all tremendous unfathomable Non Ens"—Albion has assumed a paradoxically "real non-existence." Blake's words, at the conclusion of *Jerusalem*, thus seem to have been written for us in black fire on white fire:

> *"Do I sleep amidst danger to Friends? O my cities & Counties,*
> *Do you sleep? rouze up! Eternal Death is abroad!"*
>
> *So Albion spoke & threw himself into the Furnaces of affliction.*
> *All was a Vision, all a Dream: the Furnaces became*
> *Fountains of Living Waters flowing from the Humanity Divine.*

This picture was once entitled "Glad Day" by Blake's biographer, Alexander Gilchrist, on the assumption that it was meant to illustrate a passage from Shakespeare's *Romeo and Juliet* (III:5):

Night's candles are burnt out, and jocund day
Stands tiptoe on the misty mountain tops.

But another source may be found in Blake's lines from his juvenile verse play *King Edward the Third*, in which "the gallant sun/ Springs from the hills like a young hero/ Into the battle, shaking his golden locks"; and still another, in Milton's *Samson Agonistes*, where Samson describes himself as laboring "eyeless in Gaza, at the mill with slaves." All three, most likely, must have entered into its conception.

Albion, Blake's universal God-Man, is depicted here in an attitude of exaltation and/or crucifixion. (See page 104). His posture resembles that of the famous proportional figure of "Vitruvian Man," whose outspread legs and outstretched arms, touching the rim of a circle inscribed within a square, embodied the Renaissance conception of man as the measure of all things.

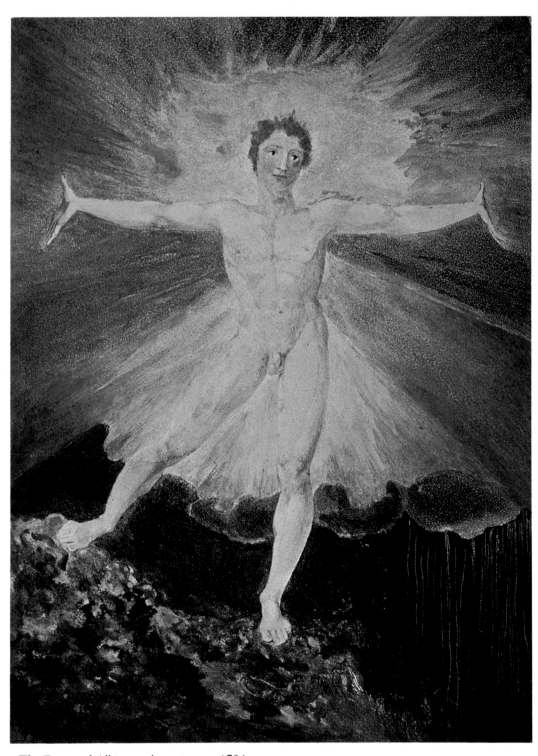

The Dance of Albion, color print, c. 1794

Albion rose from where he labour'd at the Mill with Slaves:
Giving himself for the Nations he danc'd the dance of Eternal Death.
　　　　　Inscribed by Blake on a line engraving of the same subject c. 1803

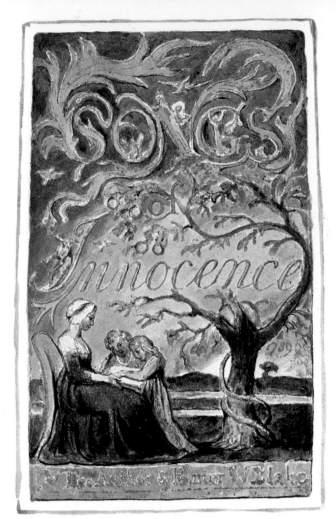

Title page, SONGS OF INNOCENCE, relief etching, painted with watercolors and gold, 1789

Songs of Innocence, containing thirty-one plates, was first published separately in 1789. Five years later, in 1794, it was combined with *Songs of Experience* into a single book of fifty-four plates, under the new title *Songs of Innocence and of Experience Shewing the Two Contrary States of the Human Soul.* ("Without Contraries," he wrote in *The Marriage of Heaven and Hell,* "is no progression.") Throughout his life Blake never ceased experimenting with the order in which the poems are arranged.

Ruthven Todd, who along with the artists Joan Miró and Stanley Hayter first succeeded in reproducing Blake's method of "illuminated printing," describes his procedure as follows. Blake first wrote the words of the poem with a "stop-out" varnish (one imper-

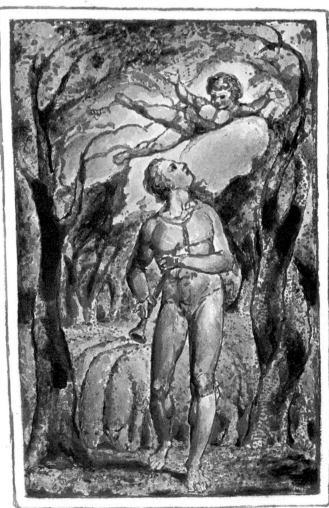

Frontispiece, SONGS OF INNOCENCE

Introduction

Piping down the valleys wild
Piping songs of pleasant glee
On a cloud I saw a child.
And he laughing said to me

Pipe a song about a Lamb:
So I piped with merry chear,
Piper pipe that song again
So I piped he wept to hear.

Drop thy pipe thy happy pipe
Sing thy songs of happy chear
So I sung the same again
While he wept with joy to hear

Piper sit thee down and write
In a book that all may read
So he vanish'd from my sight,
And I pluck'd a hollow reed

And I made a rural pen,
And I staind the water clear,
And I wrote my happy songs
Every child may joy to hear

Introduction, SONGS OF INNOCENCE

vious to acid) on a sheet of paper that had previously been soaked in gum arabic and hung out to dry. A heated copper plate was then placed over the paper and run through a press, so that the writing was transferred, in reverse, onto the plate. The paper could easily be removed by immersing the plate in water, thereby dissolving the gum arabic. Weak or faulty letters were then touched up; a decorative design was engraved on the border and between the lines; and, finally, the plate was inserted into a bath of nitric acid to be etched. The prints were pressed in relief, in the same way as woodcuts, and afterwards tinted with watercolors either by Blake or his wife Catherine. Each copy thus had a distinctive character.

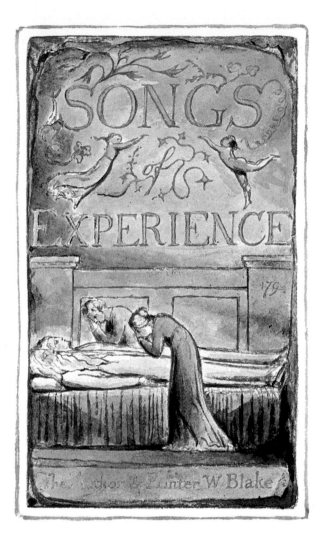

Title page, SONGS OF EXPERIENCE, relief etching, painted with watercolors and gold, 1794

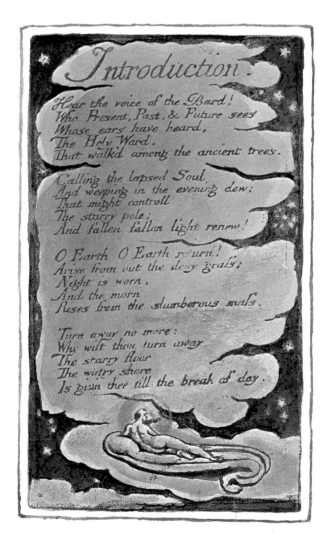

Frontispiece, SONGS OF EXPERIENCE

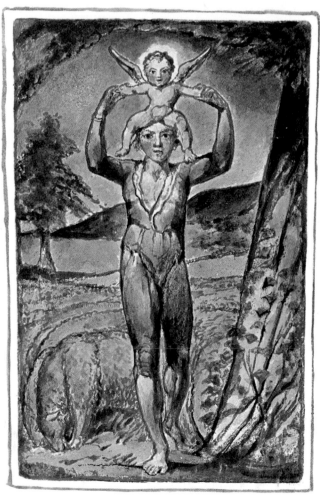

Introduction, SONGS OF EXPERIENCE

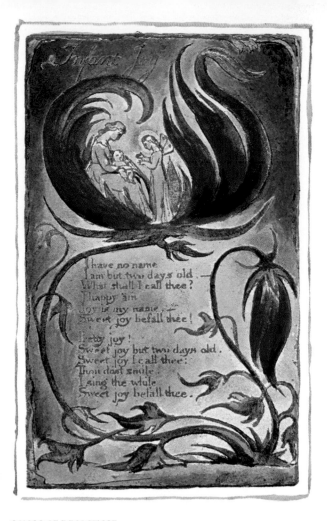

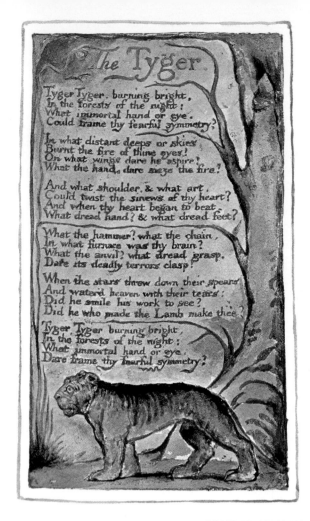

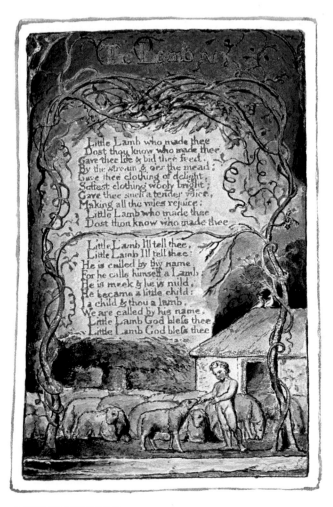

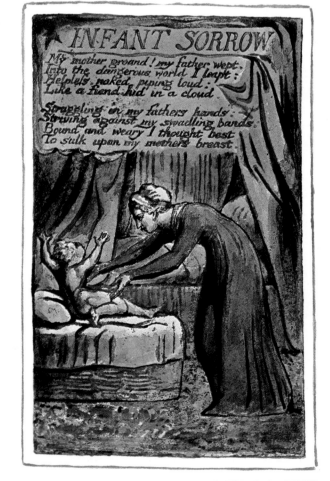

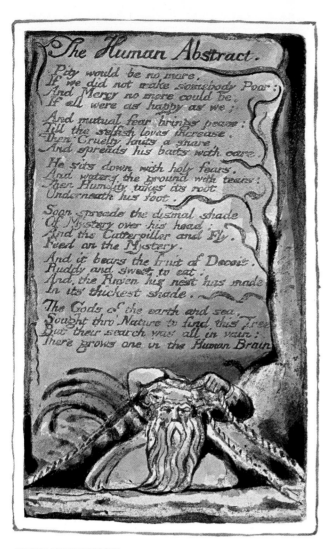

The Human Abstract.

Pity would be no more,
If we did not make somebody Poor:
And Mercy no more could be,
If all were as happy as we;

And mutual fear brings peace;
Till the selfish loves increase.
Then Cruelty knits a snare,
And spreads his baits with care.

He sits down with holy fears,
And waters the ground with tears:
Then Humility takes its root
Underneath his foot.

Soon spreads the dismal shade
Of Mystery over his head;
And the Catterpiller and Fly,
Feed on the Mystery.

And it bears the fruit of Deceit,
Ruddy and sweet to eat;
And the Raven his nest has made
In its thickest shade.

The Gods of the earth and sea,
Sought thro' Nature to find this Tree
But their search was all in vain:
There grows one in the Human Brain

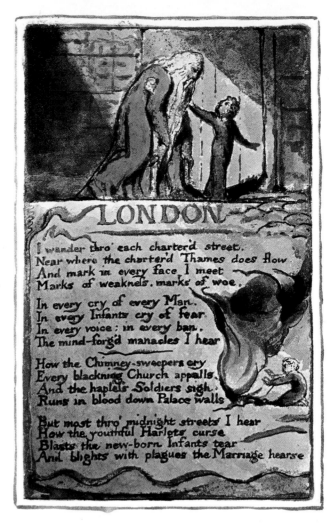

LONDON

I wander thro' each charter'd street,
Near where the charter'd Thames does flow.
And mark in every face I meet
Marks of weakness, marks of woe.

In every cry of every Man,
In every Infants cry of fear,
In every voice; in every ban,
The mind-forg'd manacles I hear

How the Chimney-sweepers cry
Every blackning Church appalls,
And the hapless Soldiers sigh,
Runs in blood down Palace walls

But most thro' midnight streets I hear
How the youthful Harlots curse
Blasts the new-born Infants tear
And blights with plagues the Marriage hearse

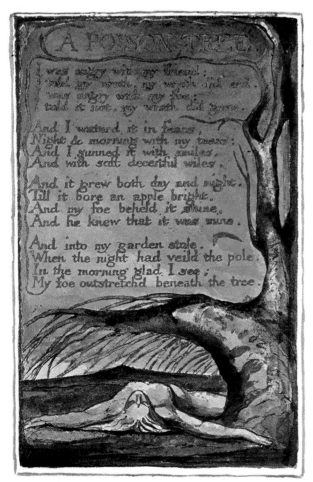

A POISON TREE.

I was angry with my friend:
I told my wrath, my wrath did end.
I was angry with my foe;
I told it not, my wrath did grow.

And I waterd it in fears,
Night & morning with my tears:
And I sunned it with smiles,
And with soft deceitful wiles.

And it grew both day and night,
Till it bore an apple bright.
And my foe beheld it shine,
And he knew that it was mine.

And into my garden stole,
When the night had veild the pole;
In the morning glad I see;
My foe outstretchd beneath the tree.

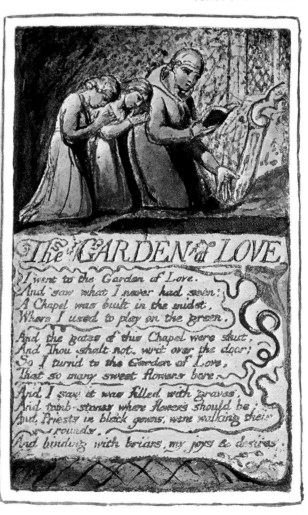

The GARDEN of LOVE

I went to the Garden of Love,
And saw what I never had seen:
A Chapel was built in the midst,
Where I used to play on the green.

And the gates of this Chapel were shut,
And Thou shalt not. writ over the door;
So I turnd to the Garden of Love,
That so many sweet flowers bore.

And I saw it was filled with graves,
And tomb-stones where flowers should be;
And Priests in black gowns, were walking their
 rounds,
And binding with briars, my joys & desires

In *The Book of Los,* etched in the same year 1795 as *The Song of Los,* Blake relates how the poet-blacksmith Los forges the sun, which he then attaches to the spine of Urizen, like a ball and chain, so that Urizen is magically held fast and imprisoned. Los is here shown leaning upon his hammer while he contemplates his labors; but behind him, on either side, radiate beams of an even greater brightness from a different source, suggesting that the sun he has created is material, while the other is spiritual.

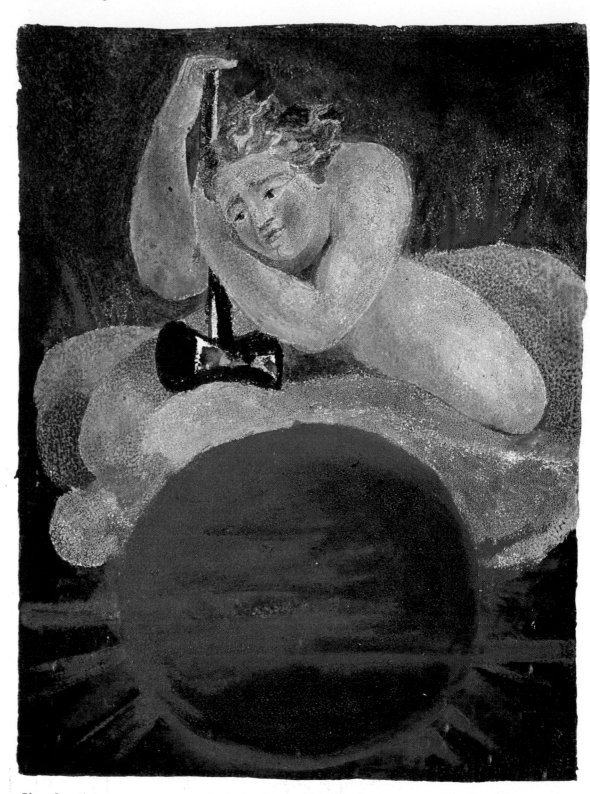

Plate 8, tailpiece, THE SONG OF LOS, relief etching, colored with opaque pigment, 1795

Nine ages completed their circles
When Los heated the glowing mass, casting
It down into the Deeps: the Deeps fled
Away in redounding smoke: the Sun
Stood self-balanc'd. And Los smil'd with joy.
　　　　The Book of Los, IV:7

In a separate painting of this subject, Blake identified the two figures on the celestial lily pod as Oberon, king of the fairies, and his queen, Titania. The "four harps" in the epigraph refer to the four continents: Africa and Asia (both dealt with in *The Song of Los*) and Europe and America (dealt with in the poems so entitled). These early prophecies traced the spiritual history of mankind, from slavery in Africa under the laws of Urizen to the revolutionary outbursts in Europe and America during Blake's lifetime. (See *Introduction*, SONGS OF EXPERIENCE, page 35.)

Plate 5, THE SONG OF LOS, relief etching, colored with opaque pigment, 1795

I will sing you a song of Los, the Eternal Prophet:
He sung it to four harps at the tables of Eternity.
The Song of Los, 3:1–2

Perhaps the most famous of all Blake's pictures, *The Ancient of Days* served as frontispiece to *Europe A Prophecy,* etched in 1794, but it was also struck off and sold separately many times as a color print. According to Blake's friend and biographer, J. T. Smith: "He was inspired by the splendid grandeur of this figure by the vision which he declared hovered over his head at the top of his staircase; and he has frequently been heard to say that it made a more powerful impression upon his mind than all he had ever been visited by."

The passage from Proverbs illustrated by this picture, it should be noted, is a direct address "to the sons of man" by Wisdom (or Sophia, or Ennoia, as she is called in gnostic theosophy), the first emanation of the true but hidden and nameless God. From the gnostic point of view, therefore, it may be interpreted as a rebuke to the malevolent demiurge Ialdaboath, Blake's "Old Nobodaddy," shown creating the universe. He is holding the compass in his left hand, which, according to Blake's symbolism, is "sinister" in both senses of the word. (See commentary, page 131.)

The Ancient of Days, frontispiece, EUROPE A PROPHECY. relief etching, white-line engraving, color printed and painted with watercolors, 1794

The Lord possessed me [Wisdom] in the beginning of his way, before his works of old. I was set up from everlasting, from the beginning, or ever the earth was. When there were no depths I was brought forth; when there were no foundations abounding with water. Before the mountains were settled, before the hills was I brought forth: While as yet he had not made the earth, nor the fields, nor the highest part of the dust of the world. When he prepared the heavens, I was there: when he set a compass upon the face of the depth. . . .

Proverbs 8:22–27

The gross-faced, bat-winged apparition enthroned above, crowned with a papal tiara and holding a copy of Urizen's brazen lawbook in his lap, is obviously meant to caricature King George III. (In the text of *Europe* he is dubbed "Albion's Angel.") His silhouette repeats itself several times diminuendo in the contours of the cathedral windows behind him. The two "angel queens" on either side paying him homage have crossed their scepters, forming the shape of Urizen's compasses and suggesting as well the tongs and pincers of torture.

Plate 11, EUROPE A PROPHECY, relief etching, color printed and painted with watercolors, 1794

Is that dead child, laid out on a shroud next to its grieving mother, meant to be boiled in the cauldron as pot-au-feu and fed to the already overfed and bejeweled matron seated in the chair? No doubt. She seems to be sniffing the aromas and hugging herself in anticipation. This gruesome scene has its counterpart in *Pestilence, on the opposite page,* where it is hard to tell whether the door, with its sardonic inscription, is locking out or locking in the plague carriers. Both pictures are unique in Blake's prophetic books in showing the figures wearing contemporary dress. (See the biblical versions of *Famine* and *Pestilence,* respectively on pages 75 and 74). They accompany

Famine, plate 6, EUROPE A PROPHECY, relief etching, white line engraving, color printed and painted with watercolors and opaque pigment, 1794

no part of the text of *Europe A Prophecy* but, like political cartoons, illustrate Old Nobodaddy's world at large.

During the early 1790s Blake was associated with the radical group of writers and intellectuals led by the publisher Joseph Johnson. Among those in Johnson's circle were the blue-stocking feminist Mary Wollstonecraft, the democratic agitator Thomas Paine, the social theorist and scientist Joseph Priestley, the American revolutionary poet Joel Barlow, and the utopian philosopher William Godwin. But to none of these was Blake closer in spirit than to his two great contemporaries, whose work he did not know, Goya in Spain and the Marquis de Sade in France.

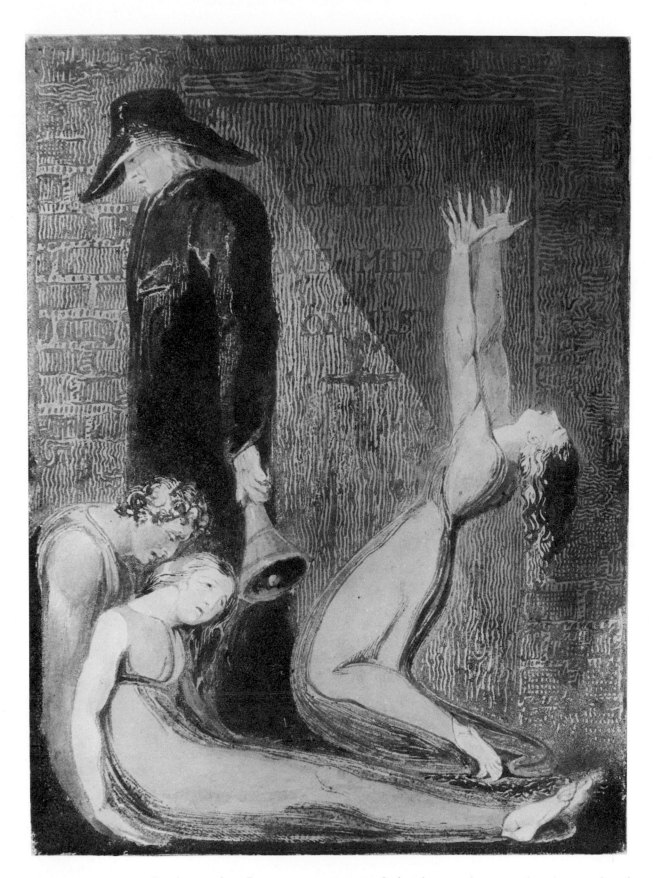

Pestilence, plate 7, EUROPE A PROPHECY, relief etching, color printed and painted with watercolors and opaque pigment, 1794

Urizen, the "self-enclosed, all-repelling" demiurge of Blake's mythic universe, is depicted here as a blind old man squatting in "fearful symmetry" upon his haunches, a quill in one hand and an etching needle in the other, simultaneously writing and illustrating his own work. With the toes of his right foot, he seems to be tracing mysterious Braille-like figures upon a book that is rooted in the ground. The Mosaic tablets of the Law behind him are like twin tombstones—or the doors of a cave leading to death—while the barren branches of the Tree of Mystery form an arch over the whole scene.

The few letters that can be made out in Urizen's book, incidentally, resemble those in the cabbalist alphabet devised by the Jesuit mystagogue Athanasius Kircher for his *Oedipus Aegypticus* (1652):

Plate 1, title page, THE [FIRST] BOOK OF URIZEN, relief etching, painted with watercolors and gold, 1794

Lo! I unfold my darkness, and on
This rock place with strong hand the Book
Of eternal brass, written in my solitude:

One command, one joy, one desire,
One curse, one weight, one measure,
One King, one God, one Law.

The [First] Book of Urizen, II: 7–8

In this uncanny picture Urizen, as an aged skeleton crouched like a foetus, is shown in the process of being born . . . not into life, however, but into death.

Plate 8, THE [FIRST] BOOK OF URIZEN, relief etching, possibly color printed and painted with watercolors, 1794

In a horrible, dreamful slumber,
Like the linked infernal chain,
A vast Spine writh'd in torment
Upon the winds, shooting pain'd
Ribs, like a bending cavern;
And bones of solidness froze
Over all his nerves of joy.
 The [First] Book of Urizen, IV:6

Around 1791 Blake, along with several other engravers, was commissioned by the publisher Joseph Johnson to do several of the engravings for a book by Captain J. G. Stedman entitled *A Narrative, of a five Years' expedition, against the Revolted Negroes of Surinam, in Guiana, on the Wild Coast of South America; from the years 1772 to 1777.* Blake did sixteen engravings in all, based on sketches supplied by the author.

Stedman, an English soldier of fortune hired by the Dutch planters to assist in putting down the slave rebellion, became a passionate abolitionist upon his return to London. His first-hand description of the cruelties inflicted upon the "Revolted Negroes" made a profound impression on Blake, and, in 1793, influenced his conception of the prophetic book *Visions of the Daughters of Albion.*

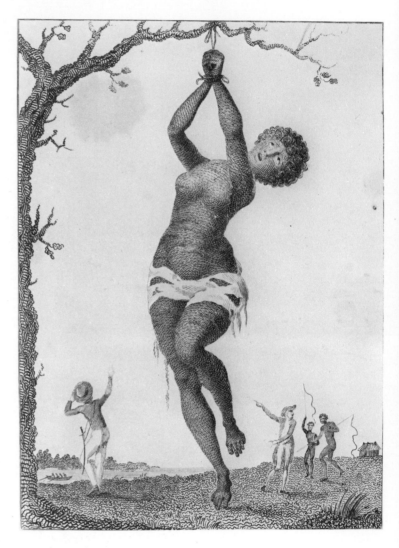

A Negro Hung Alive by the Ribs to a Gallows, REVOLTED NEGROES OF SURINAM, line engraving, c. 1792

Flagellation of a Female Samboe Slave, REVOLTED NEGROES OF SURINAM, line engraving, c. 1792

"Not long ago . . . I saw a black man suspended alive from a gallows by the ribs, between which, with a knife, was first made an incision, and then clinched an iron hook with a chain: in this manner he kept alive three days. . . ."
Revolted Negroes, Vol. 1, Chap. 6

". . . a beautiful Samboe [of mixed black and mulatto descent] girl of about eighteen, tied up by both arms to a tree, as naked as she came into the world, and lacerated in such a shocking manner by the whips of two negro-drivers, that she was from her neck to her ankles literally dyed with blood."
Revolted Negroes, Vol. 1, Chap. 13

To indicate that these Three Graces, though equally graceful, are not quite equal, Blake has festooned the neck of the white European with a loop of pearls, while the black African and the dusky Indian maidens who uphold her are wearing slave bracelets on their arms.

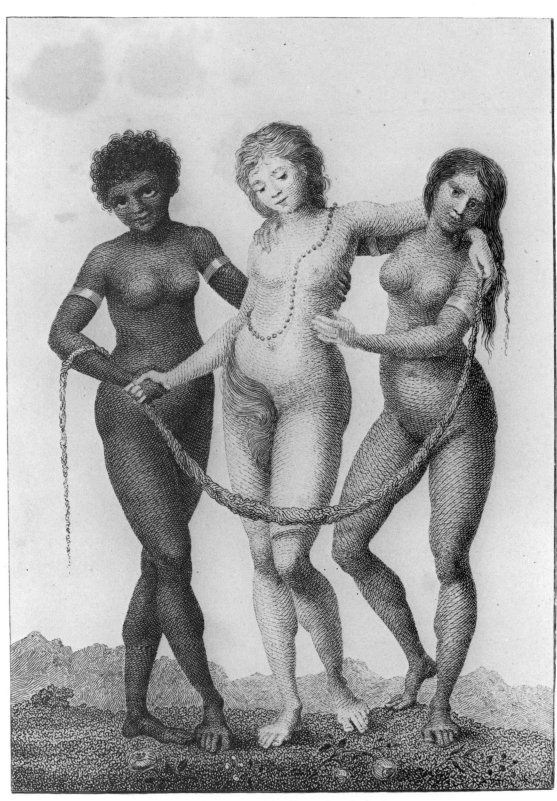

Europe Supported by Africa and America, REVOLTED NEGROES OF SURINAM, line engraving, c. 1792

Visions of the Daughters of Albion tells the story of Oothoon, Blake's personification of sexual joy and freedom, who dared to pluck "the bright Marygold of Leutha's vale" in defiance of Urizen's Thou-Shalt-Not. While winging her way toward her lover Theotormon, Oothoon was seized and raped by Bromion, who then branded her with his "signet" as a harlot. Tormented by jealousy, Theotormon rejects Oothoon as "impure," though he still loves her, and punishes the two adulterers.

The title page is emblematic of the book as a whole. Moving clockwise from the center: beneath a baleful, flame-enshrouded Urizen, Oothoon flees in terror, raising her arms in despair and/or appeal; a triskelion of fairies, doing a scarf dance, are frisking merrily about; a captive bound and in despair, is being comforted—or perhaps derided—by two figures reclining on a cloud; while, on the far right, an evil magician or demon is casting spells down a steep cliff at two obscure figures, who seem to have been turned to stone.

Plate ii, title page, VISIONS OF THE DAUGHTERS OF ALBION, relief etching, painted with watercolors, 1793

The outline of a huge skull, with a sun in its eye socket, is suggested by the shape of Bromion's cave and the leaves like matted hair above it. While Theotormon and Oothoon are self-absorbed in their own misery, Bromion is gaping with horror at something outside the picture.

David V. Erdman has traced the source of Blake's poem to J. G. Stedman's account in his *Narrative* of his own dilemma while serving as a mercenary hired by the Dutch slavemasters of Surinam. "To the torture of female slaves," Erdman writes, "Stedman was particularly sensitive, for he was in love with a beautiful fifteen-year-old slave . . . and in a quandary similar to that of Blake's Theotormon, who loves Oothoon but cannot free her."

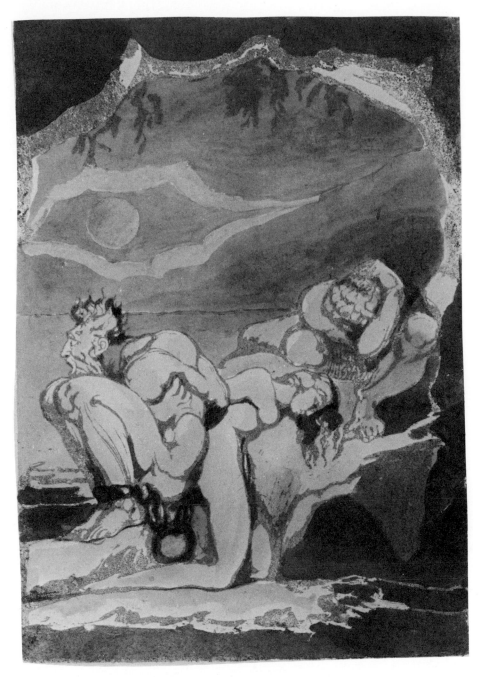

Plate i, frontispiece, VISIONS OF THE DAUGHTERS OF ALBION, relief etching, painted with watercolors, 1793

Then storms rent Theotormon's limbs; he roll'd his waves around
And folded his black jealous waters round the adulterate pair.
Bound back to back in Bromion's caves, terror & meekness dwell:

At entrance Theotormon sits wearing the threshold hard
With secret tears; beneath him sound like waves on a desart shore
The voice of slaves beneath the sun, and children bought with money,
That shiver in religious caves beneath the burning fires
Of lust, that belch incessant from the summits of the earth.
 Visions of the Daughters of Albion, 2:3–10

America, the first of Blake's works to be called by him "a Prophecy," was also the first in which he named the place where it was printed, "Lambeth," as if to defy, or even taunt, the authorities. At a time when England had recently lost her American colonies, and was mobilizing for war against revolutionary France, this was a dangerous provocation. In June of 1793, shortly after Parliament had passed an act against "divers wicked and seditious writings," Blake wrote in his Notebook: "I say I shan't live five years, And if I live one it will be a Wonder."

Beneath a dark, sleety sky a woman has just discovered the corpse of her loved one upon the battlefield and throws herself down to embrace him passionately. With his sword still clasped in his hand, he lies outstretched upon a heap of other bodies. Up in the clouds with the title, a male and a female figure, seated back to back like bookends, are apparently absorbed in reading the prophecy itself; while about them various elfin figures are turning the pages and pointing this way and that way to command our attention.

The despairing archangel, his wrists manacled to a block of stone and his head sunk between his knees, is an avatar of Blake's eternal spirit of rebellion, Orc; while the woman seated beside him with her arms enfolded about her children, staring somberly into an inner distance, has sometimes been identified as the incarnation of Blake's spirit of sexual freedom, the "soft soul of America," Oothoon. Behind them, half cut off by the margin, with its tentacles clutching the ruined wall, squats a turret-shaped polypus—or a polypus-shaped turret—that confronts us malevolently with its one dead eye. Both this picture and the battlefield scene depicted on the title page are derived from a painting by Blake exhibited in 1784, *A Breach in a City the Morning After the Battle.*

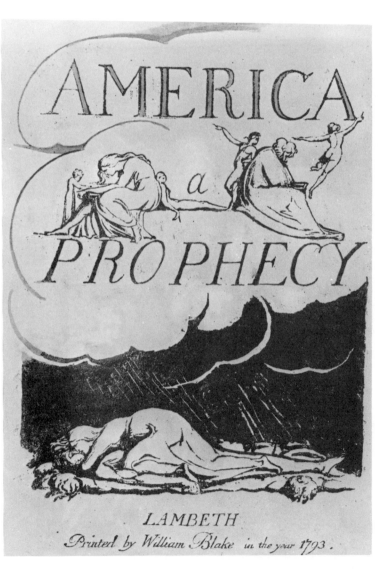

Plate ii, title page, AMERICA A PROPHECY, relief etching, painted with watercolors, 1793

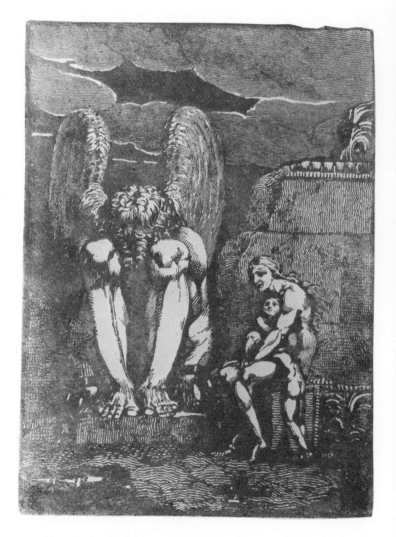

Plate i, frontispiece, AMERICA A PROPHECY, relief etching, 1793

Starting from the anguished, self-clutching figure underground, the upward-writhing roots of the tree, which resemble human torsos copulating, emerge and fuse above ground into the trunk of a drooping willow. Beneath it lies Orc, spread-eagled and chained, while a despairing couple, apparently fleeing, pause to look back at him in horror. David V. Erdman identifies the couple as Adam and Eve, the willow as the Tree of Paradise; but Kathleen Raine interprets the picture as showing Orc fettered by time and space, personified in Los and Enitharmon.

Bostons Angel" (mentioned in the topmost inscription) has been identified by David V. Erdman as the revolutionary American patriot Samuel Adams. Mounted upon a long-necked phallic swan, he is here shown flying through the clouds, high above the battlefield "burning with the fires of Orc," though looking back upon it. The picture below, of three children astride a jaunty, roguish-looking serpent (another manifestion of Orc) was probably based on an engraving, published in Blake's time, of an erotic sculpture from Herculaneum, showing a child mounted upon an enormous penis. Flying phalli and wingèd pudenda of all sorts, male and female, flit through the prophetic books as recurrent motifs.

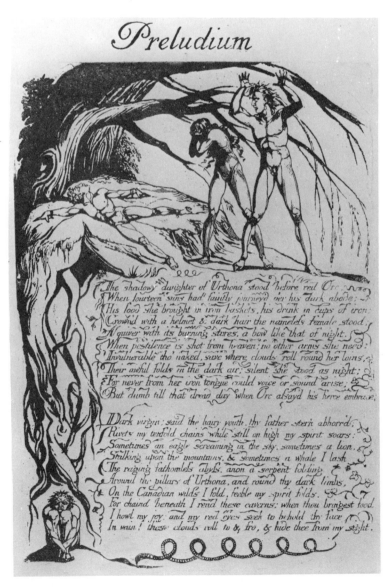

Plate 1, AMERICA A PROPHECY, relief etching, 1793

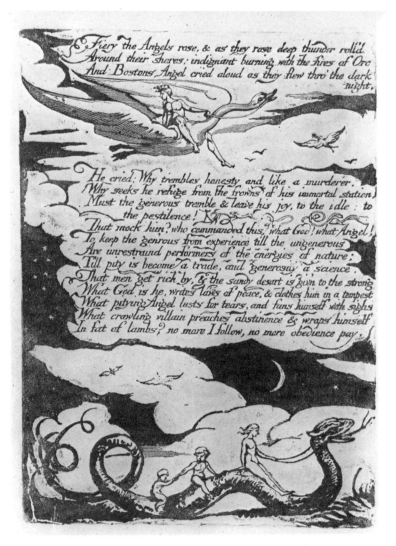

Plate 11, AMERICA A PROPHECY, relief etching, 1793

In 1793 Blake published a "small book" of 17 line engravings of emblems, entitled *For Children: The Gates of Paradise*. Twenty-five years later, in 1818, he reissued the book with a new fore-title, *For the Sexes*, added an epilogue, and wrote an epigrammatic poem, "The Keys to the Gates," which connects and interprets the emblems. The corresponding verses are set beneath each emblem.

"Gates," the overarching symbol of the book, signify the spiritual stages, or "states," in life through which each soul must pass from the womb to the grave. "Man passes on," he wrote, "but States remain for Ever; he passes thro'

them like a traveller." In *Jerusalem* (16:61–67) Blake described a gallery of sculptures created by his own mythic counterpart, Los, that might also serve as the motto over these "Gates":

*All things acted on Earth are seen in the
 bright Sculptures of
Los's Halls, & every Age renews its
 powers from these Works
With every pathetic story possible to
 happen from Hate or
Wayward Love; & every sorrow &
 distress is carved here,
Every Affinity of Parents, Marriages &
 Friendships are here*

*In all their various combinations
 wrought with wondrous Art,
All that can happen to Man in his
 pilgrimage of seventy years.*

The four emblems reproduced here symbolize the fourfold aspects of Everyman—or any man—and are personified in Blake's mythology by his Four Zoas: Water by Tharmas, or the body; Earth by Urthona, or the imagination; Air by Urizen, or the reason; and Fire by Luvah, or the emotions.

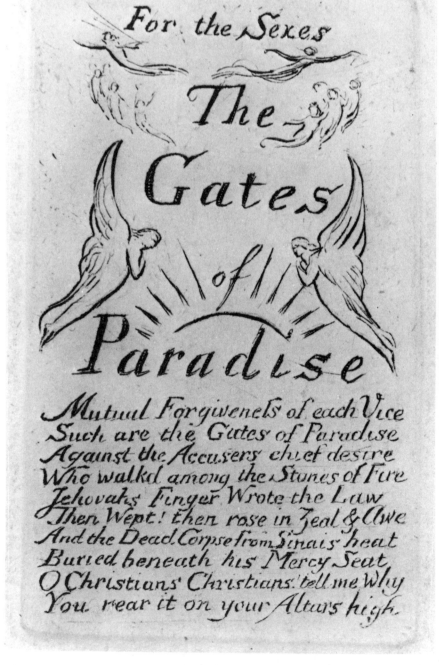

Plate ii, title page, FOR THE SEXES: THE GATES OF PARADISE, line engraving, 1793–1818

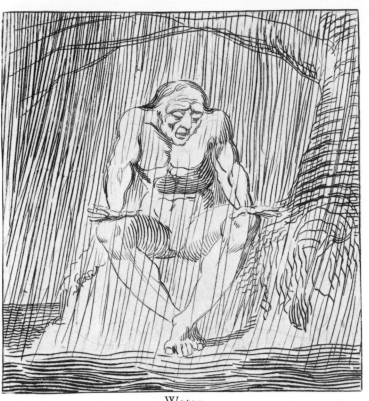

Water
Thou Waterest him with Tears

Doubt Self Jealous, Wat'ry folly,

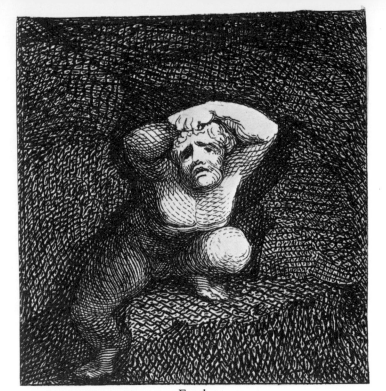

Earth
He struggles into Life

Struggling thro' Earth's Melancholy.

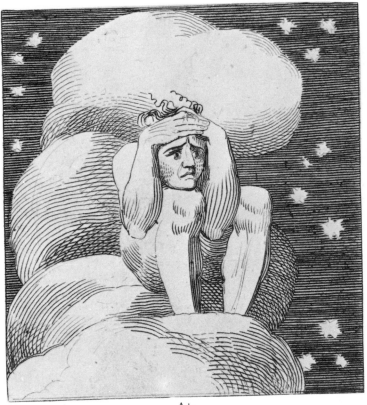

Air
On Cloudy Doubts & Reasoning Cares

Naked in Air, in Shame & Fear,

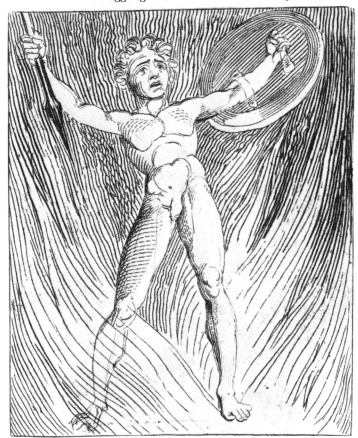

Fire
That end in endless Strife

Blind in Fire with shield & spear,
Two Horn'd Reasoning, Cloven Fiction,
In Doubt, which is Self contradiction,
A dark Hermaphrodite We stood,
Rational Truth, Root of Evil & Good.
Round me flew the Flaming Sword;
Round her snowy Whirlwinds roar'd,
Freezing her Veil, the Mundane Shell.

53

Begun around 1790 and completed in 1793, *The Marriage of Heaven and Hell* was published by Blake without his name, the date, or the place of origin on the title page. "Convinced of the importance of his book," declares S. Foster Damon, "he challenged the public to seek him out." In his *Critical Essay* on Blake, which appeared in 1868, Algernon Swinburne called it "a book as perfect as his most faultless song, as great as his most imperfect rhapsody . . . the greatest produced by the 18th century in the line of high poetry and spiritual speculation." And

for our own age, with the possible exception of *Songs of Innocence and of Experience,* it has become Blake's best-known and most representative work, the one in which his revolutionary political, psychological, and religious ideas are most succinctly expressed.

In the design for the title page, the swarms of tiny naked imps shooting upward like sparks of hellfire, embracing and coupling ecstatically, prefigure the teeming exuberance of these ideas. Even the two trees on either side, whose roots are entwined with flames, yearn toward each other. The five birds in the

distant sky symbolize the five senses, while the outstretched phoenix-like eagle ("When thou seest an Eagle," states one of the *Proverbs of Hell*, "thou seest a portion of Genius; lift up thy head!") symbolizes the creative spirit itself.

Plate 4, *on the opposite page,* has been enlarged to permit easier viewing of the figures between and in the lines of the text. The illustration at the bottom, with the positions of the characters reversed, became the color print *Good and Evil Angels.* (See page 64.)

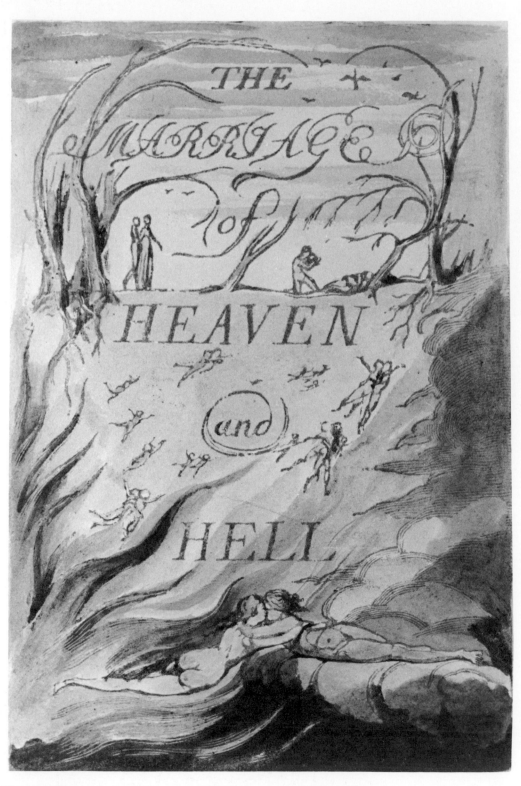

Plate 1, title page, THE MARRIAGE OF HEAVEN AND HELL, relief etching, painted with watercolors, 1793

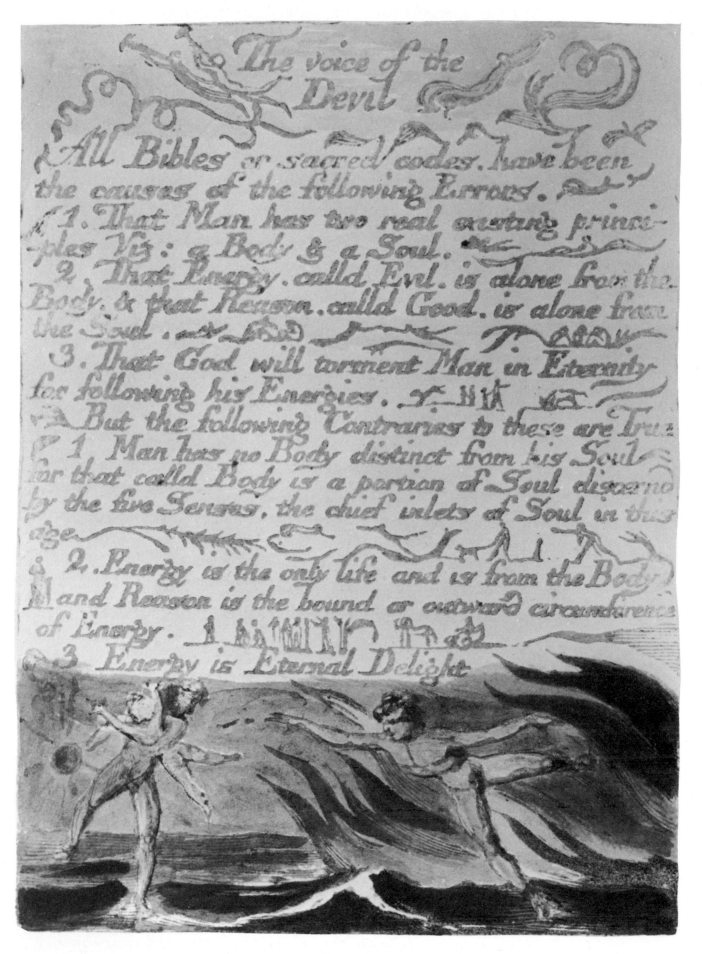

The voice of the
Devil

All Bibles or sacred codes. have been
the causes of the following Errors.

1. That Man has two real existing princi-
ples Viz: a Body & a Soul.

2. That Energy. calld Evil. is alone from the
Body. & that Reason. calld Good. is alone from
the Soul.

3. That God will torment Man in Eternity
for following his Energies.

But the following Contraries to these are True

1 Man has no Body distinct from his Soul
for that calld Body is a portion of Soul discernd
by the five Senses, the chief inlets of Soul in this
age

2. Energy is the only life and is from the Body
and Reason is the bound or outward circumference
of Energy.

3 Energy is Eternal Delight

Plate 4, THE MARRIAGE OF HEAVEN AND HELL, relief etching, painted with watercolors, 1793

55

In the illustration at the top, the flame-enshrouded creature swooping over a dead or sleeping male figure seems to be wearing a blindfold; but in two of the nine extant copies of *The Marriage*, she is depicted with her eyes wide open and shouting down at him. It has been conjectured by some critics that, when blindfolded, she symbolizes Blake's evil "Covering Cherub" (mentioned in Ezekiel 28:16), and, when open-eyed and open-mouthed, the soul summoning the body to awake.

There is a separate color print of this subject in Blake's *A Small Book of Designs*, entitled *The Soul Hovering Over the Body*.

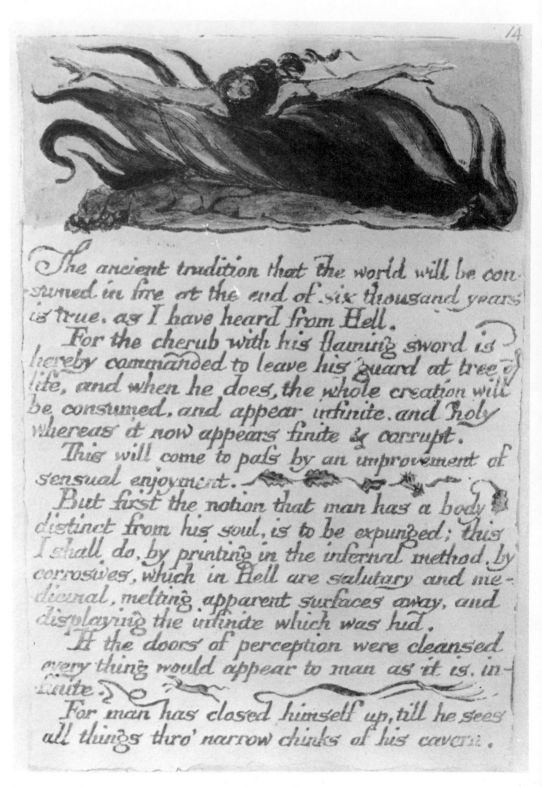

Plate 14, THE MARRIAGE OF HEAVEN AND HELL, relief etching, painted with watercolors, 1793

"The Creator of this World," wrote Blake in his *Vision of the Last Judgment*, "is a very Cruel Being." Framed in the disk of a setting sun, whose upward blazing rays repeat and extend his electrified hair and beard, the Elohim (the name by which the Creator is called in the first chapters of Genesis) has just uttered the words that will bring Adam to life. Around Adam's left leg, which seems to end in a black hoof, the serpent of materialism has coiled itself. (See page 135.)

The monotype below, and the seven others in color that follow, were part of a set of twelve executed by Blake in 1795 in a newly devised technique. Blake would first draw an outline of his design in black on a piece of millboard, which he would print under light pressure on a sheet of paper. Afterward he would apply his colors, probably egg tempera, to the millboard, printing this on top of the black outline, and then touch up the picture with watercolors.

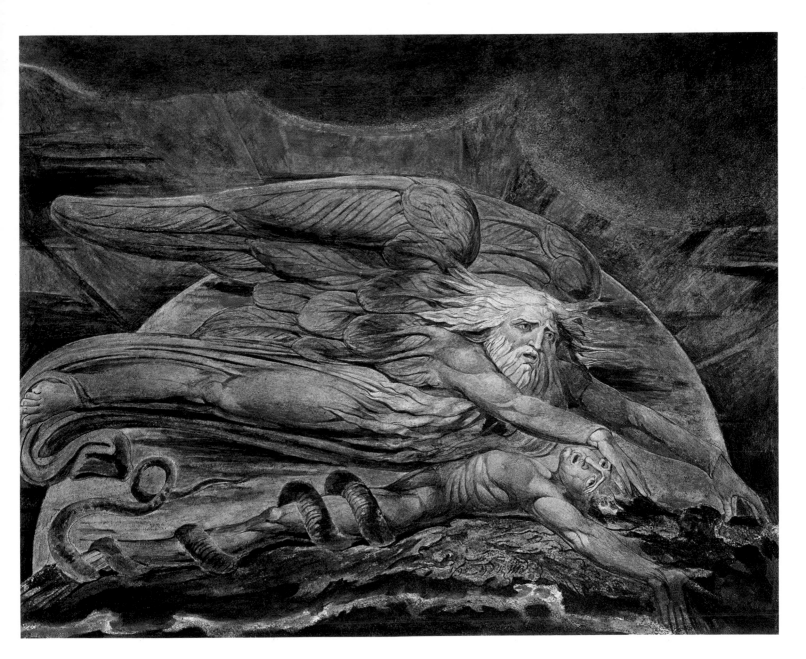

The Elohim Creating Adam, color print, 1795

So God created man in his own image in the image of God created he him; male and female created he them.

Genesis 1:27

57

Until 1965 this print was erroneously believed to show the prophet Elijah being taken up to heaven by God in a fiery chariot. But the faintly discernible title in pencil, "God Judging Adam," previously concealed under the mount of the picture, has now established its identity.

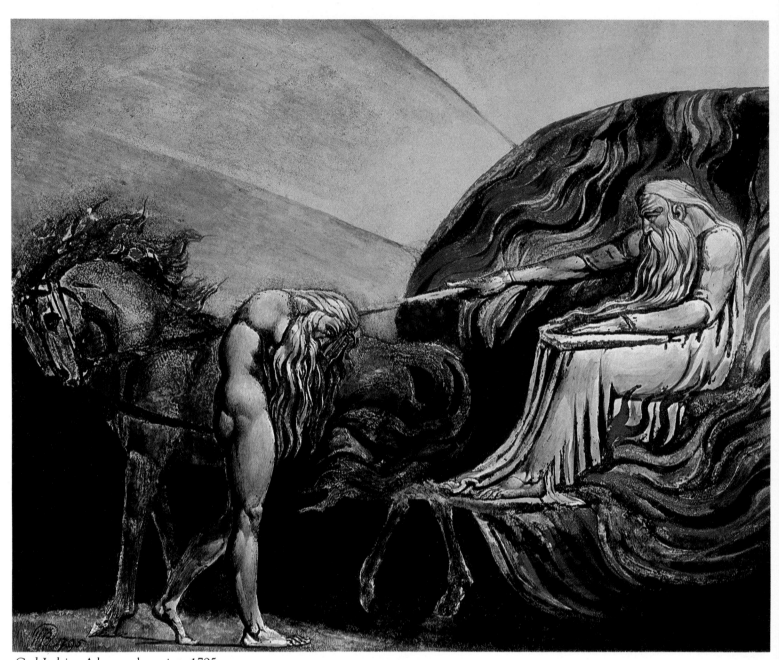

God Judging Adam, color print, 1795

And unto Adam he said, Because thou hast hearkened unto the voice of thy wife, and hast eaten of the tree, of which I commanded thee, saying, Thou shalt not eat of it: cursed is the ground for thy sake; in sorrow shalt thou eat of it all the days of thy life; Thorns also and thistles shall it bring forth to thee; and thou shalt eat the herb of the field: In the sweat of thy face shalt thou eat bread, till thou return unto the ground; for out of it wast thou taken: for dust thou art, and unto dust shalt thou return.

<div align="right">Genesis 3:17–19</div>

From the ends of the scroll (of the Law), held outstretched by the blind Old Nobodaddy, descend his thunderbolts of death, whose jagged shape is repeated in the chevrons of the mat on which his victims lie. A zomboid Despair stands ready, at the right, to quench all hope in his victims.

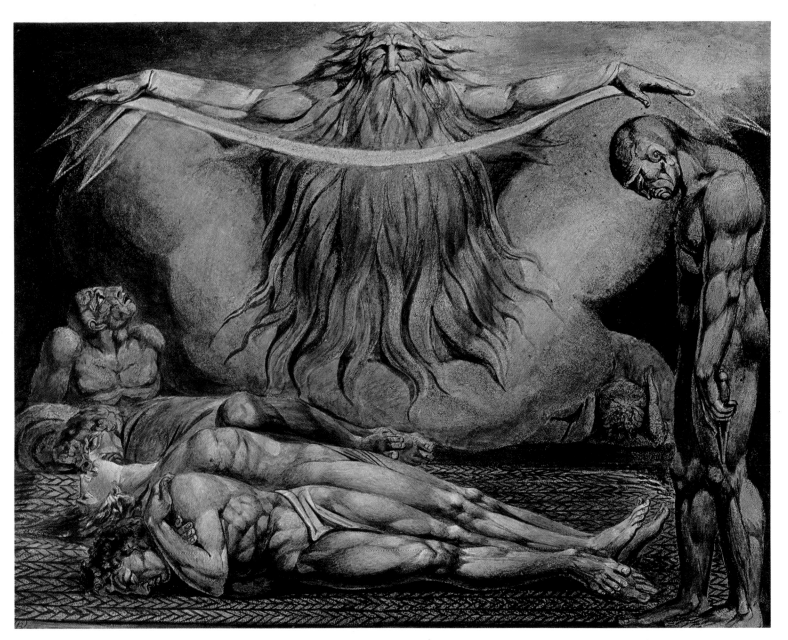

The Lazar House, color print, 1795

Immediately a place
Before his eyes appeared, sad, noisome, dark;
A lazar-house it seemed, wherein were laid
Numbers of all diseased. . . .
Dire was the tossing, deep the groans; Despair
Tended the sick, busiest from couch to couch;
And over them triumphant Death his dart
Shook, but delayed to strike, though oft invoked
With vows, as their chief good and final hope.
Paradise Lost, XI:477–493

Hecate, the triformed goddess having power over heaven, earth, and the underworld, was chiefly associated with moon worship, and Blake here depicts her in her three phases: crescent, full, and waning. She has placed her left hand on a book inscribed with Urizen-like hieroglyphs and crossed her right foot. As for the eldritch creatures who surround her, most are mentioned in the epigraph from Shakespeare, but the donkey is Blake's own addition.

Both *Hecate* and *Pity, on the opposite page,* were meant to illustrate dual aspects of what Blake regarded as the domineering Female Will, which attempts to ensnare the male in a web of religion woven out of sexual repression, chastity, and jealousy. "O Woman-born/ And Woman-nourish'd & Woman-educated & Woman-scorn'd!" he wrote in *Jerusalem* (64:16–17).

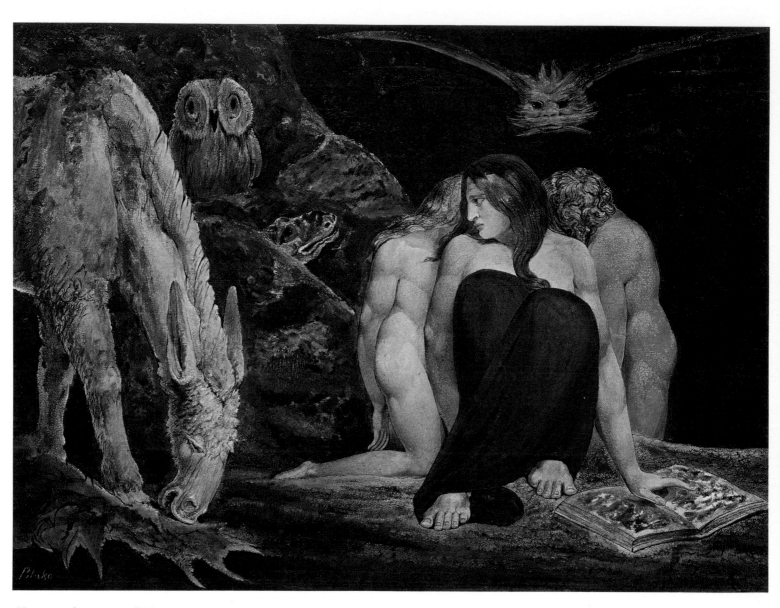

Hecate, color print, 1795

Fillet of a fenny snake,
In the cauldron boil and bake;
Eye of newt, and toe of frog,
Wool of bat, and tongue of dog,
Adder's fork, and blind-worm's sting,
Lizard's leg, and howlet's wing—
For a charm of powerful trouble,
Like a hell-broth boil and bubble.
 Macbeth, Act IV:1

Blake believed that pity, though a divine attribute in eternity, in the fallen world "divides the soul." In accord with the mystical doctrine that male and female had originally been one, until they were separated and set in opposition at the time of creation, Blake described in *The Book of Urizen* (V:9–10) how Los's emanation, Enitharmon, first emerged into being when he became self-divided through pity:

All Eternity shudder'd at sight
Of the first female now separate. . . .
They call'd her Pity, and fled.

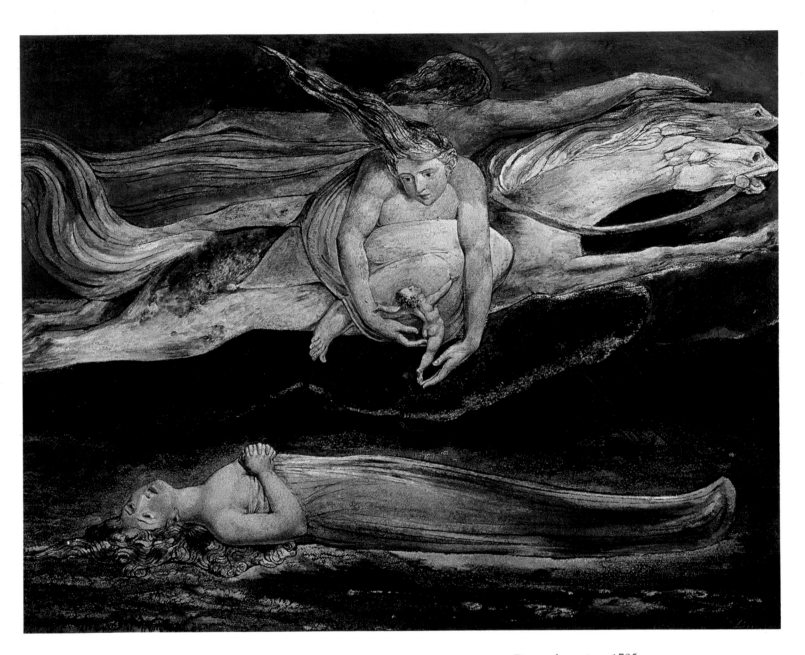

Pity, color print, 1795

And pity, like a naked new-born babe,
Striding the blast, or heaven's cherubin, hors'd
Upon the sightless couriers of the air,
Shall blow the horrid deed in every eye
That tears shall drown the wind. . . .
Macbeth, Act I:7

61

Goya's gnomic remark from *Los Dis-parates:* "The sleep of reason produces monsters," might have served as the motto for these two interrelated pic-tures of *Newton* and *Nebuchadnezzar, on the opposite page.*

The figure representing Newton is shown, in profile, sitting naked upon a rock thickly encrusted with barnacles and lichen at the bottom of the Sea of Time & Space. A polyp (symbolizing in Blake's mythology the many-ten-tacled cancer of state religion and power politics) crawls behind his left foot. Self-absorbed, and with the catatonic fixity of "single vision," he is staring at a geometrical diagram inscribed upon a snail-like scroll before him, mean-while holding in his left hand a pair of tiny Urizenic "Two Horn'd" com-passes. Newton is leaning so far forward that, just a bit further, and he would be tipped over on all fours . . .

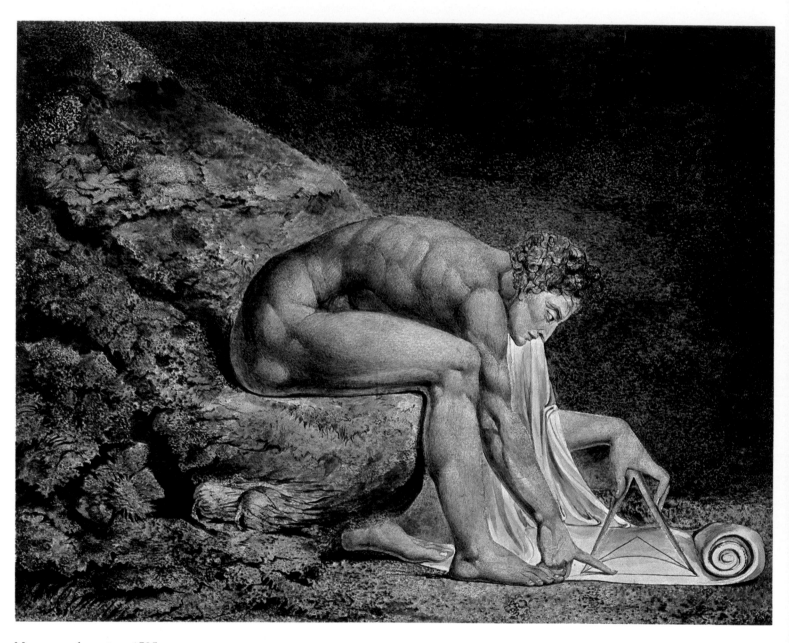

Newton, color print, 1795

May God us keep
From Single vision & Newton's sleep.

Blake's verse letter to Thomas Butts, Nov. 22, 1802, lines 87–88

. . . in the same posture as the Babylonian king Nebuchadnezzar, who stares, unseeing, directly at us. The glaucous, submarine light in the picture of Newton has here become somber and stygian as if the mind itself had darkened. Newton's diagram on the scroll, a triangle whose base subtends an arc, appears hugely aggrandized in the ogival entrance to Nebuchadnezzar's cave (if it is a cave), and is then repeated and varied spasmodically in the angles formed by his limbs.

There is a somewhat similar engraving of the same subject by John Hamilton Mortimer, an artist much admired by Blake; and it is also likely that Blake was familiar with Albrecht Dürer's engraving *The Penance of St. John Chrysostomus*, which depicts the saint submitting himself to an ordeal like Nebuchadnezzar's. The figure of "Newton," as Sir Anthony Blunt has pointed out, was derived by Blake from an engraving of Michelangelo's *Abias* in the Sistine Chapel.

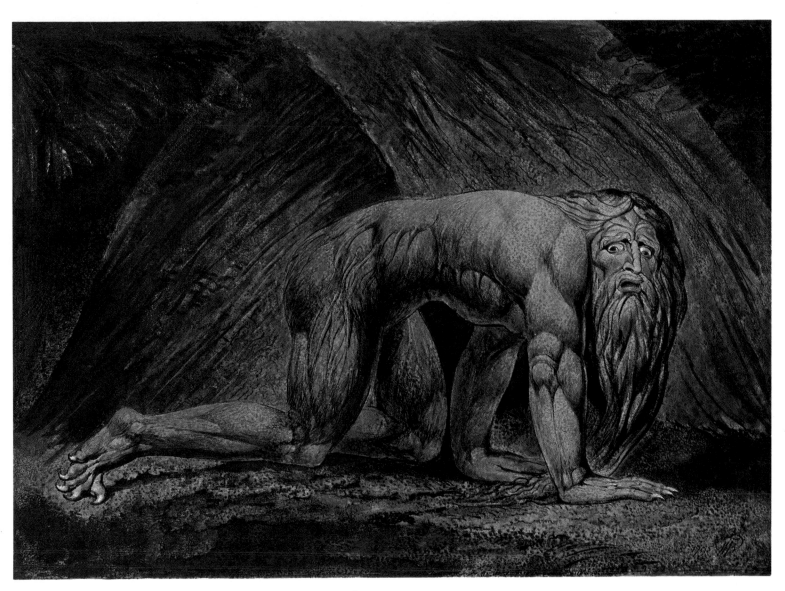

Nebuchadnezzar, color print, 1795

The same hour was the thing fulfilled upon Nebuchadnezzar: and he was driven from men, and did eat grass as oxen, and his body was wet with the dew of heaven, till his hair was grown like eagles' feathers, and his nails like birds' claws.

Daniel 4:33

Though one of Blake's best-known pictures, this is also among his most enigmatic. If meant to depict Los and Enitharmon struggling for possession of "red Orc," their firstborn son, then why is Los enshrouded in flames and shackled by the left foot? And the other angel, whether good or evil, is undoubtedly male. It has been conjectured that the picture illustrates a myth of the birth of Orc from a lost book by Blake. Kathleen Raine, in an attempt to unriddle its symbolism, cites this passage from Jacob Boehme: "Thus we are to understand that the *Evil* and *Good* Angels dwell near one another, and yet there is the greatest distance between them. For the *Heaven is in Hell*, and the *Hell is in Heaven*, and yet the one is not manifest to the other. . . ."

The same design, but with the positions of the figures reversed, appears in *The Marriage of Heaven and Hell* (see page 55), as well as in a watercolor done in the late 1780s.

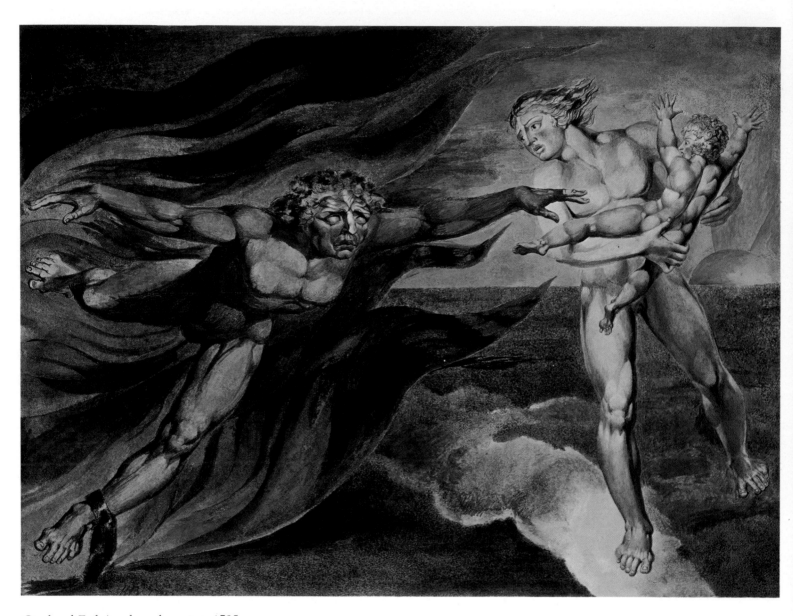

Good and Evil Angels, color print, 1795

So sung the Demons round red Orc & round faint Enitharmon.
Sweat & blood stood on the limbs of Los in globes; his fiery Eyelids
Faded.
 Vala, or the Four Zoas, V:61–63

In accord with Blake's dialectic in *The Marriage of Heaven and Hell*, this picture may be interpreted as the copulation of Good and Evil. The two figures are so closely and conjugally convolved, in an active-passive, yin-yang union with each other, that they form a design similar to the famous Chinese talisman depicted at the right. Michael, binding the Dragon, has also been bound to him, and by the same chain.

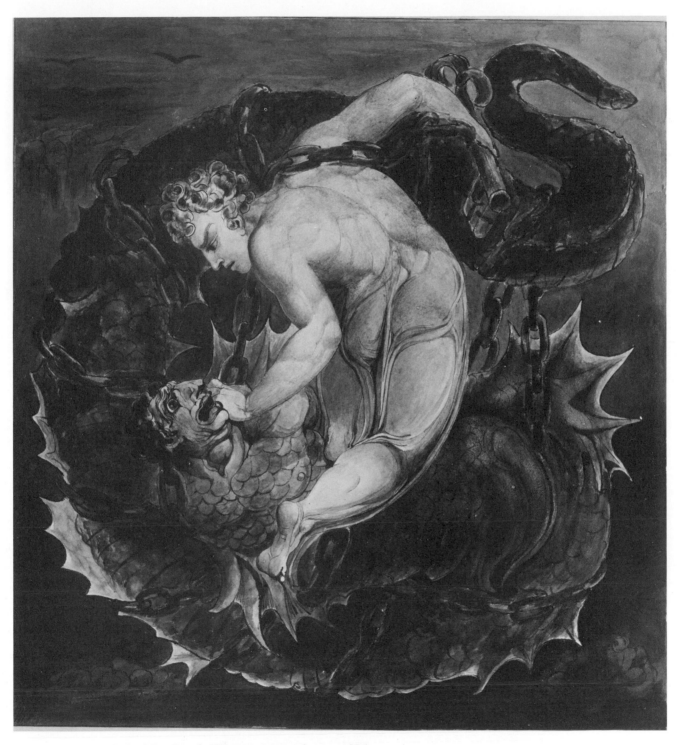

Michael Binding the Dragon, watercolor, c. 1805

And there was a war in heaven: Michael and his angels fought against the dragon; and the dragon fought and his angels, And prevailed not; neither was their place found any more in heaven. And the great dragon was cast out, that old serpent, called the Devil, and Satan, which deceiveth the whole world: he was cast out into the earth, and his angels were cast out with him.

Revelation 12:7–9

On the lowest steps of this ziggurat-shaped "ladder," two descending angels bear a basket of loaves and a jug of wine, perhaps to prefigure the future Christian communion; on the steps just above them, two descending angels carry an open parchment and a golden book, symbolizing God's covenant with Israel; and a few steps higher up, an angel ascending toward heaven unfolds a long scroll on which may be written the names of all the unborn children of Israel; while another is descending with a huge compass in her left hand, as if to measure the extent of the promised land.

After his vision at Bethel, Jacob was exalted and renamed Israel . . . just as Enoch became the Archangel Metatron, and Blake himself, *mutatis mutandis*, became Los in the Divine Imagination.

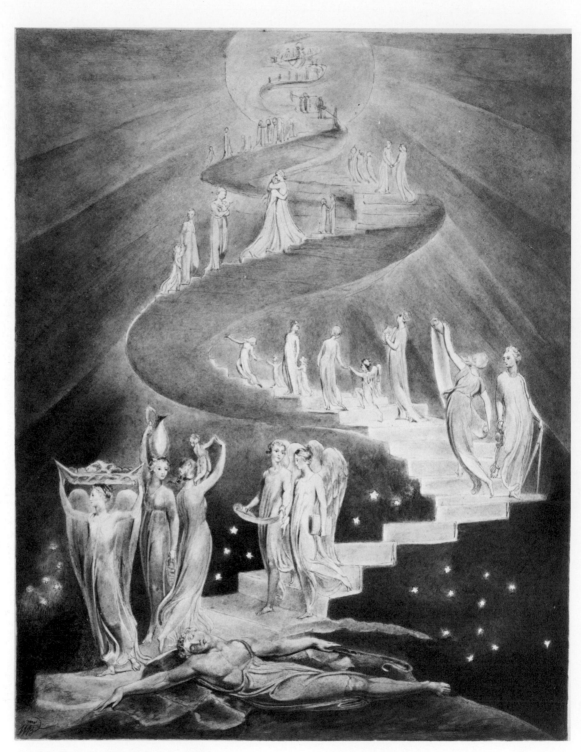

Jacob's Dream, watercolor, c. 1800

And Jacob . . . lighted upon a certain place, and tarried there all night, because the sun was set; and he took of the stones . . . and put them for his pillows, and lay down in that place to sleep. And he dreamed, and behold a ladder set up on the earth, and the top of it reached to heaven: and behold the angels of God ascending and descending on it.

Genesis 28:10–12

Ezekiel's fourfold vision by the river Chebar directly inspired Blake's own conception of the Four Zoas—Luvah, with the face of a man; Los, with the face of an eagle; Tharmas, with the face of an ox; and Urizen, with the face of a lion—who personify in his mythology the fourfold aspects of the eternal Man. (See page 111.)

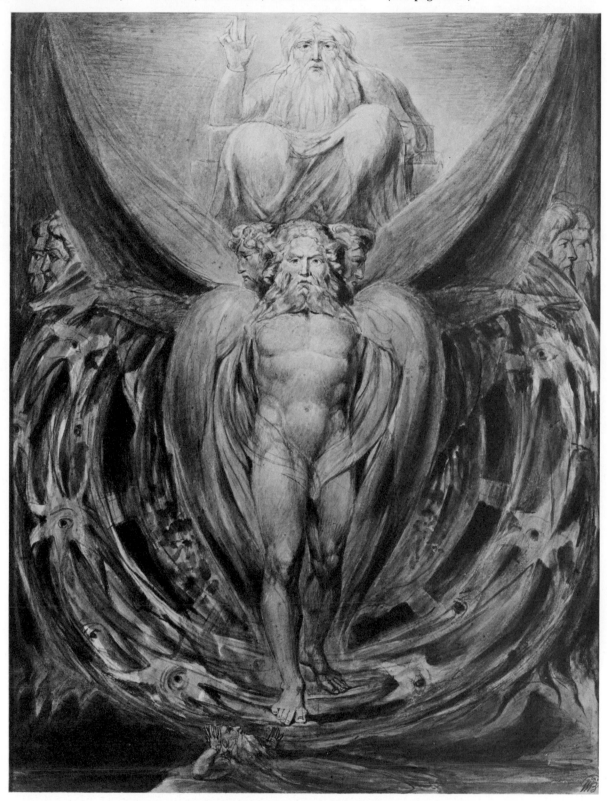

Ezekiel's Vision, watercolor, c. 1800–1805

And I looked, and, behold, a whirlwind came out of the north, a great cloud, and a fire infolding itself. . . . Also out of the midst thereof came the likeness of four living creatures. And this was their appearance; they had the likeness of a man. And every one had four faces, and every one had four wings. . . . And they had the hands of a man under their wings on their four sides; and they four had their faces and their wings. . . . As for the likeness of their faces, they four had the face of a man, and the face of a lion, on the right side; and they four had the face of an ox on the left side; they four also had the face of an eagle.

Ezekiel 1:4–11

67

According to Christian typology, the hiding of Moses in the ark prefigured the birth of Christ in the manger. Moses has here been cocooned by Blake like a tiny Egyptian mummy, destined to rise again in the hereafter. As it so happened. . . . Some twenty-five years after painting this watercolor, Blake made a Christmas-card sized (2-11/16″ x 3-13/16″) engraving of the same design for a book entitled *Remember Me! A New Year's Gift or Christmas Present*, published in 1825.

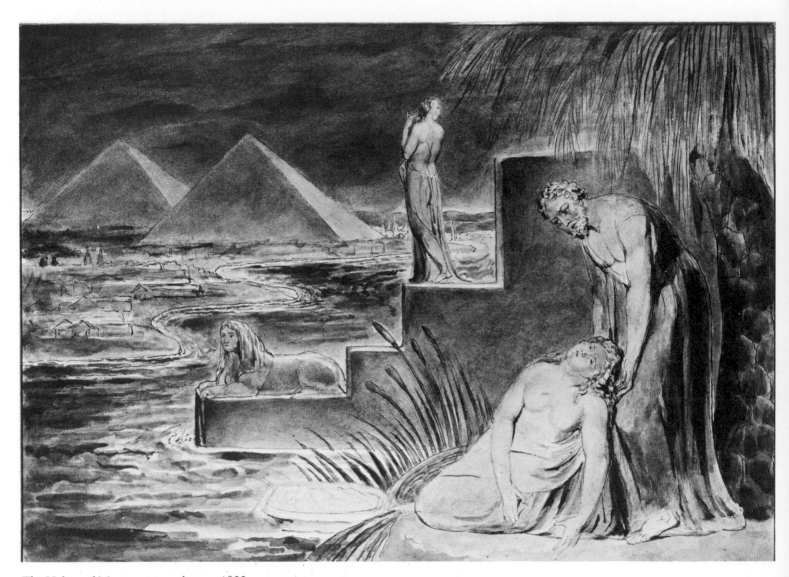

The Hiding of Moses, watercolor, c. 1800

And Pharaoh charged all his people, saying, Every son that is born ye shall cast into the river, and every daughter ye shall save alive. . . . And there went a man of the house of Levi, and took to wife a daughter of Levi. And the woman conceived, and bare a son: and when she saw him that he was a goodly child, she hid him three months. And when she could no longer hide him, she took for him an ark of bulrushes . . . and put the child therein; and she laid it in the flags by the river's brink. And his sister stood afar off, to wit what would be done to him.

Exodus 1:22; 2:1–4

Saint Joseph supports the swooning Mary, who has just given birth to Jesus in the manger, while Saint Elizabeth, with the young John the Baptist in her lap, reaches out her arms for him. Roger van der Weyden's *The Vision of the Three Magi* contains a similar image of the infant Christ miraculously afloat in his own spiritual radiance; but an even closer, and more likely, source for Blake's picture may have been the lines:

A pretty babe, all burning bright,
Did in the air appear. . . .

from "The Burning Babe," by the Elizabethan poet Robert Southwell.

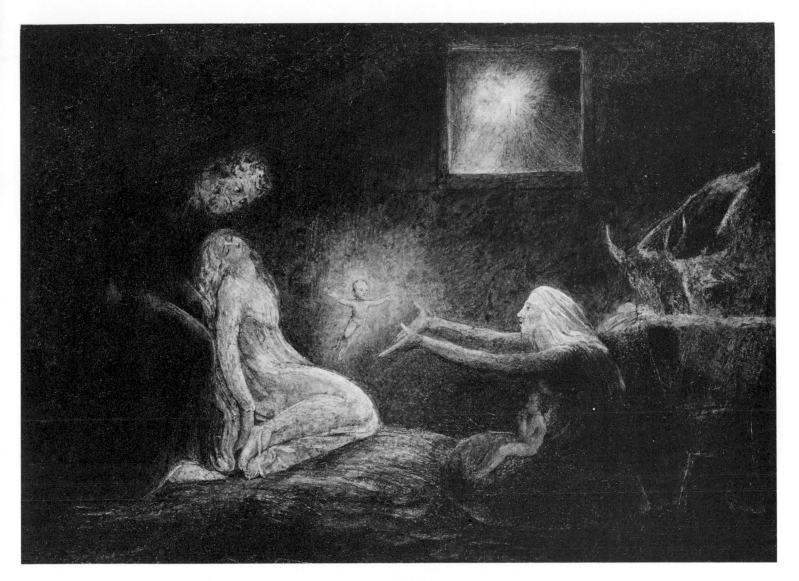

The Nativity, tempera on copper, c. 1800

And she brought forth her firstborn son, and wrapped him in swaddling clothes, and laid him in a manger; because there was no room for them in the inn.

Luke 2:7

The two children on either side of Bathsheba, unmentioned in the Bible, were most likely added by Blake for the sake of the composition. The palm-tree pillars make it uncertain whether the scene is occurring at a rustic pool-side or in an enclosed bath area.

This picture was one of the so-called frescoes in which Blake experi-mented with diluted carpenter's glue, instead of the egg yolk usually em-ployed in tempera, to fix his colors. As a result, the paint has cracked and darkened over the years, yet it has also acquired the weathered and stylish elegance of a Pompeian mosaic.

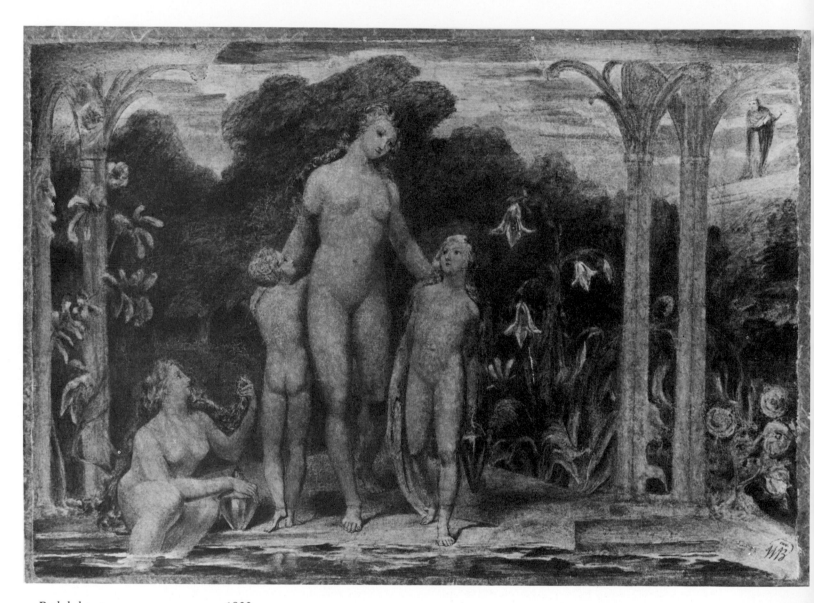

Bathsheba, tempera on canvas, c. 1800

And it came to pass in an eveningtide, that David arose from off his bed, and walked upon the roof of the king's house: and from the roof he saw a woman washing herself; and the woman was very beautiful to look upon.

2 Samuel 11:2

The child born to the elder daughter was Moab, the eponymous ancestor of Ruth the Moabite, and she, in turn, became the ancestress of King David, and thus of Jesus Christ. "It would seem," declares S. Foster Damon, "as though Blake knew of the seventeenth-century Jewish heresy which taught that the ancestry of the Messiah must consist of the worst stock if he is to plumb the depths of sin."

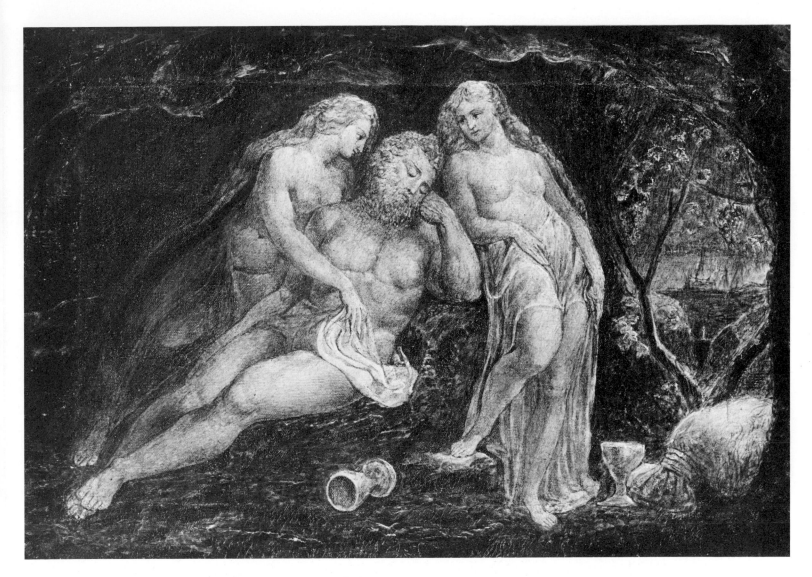

Lot and His Daughters, tempera, c. 1799

And Lot went up out of Zoar, and dwelt in the mountain, and his two daughters with him; for he feared to dwell in Zoar: and he dwelt in a cave, he and his two daughters. And the firstborn said to the younger, Our father is old, and there is not a man in the earth to come in unto us after the manner of all the earth: Come, let us make our father drink wine, and we will lie with him, that we may preserve seed of our father. . . . Thus were both the daughters of Lot with child by their father.

Genesis 20:30–36

71

This picture and *The Blasphemer, on the opposite page*, both conceived about the same time, were meant to contrast the stony Law-Giver of the Old Testament, as Blake saw him, with the merciful Saviour of the New. In the gospel story of the adulteress caught "in the very act," yet whose accusers, being sinners themselves, stood self-accused and "convicted by their own conscience"—that is, in thought—Blake would have found confirmation of his own mystical as well as primitivist credo: "Thought is Act." According to anthropologists, in certain savage tribes anyone who so much as dreams of committing adultery with another man's wife must pay the imagined cuckold a fine in real cash.

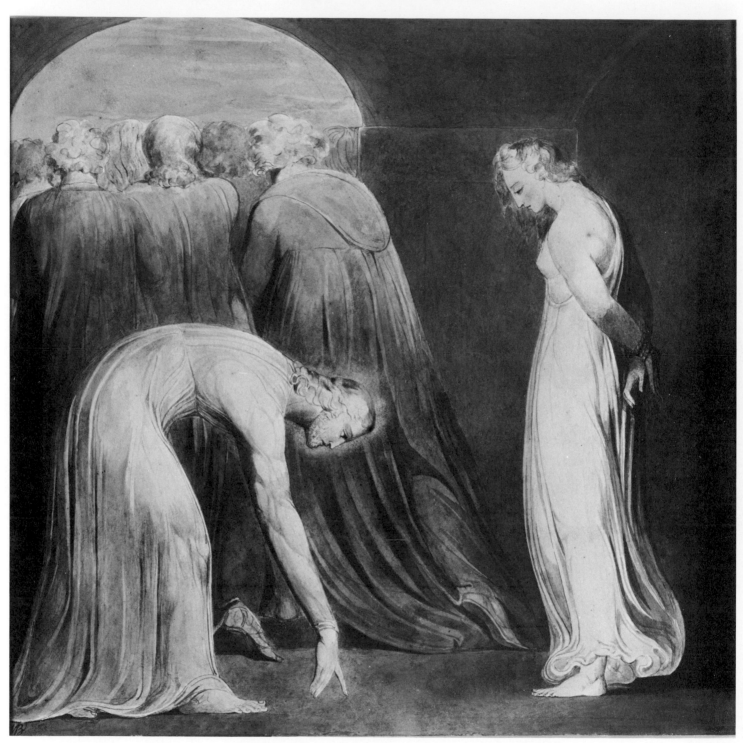

The Woman Taken in Adultery, pencil and watercolor, c. 1800–1805

And the scribes and Pharisees brought unto him a woman taken in adultery; and when they had set her in the midst, They say unto him, Master, this woman was taken in adultery, in the very act. Now Moses in the law commanded us, that such should be stoned: but what sayest thou? . . . But Jesus stooped down, and with his finger wrote on the ground, as though he heard them not. So when they continued asking him, he lifted up himself, and said unto them, He that is without sin among you, let him first cast a stone at her. . . . And they which heard it, being convicted by their own conscience, went out one by one. . . .

John 8:3–9

The mysterious wreath of smoke above the head of the central figure suggests that Blake meant to connect his stoning with the rite of human sacrifice practiced by the Druids. He later adapted the agonized posture of this figure for an illustration in *Jerusalem* (plate 25), showing Albion being disemboweled by Vala, Rahab, and Tirzah.

Once mistakenly believed to illustrate the stoning of Achan (as told in Joshua 7), within recent years an inscription found on the mat, with the title "The Blasphemer" and a reference to Leviticus 24, has established its identity.

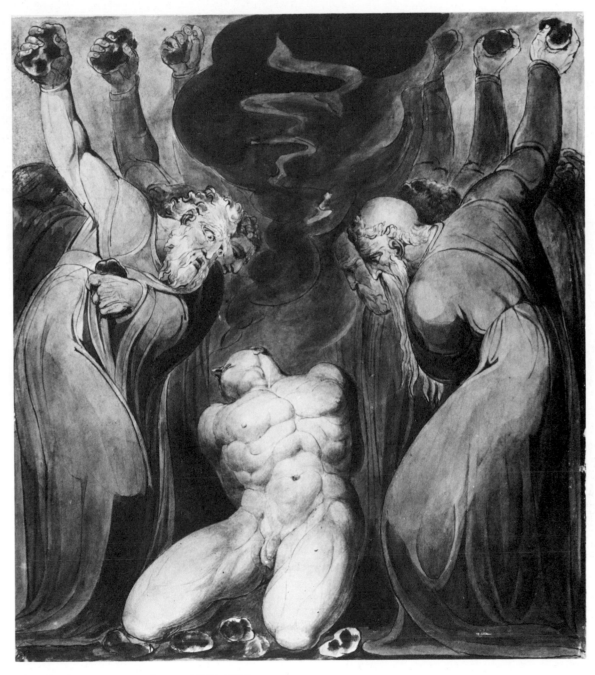

The Blasphemer, watercolor, c. 1800–1805

And the son of an Israelitish woman, whose father was an Egyptian, went out among the children of Israel: and this son of the Israelitish woman and a man of Israel strove together in the camp; And the Israelitish woman's son blasphemed the name of the Lord, and cursed. And they brought him unto Moses. . . . And the Lord spake unto Moses, saying, Bring forth him that hath cursed without the camp; and let all that heard him lay their hands upon his head, and let all the congregation stone him.

Leviticus 24:10–14

The stalking horror of Pestilence, with his buglike features and scaly hide, seems to be first cousin to the Dragon bound by St. Michael (see page 65) as well as to the Ghost of a Flea (see page 125). It has been suggested by Anthony Blunt that *Pestilence* and *Famine, on the opposite page,* may have been intended by Blake to illustrate the Litany in the Book of Common Prayer.

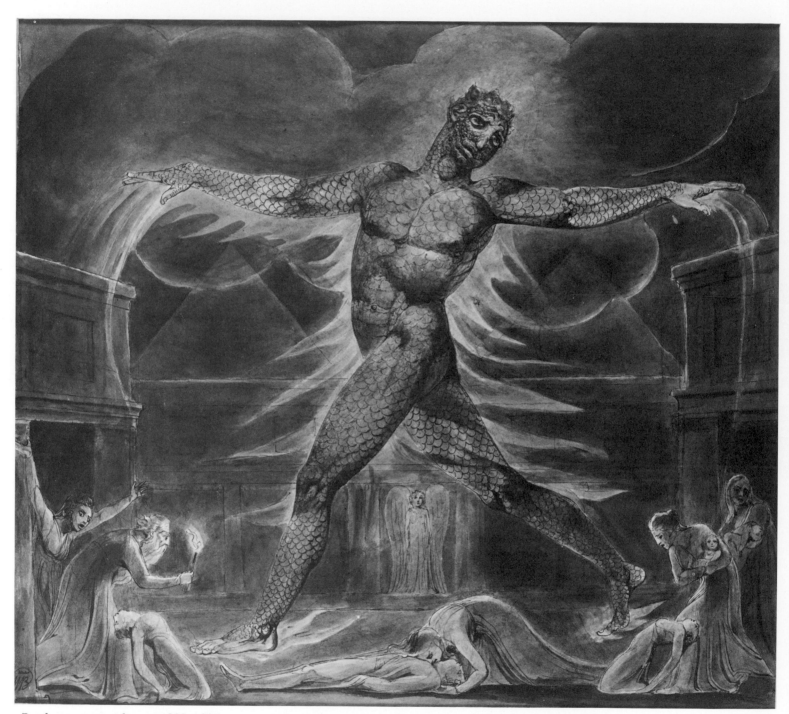

Pestilence, watercolor, c. 1800–1805

And it came to pass, that at midnight the Lord smote all the firstborn in the land of Egypt, from the firstborn of Pharaoh that sat on his throne unto the firstborn of the captive that was in the dungeon; and all the firstborn of cattle. And Pharaoh rose up in the night, he, and all his servants, and all the Egyptians; and there was a great cry in Egypt; for there was not a house where there was not one dead.

Exodus 12:29–30

An act of real cannibalism—and in the raw—unlike the one merely hinted at in the illustration for *Europe A Prophecy* (see page 42), is taking place in the right-hand corner. The angles made by the distorted limbs of the figures are repeated in the agonizedly twisted branches of the blighted tree that dominates this surrealist landscape.

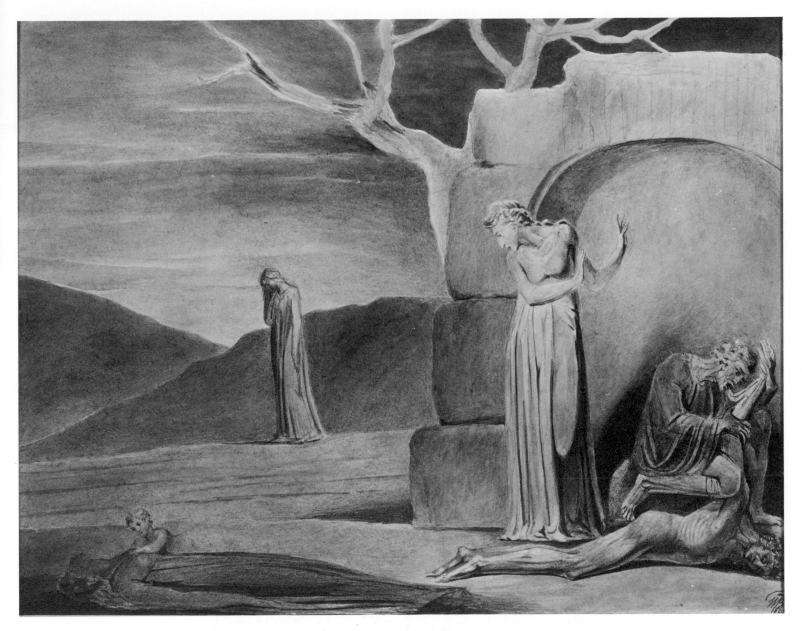

Famine, pencil and watercolor, c. 1800–1805

And Moses stretched forth his rod over the land of Egypt, and the Lord brought an east wind upon the land all that day, and all that night; and when it was morning the east wind brought the locusts. . . . For they covered the face of the whole earth, so that the land was darkened; and they did eat every herb of the land, and all the fruit of the trees which the hail had left: and there remained not any green thing in the trees, or in the herbs of the field, through all the land of Egypt.

Exodus 10:13–15

In Blake's commentary on his lost painting A *Vision of the Last Judgment* (1810), he wrote that the "woman clothed with the sun" was meant to symbolize the universal Christian Church: "There is such a State in Eternity: it is composed of the Innocent civilized Heathen and the Uncivilized Savage, who, having not the Law, do by Nature the things contain'd in the Law. This State appears like a Female crown'd with stars, driven into the Wilderness; she has the Moon under her feet." The "great red dragon" was there described as having "Satan's book of Accusations lying on the Rock open before him" and "bound in chains by Two strong demons."

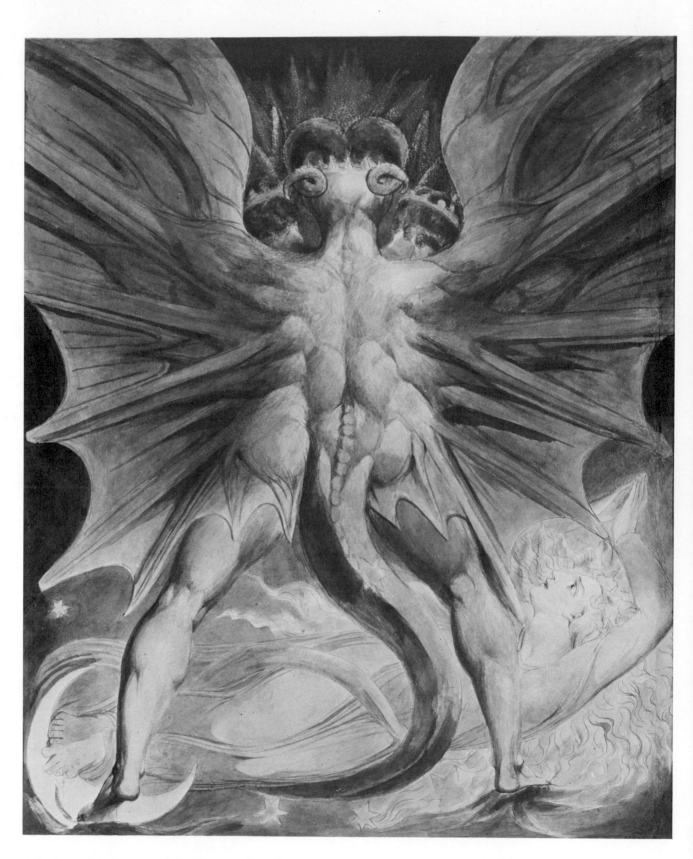

The Great Red Dragon and the Woman Clothed with the Sun (I), watercolor, c. 1800–1805

76

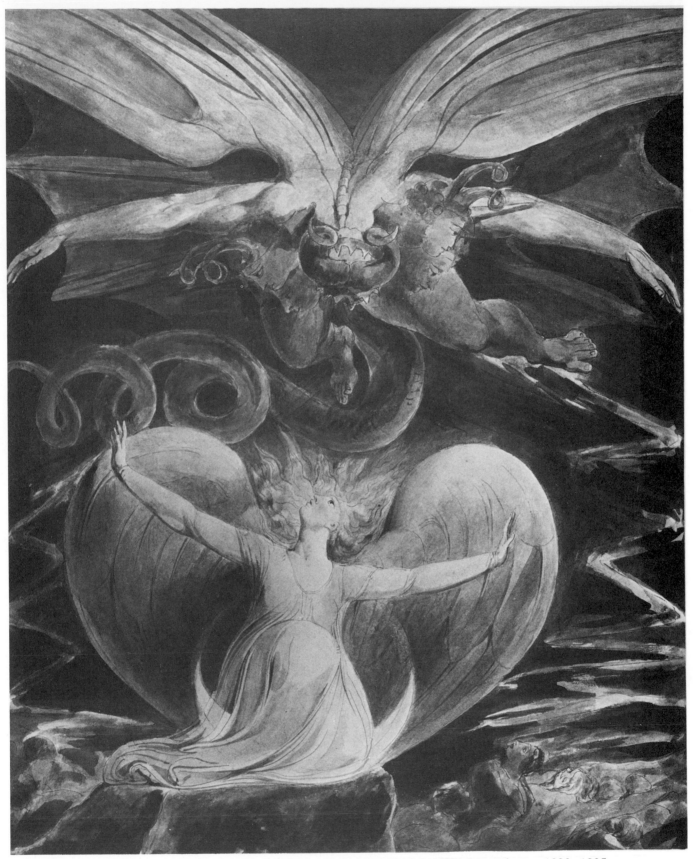

The Great Red Dragon and the Woman Clothed with the Sun (II), watercolor, c. 1800–1805

And there appeared a great wonder in heaven; a woman clothed with the sun, and the moon under her feet, and upon her head a crown of twelve stars: And she being with child cried, travailing in birth, and pained to be delivered. And there appeared another wonder in heaven; and behold a great red dragon, having seven heads and ten horns, and seven crowns upon his heads. And his tail drew the third part of the stars of heaven, and did cast them to·the earth: and the dragon stood before the woman . . . for to devour her child as soon as it was born.

Revelation 12:1–4

The two lovers, just uncoupled but still languidly, or even despondently, embracing in what seems a postcoital *tristesse*, are Albion and his bride Jerusalem. Blake's iconography stems from the illustrations in alchemical treatises depicting the sacred marriage of Sulphur (male) and Quicksilver (female) which releases the soaring eagle of the spirit. In his version, however, the eagle is not soaring, but swooping downward and screaming, as if to arouse the lovers, indicating that their union has been unsuccessful.

The Marriage of Sulphur and Quicksilver,
MS page 16, EGERTON 845

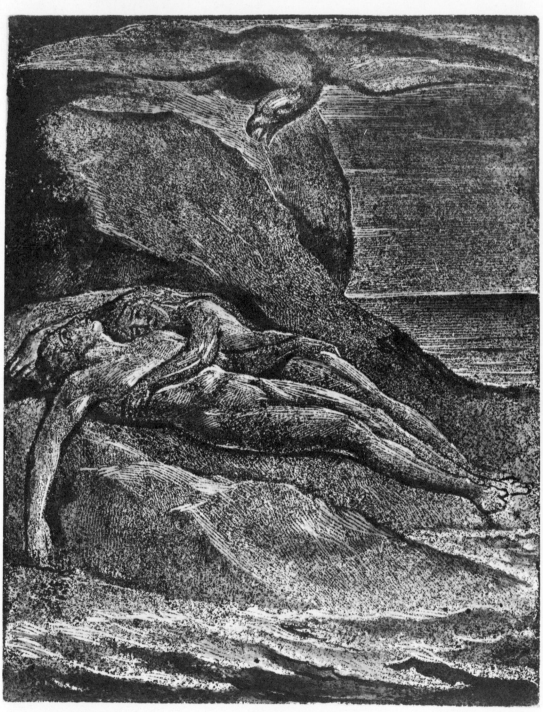

Plate 42, MILTON, A POEM, white-line etching, painted with watercolors, c. 1804–1808

Awake, Albion awake! reclaim thy Reasoning Spectre, Subdue
Him to the Divine Mercy. Cast him down into the Lake
Of Los that ever burneth with fire ever & ever, Amen!
Let the Four Zoas awake from Slumbers of Six Thousand Years.

Milton, 44:10–14

The lady with the *sanctum sanctorum* between her thighs personifies Blake's conception of religious chastity. Opposite her is a study of Eve and the Serpent for an illustration of *Paradise Lost*. (See page 83.) The Serpent has here enwreathed himself around her body from head to foot ("Embraces," wrote Blake, "are comminglings from the Head even to the Foot,/ And not a pompous High Priest entering by a Secret Place."), while she seems to be in a sexual trance as he presses his forked tongue into her mouth. Blake accepted as gospel the gnostic gossip that the temptation and fall of Eve was a physical as well as moral—not to mention allegorical and anagogical—seduction. The poem, from Blake's MS *Notebook*, conjoins the ideas of both pictures.

The Golden Chapel, MS page 22 (detail), VALA, OR THE FOUR ZOAS, pencil drawing, c. 1797

I saw a chapel all of gold
That none did dare to enter in,
And many weeping stood without,
Weeping, mourning, worshipping.

I saw a serpent rise between
The white pillars of the door,
And he forc'd & forc'd & forc'd,
Down the golden hinges tore.

And along the pavement sweet,
Set with pearls & rubies bright,
All his slimy length he drew,
Till upon the altar white

Vomiting his poison out
On the bread & on the wine.
So I turn'd into a sty
And laid me down among the swine.
 Blake's MS *Notebook*
 (Rossetti Manuscript)

Eve Tempted by the Serpent, pencil drawing, c. 1807

79

Though Blake revered Milton as his master, much as Dante did Virgil, he scorned his religious orthodoxy and sexual prudery. "The reason Milton wrote in fetters when he wrote of Angels & God," he declared in *The Marriage of Heaven and Hell*, "and at liberty when of Devils & Hell, is because he was a true Poet and of the Devil's party without knowing it." In illustrating Milton's poems, therefore, he took the liberty of welcoming Milton back to the party by giving them a "diabolical" twist of his own.

This passage from *Paradise Lost*, cited by Edmund Burke in his *On the Sublime and the Beautiful* as "dark, uncertain, confused, terrible, and sublime to the last degree," also inspired paintings by Blake's contemporaries Henry Fuseli, James Barry, and Thomas Stothard.

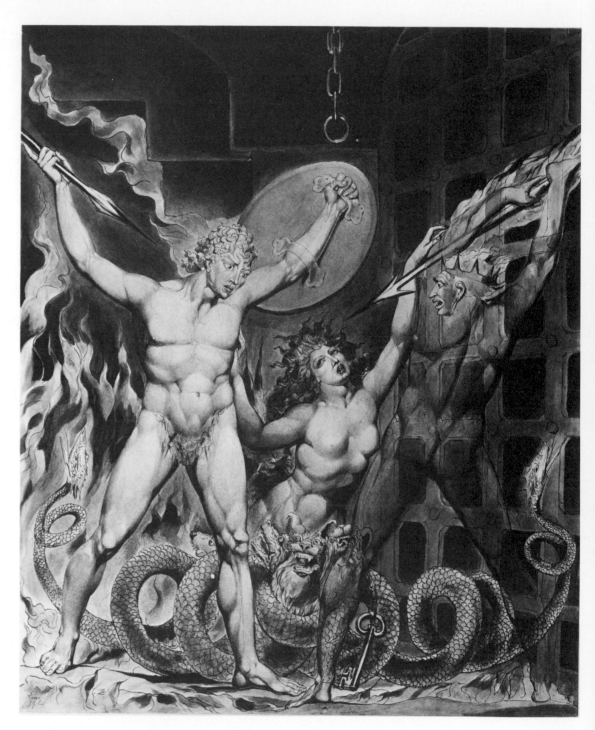

Satan, Sin, and Death, PARADISE LOST, watercolor, 1808

Before the gates there sat
On either side a formidable Shape.
The one seemed woman to the waist, and fair,
But ended foul in many a scaly fold,
Voluminous and vast—a serpent armed
With mortal sting. About her middle round
A cry of Hell-hounds never-ceasing barked
With wide Cerberean mouths. . . .

The other Shape—
If shape it might be called that shape had none
Distinguishable in member, joint, or limb;
Or substance might be called that shadow seemed,
For each seemed either—black it stood as Night,
Fierce as ten Furies, terrible as Hell,
And shook a dreadful dart: what seemed his head
The likeness of a kingly crown had on.

Paradise Lost, II:648–673

The cherubim Ithuriel and Zephon, searching for Satan in the Garden of Eden, have arrived too late. Eve has turned her head away from Adam as if already half seduced in thought.

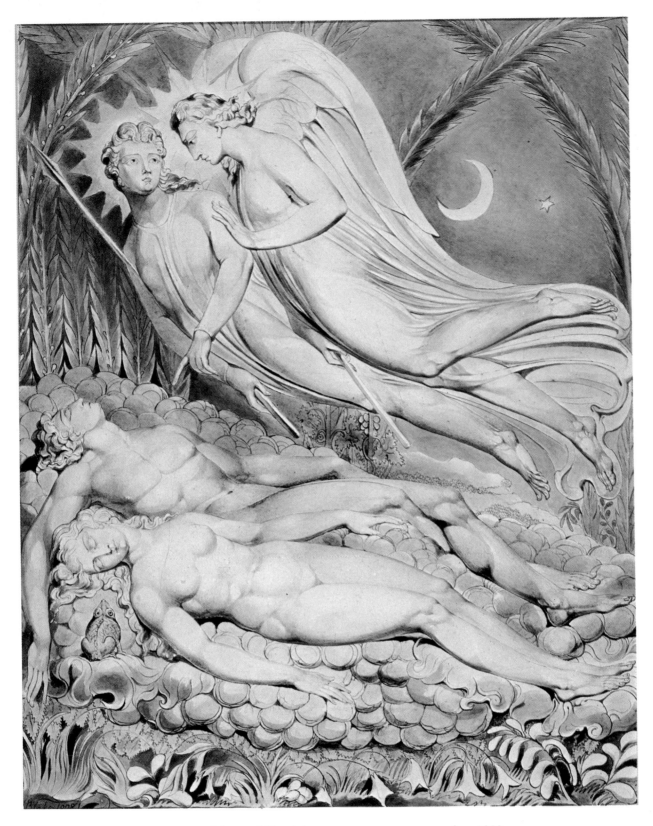

Adam and Eve Asleep, PARADISE LOST, watercolor, 1808

Him there they found
Squat like a toad, close at the ear of Eve,
Assaying by his devilish art to reach
The organs of her fancy, and with them forge
Illusions as he list, phantasms and dreams. . . .
Paradise Lost, IV:799–803

Enclosed within the ogive formed by his own wings, like palms joined in prayer, Raphael points a warning forefinger with his left hand upward toward heaven, while with his other hand he points toward the forbidden Tree of Good and Evil. About its trunk the gigantic phallic snake has already coiled himself, as he will later coil himself around the body of Eve. The spiral motif repeats itself throughout, from the curls of Eve's hair down to the handle of the cup she is holding, and from the sprouts and tendrils of the flowering archway to the chairs upon which Adam and Raphael are sitting.

Adam opens his hands to protest his innocence, while Eve, afflicted by a "thought infirm" (in Blake's version) turns her head away. The whole picture seems bursting with an orgasmic fecundity.

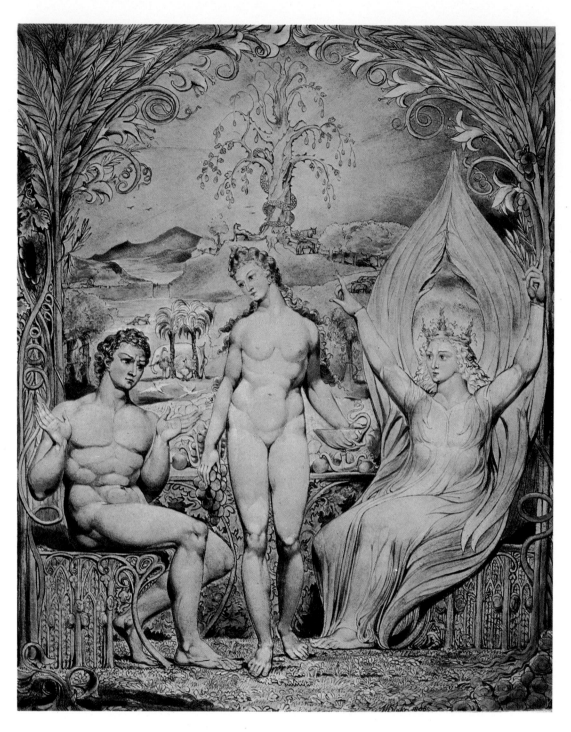

Raphael Conversing with Adam and Eve, PARADISE LOST, watercolor, 1808

> So to the sylvan lodge
> *They came, that like Pomona's arbour smiled,*
> *With flowerets decked and fragrant smells. But Eve,*
> *Undecked, save with herself, more lovely fair*
> *Than wood-nymph, or the fairest goddess feigned*
> *Of three that in Mount Ida naked strove,*
> *Stood to entertain her guest from Heaven; no veil*
> *She needed, virtue proof; no thought infirm*
> *Altered her cheek. On whom the Angel "Hail!"*
> *Bestowed—the holy salutation used*
> *Long after to blest Mary, second Eve. . . .*
>
> Paradise Lost, V:377–387

This climactic scene of *Paradise Lost* has undergone a re-"vision" by Blake. The serpent, who in Milton's version had slithered off after seducing Eve, is here still coiled about her, pressing the apple to her mouth, while she supports him tenderly with her right hand. Adam, according to Milton, "took no thought, eating his fill" of the forbidden fruit, and afterward "began to cast lascivious eyes on Eve"; but Blake has depicted Adam as standing amazed by the Urizenic lightning flashing about him, whose zigzag forks seem to be part of the tree itself.

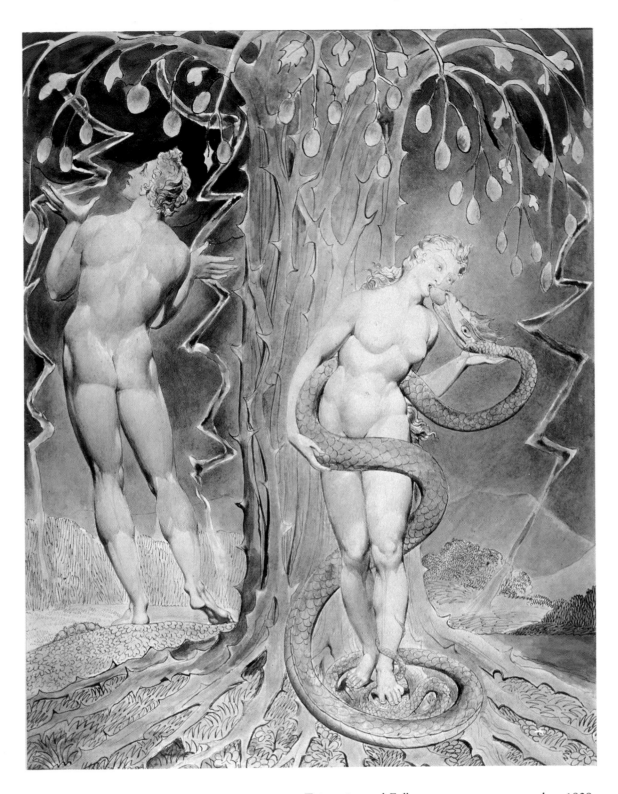

Temptation and Fall, PARADISE LOST, watercolor, 1808

Earth trembled from her entrails, as again
In pangs, and Nature gave a second groan;
Sky loured, and, muttering thunder, some sad drops
Wept at completing of the mortal Sin
Original. . . .

Paradise Lost, IX:1000–1005

83

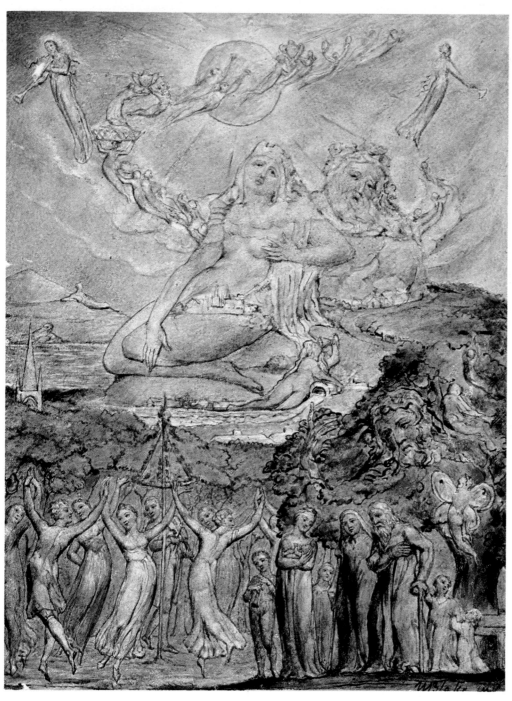

The Sunshine Holiday, L'ALLEGRO, watercolor, c. 1816

Around 1816, Blake did a series of six watercolors illustrating *L'Allegro*, for each of which he provided descriptive notes in manuscript. The one for *The Sunshine Holiday* states:

In this design is Introduced

> Mountains on whose barren breast
> The Labring Clouds do often rest

Mountains Clouds Rivers Trees appear Humanized on the Sunshine Holiday. The Church Steeple with its merry bells. The Clouds arise from the bosoms of Mountains, While Two Angels sound their Trumpets in the Heavens to announce the Sunshine Holiday.

An Olympian variety of colossal figures—some fused within the landscape, others superimposed upon its contours—has been concealed in *trompe-l'œil* fashion throughout the picture. (Note the Psyche, symbolizing spiritual rebirth, fluttering in the right-hand corner.) "The ancient Poets," declared Blake in *The Marriage of Heaven and Hell,* "animated all sensible objects with Gods or Geniuses, calling them by the names and adorning them with the properties of woods, rivers, mountains, lakes, cities, nations. . . ."

Sometimes with secure delight
The upland Hamlets will invite,
When the merry Bells ring round,
And the jocund rebecks sound
To many a youth, and many a maid,
Dancing in the Chequered shade;
And young and old come forth to play
On a Sunshine Holyday. . . .
 L'Allegro, lines 91–98

Blake's note states:

The Goblin crop full flings out of doors from his Laborious task dropping his Flail & Cream bowl, yawning & stretching, vanishes into the Sky, in which is seen Queen Mab Eating the Junkets. The Sports of the Fairies are seen thro the Cottage where "She" lays in Bed "pinchd & pulld" by Fairies as they dance on the Bed, the Ceiling & the Floor, & a Ghost pulls the Bed Clothes at her Feet. "He" is seen following the Friars Lantern towards the Convent.

Both in its conception and execution, *Queen Mab* calls to mind the merry Hassidic *diablerie* of Marc Chagall's early cubist paintings.

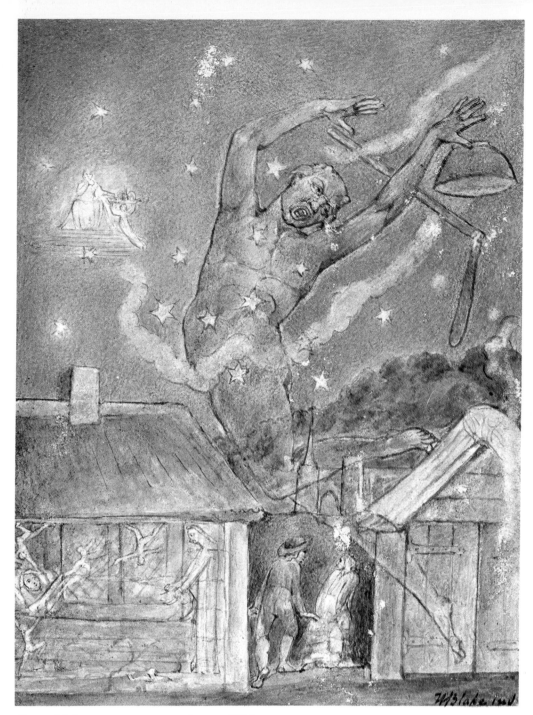

Queen Mab, L'ALLEGRO, watercolor, c. 1816

With stories told of many a feat,
How Faery Mab the junkets eat.
She was pinched, and pulled she said;
And he, by Friar's Lantern led,
Tells how the drudging Goblin sweat,
To earn his Cream-bowl duly set,
When in one night, ere glimpse of morn,
His shadowy Flail hath threshed the Corn
That ten day-laborers could not end;
Then lies him down, the lubber fiend,
And stretched out all the Chimney's length,
Basks at the fire his hairy strength;
And Crop-full out of doors he flings,
Ere the first Cock his Matin rings.
 L'Allegro, lines 100–115

For *Comus*, the first of Milton's works to be illustrated by Blake, he made two sets of watercolor drawings around 1801. Blake had already dealt with the theme of maidenly Innocence tempted and threatened by Experience in *The Book of Thel*, engraved in 1789, which owes much to *Comus*. But of course his own attitude toward female (or male) chastity was diametrically opposed to Milton's. The rampant and prancing sexual exuberance of Comus, in Blake's version, contrasts with the frozen stolidity and almost zomboid vapidity of The Lady.

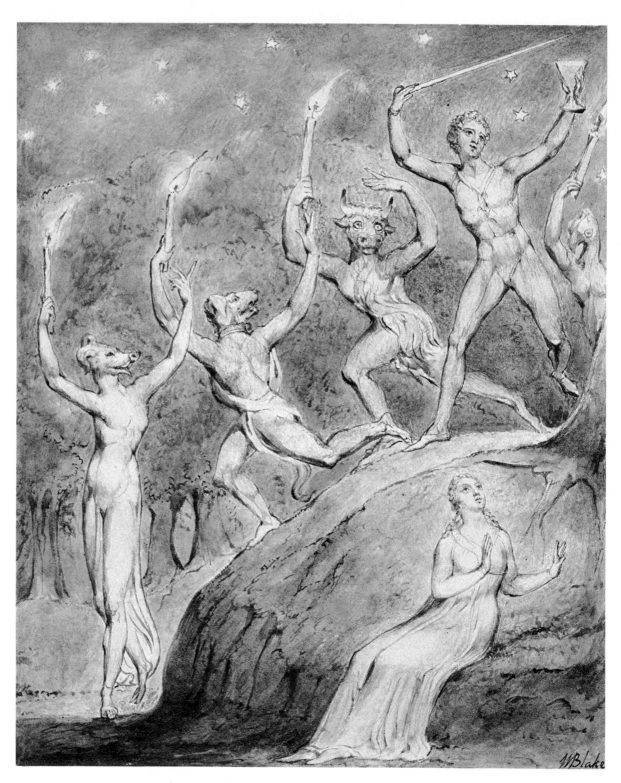

Comus with the Revellers, COMUS, watercolor, c. 1801

COMUS enters, with a charming rod in one hand, his glass in the other; with him a rout of monsters, headed like sundry sorts of wild beasts, but otherwise like men and women, their apparel glistering. They come in, making a riotous and unruly noise, with torches in their hands.

Comus, line 93

The Magic Banquet, COMUS, watercolor, c. 1801

The scene changes to a stately palace, set with all manner
of deliciousness: soft music, tables spread with all dainties.
COMUS appears with his rabble, and THE LADY set in an
enchanted chair: to whom he offers his glass; which she
puts by, and goes about to rise.

Comus, line 659

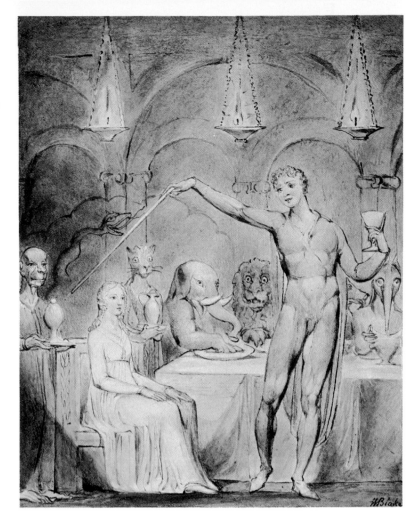

Comus Put to Flight, COMUS, watercolor, c. 1801

The BROTHERS rush in with swords drawn, wrest his glass
out of his hand, and break it against the ground: his rout
make sign of resistance, but are all driven in. . . .

Comus, line 814

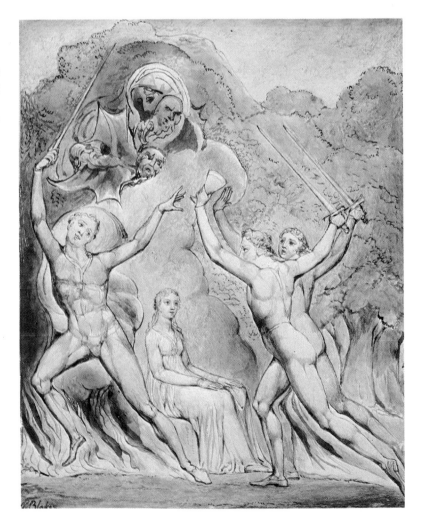

Thomas Gray wrote his mock-heroic ode, in 1747, to commemorate the death by drowning of Sir Horace Walpole's cat Selima. But it also served as an occasion for him to comment genteelly—and with the kind of oinking condescension nowadays regarded as male chauvinist *cochonnerie*—on the supposed resemblance between the feline and feminine temperaments.

To Blake the allegory implicit in the poem was irresistible catnip, enabling him to employ fully his satirical genius as an illustrator and, in addition, to point a transcendental moral of his own. What Gray intended as metaphorical, Blake, with his "fourfold vision," makes literal, and vice versa, in a contrapuntal, playful irony.

The grotesque cat-woman crouched upon the box, who gazes down at the

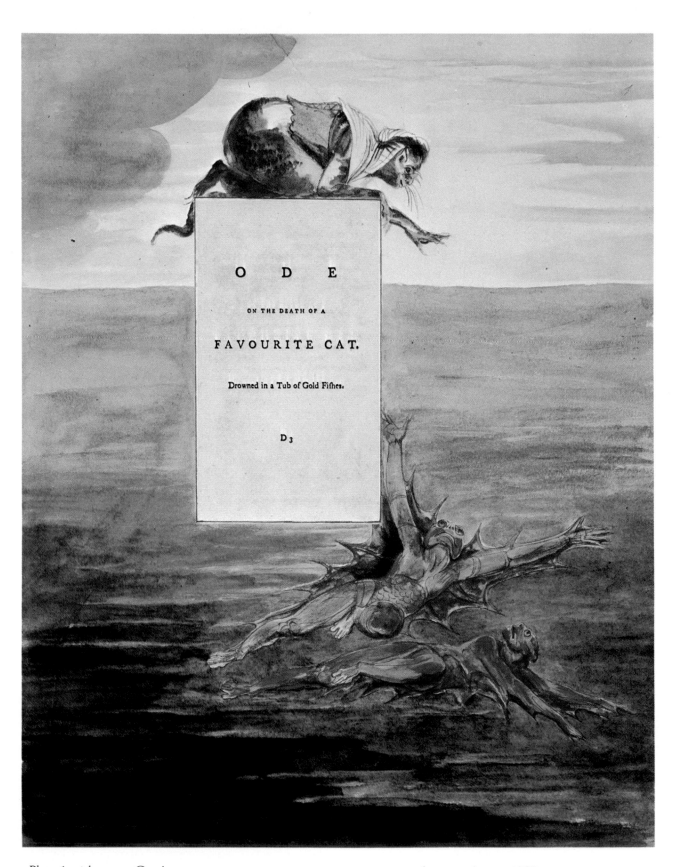

Plate 1, title page, Gray's ODE ON THE DEATH OF A FAVOURITE CAT, pen and watercolor, c. 1798

two alarmed batfinned and fiendish-looking creatures swimming below, as if to devour them with her eyes, abruptly changes form . . . and (in the plate below) becomes the mewing Selima herself, a real cat, "demurest of the tabby kind," while the creatures also metamorphose into easy-going glittering goldfish. Surmounting each is a tiny sprite, mischievous homunculi, especially the one with the bouffant hairdo and the languishing air propped on her elbow above Selima, who stares back flirtatiously at the viewer. With-in the box are lines from the poem that provide mottoes for the illustrations.

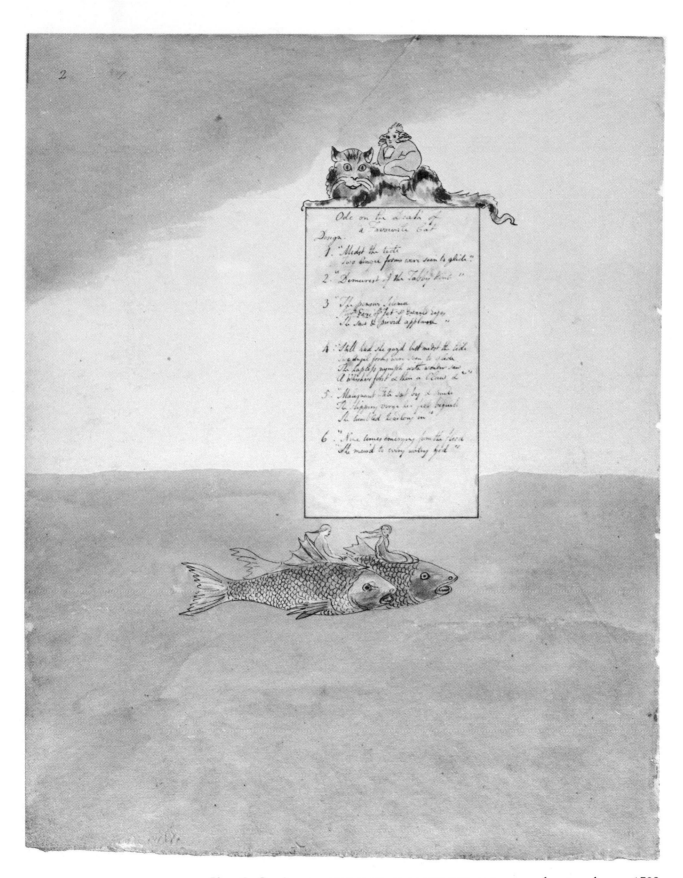

Plate 2, Gray's ODE ON THE DEATH OF A FAVOURITE CAT, pen and watercolor, c. 1798

The fashionably dressed Selima, almost human except for her slit eyes, pointy ears, and luxuriant tail, which is waving and curling in self-satisfaction, admires her own reflection Narcissus-like in the water. The fish, meanwhile, who are also partly humanized, have managed to find a secluded nook, even in a goldfish bowl, where they can embrace unobserved.

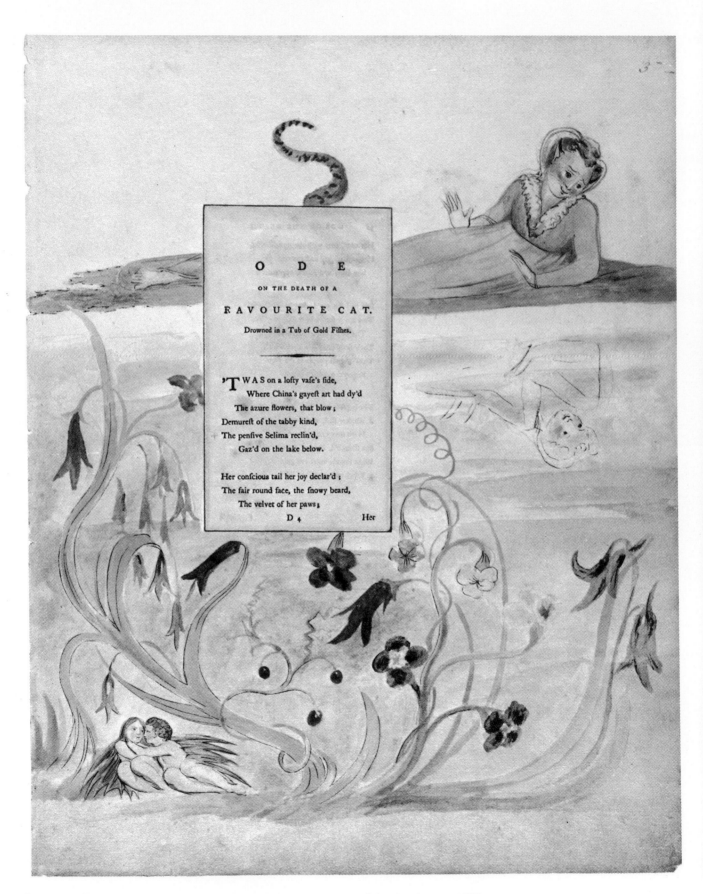

Plate 3, Gray's ODE ON THE DEATH OF A FAVOURITE CAT, pen and watercolor, c. 1798

At once, with the blink of an eye, as soon as Selima spies the fish, she turns into a predacious cat once more, while the fish, in their turn, flee in panic. But a new character, a sinister-looking old crone, has now joined the scene. She is none other than the "Malignant Fate," Atropos, who stands ready to cut the thread of Selima's life with her shears.

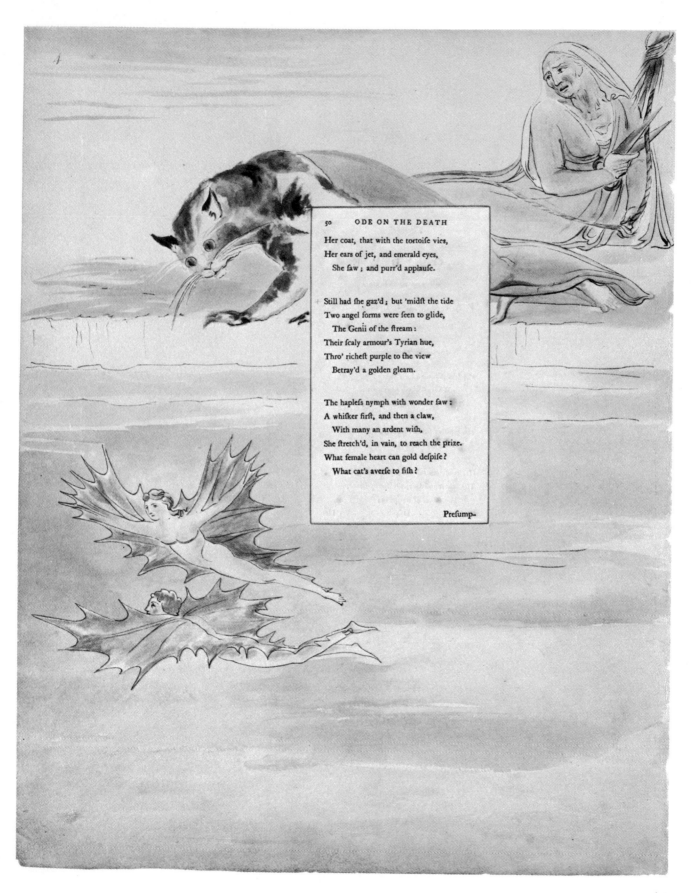

50 ODE ON THE DEATH

Her coat, that with the tortoife vies,
Her ears of jet, and emerald eyes,
 She faw ; and purr'd applaufe.

Still had fhe gaz'd ; but 'midft the tide
Two angel forms were feen to glide,
 The Genii of the ftream :
Their fcaly armour's Tyrian hue,
Thro' richeft purple to the view
 Betray'd a golden gleam.

The haplefs nymph with wonder faw :
A whifker firft, and then a claw,
 With many an ardent wifh,
She ftretch'd, in vain, to reach the prize.
What female heart can gold defpife ?
 What cat's averfe to fifh ?

Prefump-

Plate 4, Gray's ODE ON THE DEATH OF A FAVOURITE CAT, pen and watercolor, c. 1798

Atropos, reversing direction, pushes a now fully human Selima into the water. The fish, clad in "Their scaly armour's Tyrian hue," and kicking away in the water with their feet—for they too have been humanized—raise their spears and shields, either in triumph or consternation, as they watch her plunge to her doom. Though Gray, in the next to last stanza, wrote that Selima went down "eight" times, Blake in his box of mottoes wrote "nine," as if to say that the feline female had passed beyond moral preachment.

OF A FAVOURITE CAT. 5£

Presumptuous maid! with looks intent
Again she stretch'd, again she bent,
 Nor knew the gulph between :
(Malignant Fate sat by, and smil'd)
The slipp'ry verge her feet beguil'd,
 She tumbled headlong in.

Eight times emerging from the flood
She mew'd to ev'ry wat'ry God,
 Some speedy aid to send.
No Dolphin came, no Nereid stirr'd,
Nor cruel Tom, nor Susan heard,
 A fav'rite has no friend !

From hence, ye beauties, undeceiv'd,
Know, one false step is ne'er retriev'd,
 And be with caution bold.

Not

Plate 5, Gray's ODE ON THE DEATH OF A FAVOURITE CAT, pen and watercolor, c. 1798

Selima, now neither one nor the other, but pure spirit, is seen after death with her hands clasped in prayer, rising from the waters of materialism to a higher realm, while the fish have become plain fish. With this last illustration the series as a whole has also risen along with Selima into a spiritual, or anagogical, level of meaning. For throughout Blake has related Selima's temptation and fall to the gnostic myth of creation, which tells how the divine Ennoia (or Sophia) descended into materiality after she mistook the glimmer of her own reflection in the darkness of chaos for the "Light of Lights."

5² O D E, &c.

Nor all that tempts your wand'ring eyes,
And heedlefs hearts, is lawful prize;
 Nor all that glifters, gold.

ODE

Plate 6, Gray's ODE ON THE DEATH OF A FAVOURITE CAT, pen and watercolor, c. 1798

In 1796 Blake was commissioned by the bookseller Richard Edwards to illustrate a new edition of the Reverend Edward Young's *Night Thoughts or, The Complaint and the Consolation,* the most imposing mausoleum of the so-called "Graveyard School" of poetry in England during the eighteenth century.

Blake did 537 designs in watercolor and engraved 43 plates, for which he was paid *in toto* 20 guineas, or approximately ninepence for each design. Published in the fall of 1797, the book proved a commercial as well as artistic failure, and only the first part of the edition was ever printed. Young's fashionably lugubrious

verses, though hedged within their letter-press borders, were overwhelmed by the tropically exuberant and gigantesque exfoliations of Blake's designs. One indignant critic referred to them as "the conceits of a drunken fellow or a madman."

Night the First, title page, Young's NIGHT THOUGHTS OR, THE COMPLAINT AND THE CONSOLATION, engraving, 1797

Death, in the character of an old man, having swept away with one hand part
of the family seen in this print, is presenting with the other their spirits to immortality.
"Explanation of the Engravings," author anonymous

Blake has here depicted Young's various images in their "minute particularity," but rearranged them to form a sequence, beginning at the left corner and reading clockwise around the page.

4

An heir of glory! a frail child of dust!
Helpless immortal! insect infinite!
A worm! a God!——I tremble at myself,
And in myself am lost! At home a stranger,
Thought wanders up and down, surprised, aghast,
And wond'ring at her own: how reason reels!
O what a miracle to man is man,
Triumphantly distress'd! what joy, what dread!
Alternately transported, and alarm'd!
What can preserve my life? or what destroy?
An angel's arm can't snatch me from the grave—
Legions of angels can't confine me there.
 'Tis past conjecture: all things rise in proof.
While o'er my limbs sleep's soft dominion spread:
* What, though my soul fantastick measures trod
O'er fairy fields; or mourn'd along the gloom
Of pathless woods; or down the craggy steep
Hurl'd headlong, swam with pain the mantled pool;
Or scaled the cliff; or danced on hollow winds,
With antick shapes wild natives of the brain?
Her ceaseless flight, though devious, speaks her nature
Of subtler essence than the trodden clod;
Active, aërial, tow'ring, unconfined,
Unfetter'd with her gross companion's fall.
Even silent night proclaims my soul immortal;
Even silent night proclaims eternal day.
For human weal, Heaven husbands all events;
Dull sleep instructs, nor sport vain dreams in vain.
 Why then their loss deplore that are not lost?
Why wanders wretched thought their tombs around,

Night the First, page 4, Young's NIGHT THOUGHTS OR, THE COMPLAINT AND THE CONSOLATION, engraving, 1797

The imagery of dreaming variously delineated according to the poet's description in the passage referred to by the *.

 "Explanation of the Engravings," author anonymous

The obfuscatory "explanation" below may itself be explained away as an instance of Blake's dictum: "As the Eye, Such the Object." The grim figure swooping down upon the maiden, and about to ensnare her in his mantle, is not death but reason, as the text plainly states; and the maiden herself, personifying the senses, appears not so much wanton as exultant in her newfound freedom. The illustration is thus in direct opposition to Young's prudish verses. In *The Marriage of Heaven and Hell*, Blake wrote that the millennium "will come to pass by an improvement of sensual enjoyment." (See pages 48 and 56.)

Night the Third, page 46, Young's NIGHT THOUGHTS OR, THE COMPLAINT AND THE CONSOLATION, engraving, 1797

The folly and danger of pursuing the pleasures of sense as the chief objects of life illustrated by the figure of Death just ready to throw his pall over a young and wanton female.
"Explanation of the Engravings," author anonymous

The Scottish poet Robert Blair's *The Grave* (1743), a sepulchral echo of Young's *Night Thoughts*, was also immensely popular in its time. In 1805 Blake was hired by R. H. Cromek, a former engraver turned publisher, to do the illustrations for a new edition of the poem. Blake made about twenty designs, which were accepted by Cromek enthusiastically; but then, instead of giving Blake the far more lucrative commission of engraving them, as had been agreed, he turned over his designs to the modish engraver Louis Schiavonetti ("Assassinetti," Blake called him) to ensure the success of the project.

In the notes on Blake's designs, attributed to Henry Fuseli, he wrote of this one that "the world in flames typifies the renovation of all things, the end of Time, and the beginning of Eternity."

The Skeleton Re-animated, title page, Blair's THE GRAVE, etching, 1805–08

When the dread trumpet sounds, the slumb'ring dust,
(Not unattentive to the call) shall wake . . .
 The Grave, lines 750–752

Fuseli's note to this design states:

> The Soul, prior to the dissolution of the Body, exploring through and beyond the tomb, and there discovering the emblems of mortality and immortality.

As envisioned by Blake the soul, like Jung's "anima," is feminine, while the spirit, or "animus," is masculine. Poised above the tomb that contains their body, he observes the scene with dread. The moony landscape indicates that this revelation of death is taking place within a dream.

The Soul Exploring the Recesses of the Grave, Blair's THE GRAVE, etching, 1805–08

> 　　　　　　　　*The sickly taper,*
> *By glimm'ring thro' thy low-brow'd misty vaults,*
> *(Furr'd round with moldy damps, and ropy slime,)*
> *Lets fall a supernumerary horrour,*
> *And only serves to make thy night more irksome.*
> 　　　　　　　　*The Grave*, lines 16–20

According to Fuseli's note:

The Door opening, that seems to make utter darkness visible; age, on crutches, hurried by a tempest into it. Above is the renovated man seated in light and glory.

This picture is a composite of several designs, previously used by Blake, from *America A Prophecy; For the Children: The Gates of Paradise;* and *The Marriage of Heaven and Hell.*

Death's Door, Blair's THE GRAVE, etching, 1805–08

Behold him in the evening tide of life,
A life well spent . . .
Whilst the glad gates of sight are wide expanded
To let new glories in.
 The Grave, lines 716–725

99

Within the drawing:
Till she became a Dragon winged bright & poisonous
I opend all the floodgates of the Heavens to quench her thirst
And

Dragon Forms, MS page 26 (detail), VALA, OR THE FOUR ZOAS, pencil drawing, c. 1797

The nightmarish figure hovering on extended batlike wings has the head and neck of an ibis attached to the scaly trunk and thighs of a siren, but her well-defined genitals are human. Flying beneath her is a female dragon whose long tail undulates into a double spiral. Both images are derived from alchemical lore: the ibis as a bird sacred to Thoth, the Egyptian god of magic and alchemy; and the dragon as a symbol of the chaotic forces of nature. But Blake has also transmuted and incorporated them into his own mythology. (See page 78 and *Swan-woman, on opposite page.*)

The Jealousy of Los, MS page 60, VALA, OR THE FOUR ZOAS, pencil drawing, c. 1797

Orc is depicted with his limbs entwined almost incestuously about those of Enitharmon while Los glares at them with jealous hatred. Los's constricting girdle "was form'd by day, by night was burst in twain," for at night she belongs to him, by day to Orc. Blake has here envisioned long before Freud—but from the point of view of the father, not the son—the primordial triangle of the Oedipus complex. (See page 64.)

> Los beheld the ruddy boy
> Embracing his bright mother, & beheld malignant fires
> In his young eyes, discerning plain that Orc plotted his death.
> Grief rose upon his ruddy brows; a tightening girdle grew
> Around his bosom like a bloody cord . . .
> Vala, or The Four Zoas, V:80–84

Joseph Wicksteed remarks that "one of the cellars of the most ancient inn in Glastonbury (that Blake may well have heard of) was said to have contained a stone seat or recess which a perennial spring kept watered, 'and women of loose character were compelled to do penance by sitting with the water up to their knees.' This so exactly describes the posture," concludes Wicksteed, "as to leave little doubt that the Swan-Woman represents Blake's bitter indictment of . . . the callous judgments of society."

Swan-woman, plate 11 (detail), JERUSALEM, white-line etching, usually uncolored, 1804–20

Striving with Systems to deliver Individuals from those Systems.
Jerusalem, 11:5

This unique print showing Albion and his bride Vala copulating on a lily pad, in the position sometimes referred to in French as *à la chandelle* (as candle and candlesnuffer), was considerably altered by Blake in a later version. On the same plate he re-engraved the hair and features of the pair so that their sexes became indistinguishable; shifted their limbs to depict them side by side and uncoupled; and eliminated the huge phallic caterpillar emerging from under the shadows. But in both versions they are still enshrouded by the net, or web, of religion. "As the caterpiller [*sic*] chooses the fairest leaves to lay her eggs on," Blake wrote in the *Proverbs of Hell*, "so the priest lays his curse on the fairest joys."

Plate 28 (suppressed version, detail), JERUSALEM, relief etching, usually uncolored, 1804–20

David Erdman sees this picture as an "icon of the high priestess of Deism or State Religion, Vala [Nature] dressed as Rahab [the biblical Whore of Babylon]." She is wearing a kind of papal tiara (like the one worn by "Albion's Angel" on page 41), so heavy that she has to support her head with both hands beneath her chin. The back of the zodiacal throne upon which she is seated—or it might be her own gorgeous buglike wings—eclipses the spiritual sun behind her. Blake's design has been traced to a fairly similar engraving of an Indian deity published in Moor's *Hindoo Pantheon*, a book widely known in his time.

Vala Enthroned on a Sunflower, plate 53 (detail), JERUSALEM, white-line etching, usually uncolored, 1804–20

A brooder of an Evil Day, and a Sun rising in blood.
 Jerusalem, 50:29

Within this chimerical vehicle are seated a grim-faced, patriarchal old man and a half-hidden shrinking figure wearing what appears to be a nun's habit. The chariot itself is a composite of motifs derived from engravings of ancient art—the human-headed bulls from sculptures unearthed at Persepolis; their convoluted horns from Egyptian bas-reliefs showing the sun's rays terminating in tiny human hands. But the bird-faced little gnomes seated on the backs of the monsters, one of whom holds a quill, and the snakes whose bodies roll up into the wheels and then stiffen into the shafts, are Blake's own inventions.

The Chariot of Inspiration, plate 41 (detail), JERUSALEM, white-line etching, usually uncolored, 1804–20

Repose upon our bosoms
Till the Plow of Jehovah, and the Harrow of Shaddai
Have passed over the Dead, to awake the Dead to Judgment.
 Jerusalem, 41:13–15

With his right foot planted upon a winged moon, Albion sinks dying into the arms of Jesus, who is irradiated by divine light. The same blasted oak, but with its leaves blowing in an opposite direction, reappears in Blake's wood engraving for Thornton's *Virgil*. (See page 126.)

In the lower half of the plate, a bat-winged specter hovers over the corpse of Jerusalem, which is laid out upon a bier and ready to enter its sepulcher for "a Death of Eight thousand years." An alchemical sun and moon (which is crescent, symbolizing the purified soul, but with its bright side turned away from the sun) float in the heavens above the scene.

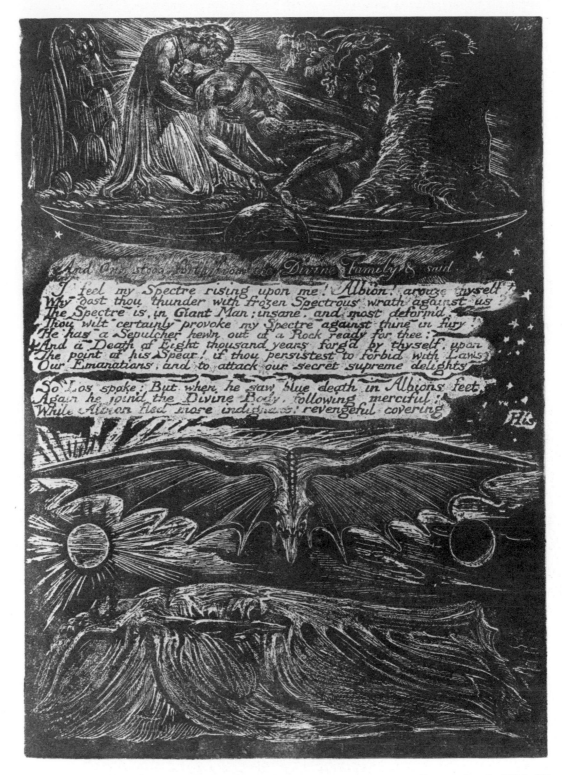

Plate 33 [37], JERUSALEM, white-line etching, usually uncolored, 1804–20

He stood between the Palm tree & the Oak of weeping
Which stand upon the edge of Beulah; and there Albion
Sunk down in sick pallid languor! . . .

Look not so merciful upon me O thou Slain Lamb of God
I die! I die in thy arms tho Hope is banished from me.
Jerusalem, 23:24–26; 24:59–60

103

Jesus is here shown nailed to a forked oak tree, sacred to the ancient Druids, as a human sacrifice in their primitive nature-worshiping religious rites. David Erdman suggests, therefore, that he does not represent the divine Jesus but the God of this world, the God of Deism and natural religion, who has assumed what Blake called "the Satanic Body of Holiness." However, an epiphany seems to be taking place, for on the horizon to the lower left the materialist sun is setting, while behind the head of Jesus, as Erdman points out, "the sun of the imagination is bursting forth in all its glory."

The pose of Albion is the same, seen from the rear, as that of the exultant figure in *The Dance of Albion* (see page 33), which Blake had conceived almost four decades earlier. With its spidery thin and mercurial white line on a black ground, like the afterimage of a vision, this plate is generally regarded as Blake's most superb realization of the technique he described as "woodcut on copper": "instead of etching the blacks Etch the whites & bite it in."

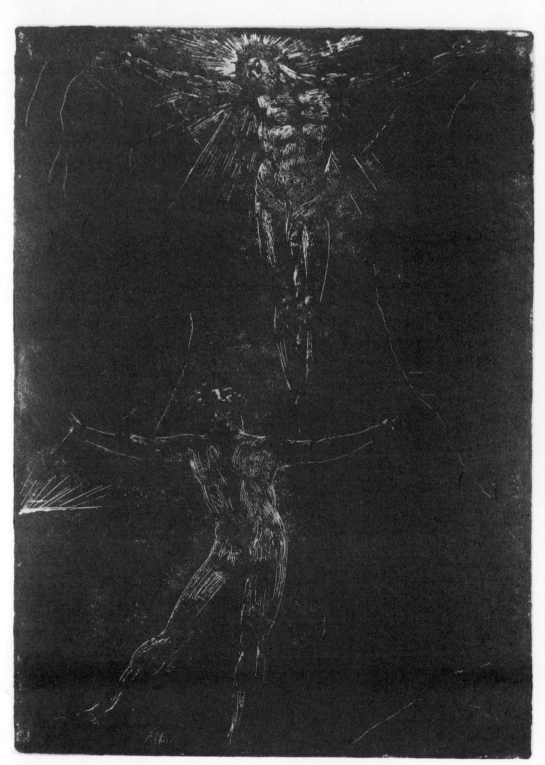

Plate 76, JERUSALEM, white-line etching, usually uncolored, 1804–20

Then Jesus appeared standing by Albion as the Good Shepherd
By the lost Sheep that he hath found, & Albion knew that it
Was the Lord, the Universal Humanity; & Albion saw his Form
A Man, & they conversed as Man with Man in Ages of Eternity.
And the Divine Appearance was the likeness & similitude of Los.

Jerusalem, 96:5–9

Based on the third-century Neoplatonist philosopher Porphyry's mystical treatise on Ulysses' homecoming, *De Antro Nympherum* [The Cave of the Nymphs], this picture combines two separate events related in Books V and XIII of the *Odyssey*.

Ulysses, with averted head, is throwing back the girdle (his physical body) lent to him by the sea-goddess Leucothea in order to bring him safely ashore. Leucothea is seen out at sea, accompanied by two lesser spirits, guiding four dark sea-stallions through the waves. She has just caught the girdle, which dissolves into a cloud of mist above her. Behind Ulysses, unrecognized by him, stands the goddess Athena in her aspect as the Divine Wisdom (Sophia), who points him heavenward.

There (beginning at the upper left-hand corner and returning to the foreground) the Cycle of the Life of Man commences. First, the chariot of the sun, with the sleepy, newborn spirit inside, is being harnessed to four eager horses (Blake's Four Zoas) about to make their journey into mortality. Inside the cave (at the upper right-hand corner) naiades are bearing urns and bowls filled with the water of life and the honey of generation; while other nymphs (proceeding downward) are busily working at their looms to weave the fabric of the mortal body. Below, in the water of the estuary opening into the Sea of Time and Space, the Three Fates receive the yarn and are cutting it to suit. They are assisted by the sea-god Phorcis, whose cave this is, holding the distaff.

Blake's painting was rediscovered as recently as 1949, at Arlington Court in Devonshire, where it had remained unnoticed over the years.

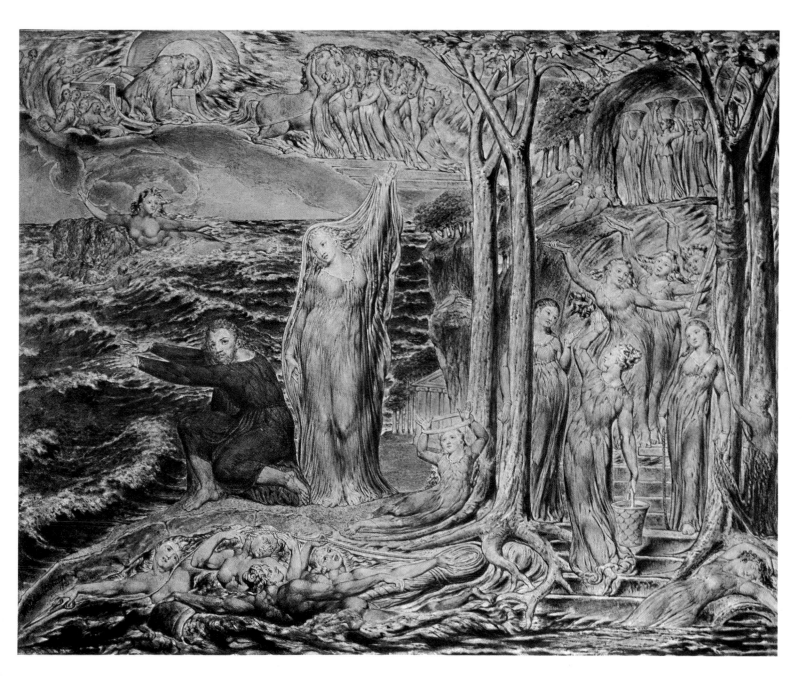

De Antro Nympherum, tempera, 1821

In the foreground Christ is shown guiding two children through the stream of time toward the divine sun; while at the right his Bride, the New Jerusalem, swoops down to sever the thread of remembrance. The stream flows between the banks of Innocence (left) and Experience (right), each side with its sacred musician, one clad in white and the other in pink. Above Christ, encircled by the sun, floats Saint John the Divine, accompanied by winged figures symbolizing eternal marriage. On each bank grows the tree of life with its "twelve manner of fruits" and healing leaves.

Commenting on the Mannerist distortion of the two musicians, whose heads are one-tenth the size of their bodies, Anthony Blunt remarks that "Blake uses these proportions . . . to give a spiritual and ethereal character to the figures and to lift them out of the material world into the world of the imagination."

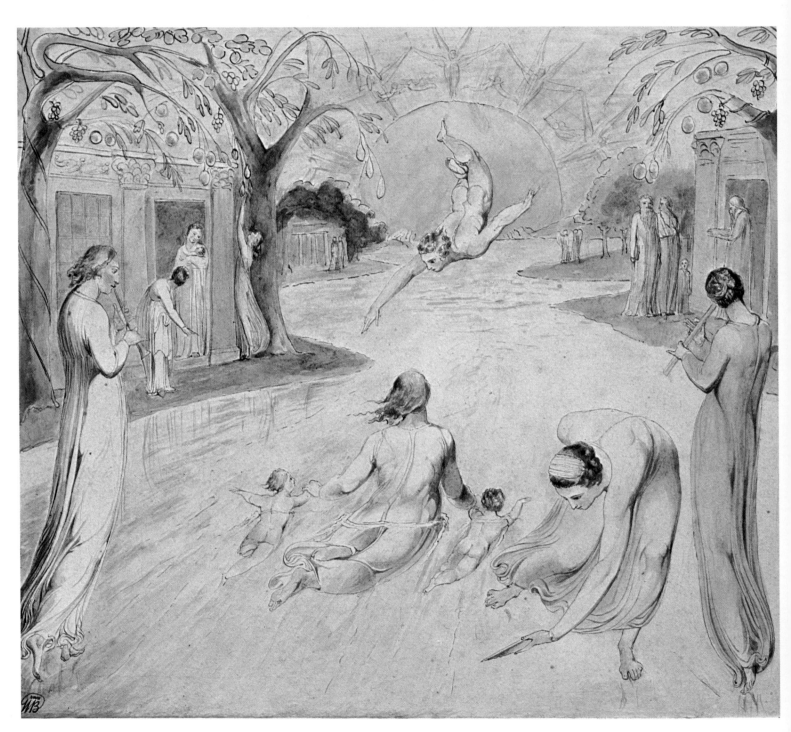

The River of Life, watercolor, c. 1800–1805

And he showed me a pure river of water of life, clear as crystal, proceeding out of the throne of God and of the Lamb. In the midst of the street of it, and on either side of the river, was there the tree of life, which bare twelve manner of fruits, and yielded her fruit every month: and the leaves of the tree were for the healing of the nations.

Revelation 22:1–2

Blake has depicted the scene just after the angel has trumpeted the good news. The foolish virgins, pleading with the wise ones for some of their oil, are being told "*Not so;* lest there be not enough for us and you: but go ye rather to them that sell, and buy for yourselves." The stately posture of these wise virgins, haughty as Grecian caryatids, and the precisely contrapuntal movements of their heads and feet, are set off by the groveling dishevelment of their sisters. Though Blake undoubtedly agreed with the intent of the parable, he must also have been repelled by its seeming lack of charity.

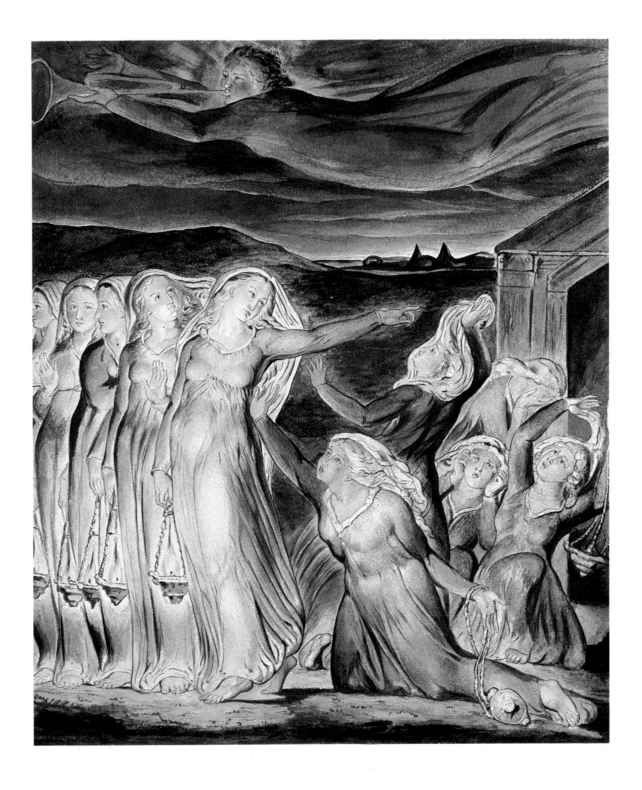

The Wise and Foolish Virgins, watercolor, c. 1826

Then shall the kingdom of heaven be likened unto ten virgins, which took their lamps, and went forth to meet the bridegroom. And five of them were wise, and five were foolish. They that were foolish took their lamps, and took no oil with them: But the wise took oil in their vessels with their lamps. While the bridegroom tarried, they all slumbered and slept. And at midnight there was a cry made, Behold, the bridegroom cometh; go ye out to meet him.

Matthew 25:1–6

No such scene, of course, is described in the Bible, but one like it does occur in Blake's short play *The Ghost of Abel* (1822), dedicated "To LORD BYRON in the Wilderness." Byron, a year before, had published his heretical *Cain, A Mystery*, which indicted God in essentially gnostic terms as the source of all the sins for which he condemned mankind. For this Blake bestowed upon Byron the mantle of Elijah as a true prophet. But in his own play, written in response, Blake contrasted the vindictive Elohim demanding blood sacrifice and "Life for Life! Life for Life!" with a merciful Jehovah who offers forgiveness and atonement.

The outcast and rebel Cain, branded by the Creator, became an exalted figure in gnostic theosophy. Blake accepted the doctrine that Christ, by the maternal line, was descended from Cain's wife, whom he called "Cainah."

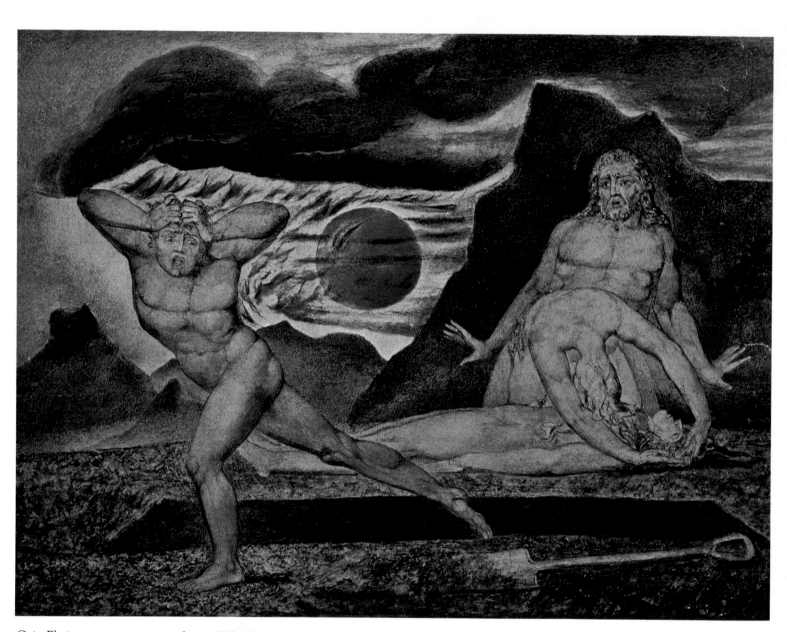

Cain Fleeing, tempera on wood, c. 1826–27

The body of Abel found by Adam and Eve; Cain, who was about to bury it, fleeing from the face of his Parents.

Blake's *A Descriptive Catalogue*

108

Standing upon the body of Job, a gleeful Satan pours a vial of venereal disease upon him with his left hand, while from his right four arrows shoot out to destroy the senses of sight, hearing, taste, and smell. The fifth sense, touch, which is the dominant sense in sexual love, has also been polluted. With his palms as well as the soles of his feet, Job pushes away with loathing the wife who is on her knees before him. Closely related to the scene depicted here is a passage in *Jerusalem* (21:3–6), in which Albion declares:

The disease of Shame covers me from head to feet: I have no hope.
Every boil upon my body is a desperate and deadly Sin.
Doubt first assailed me, then Shame took possession of me.
Shame divides families. Shame hath divided Albion in sunder.

This painting was done several years after Blake's watercolors and engravings illustrating *The Book of Job* (see pages 132–137), and represents a further extension and refinement of plate 11 in that series.

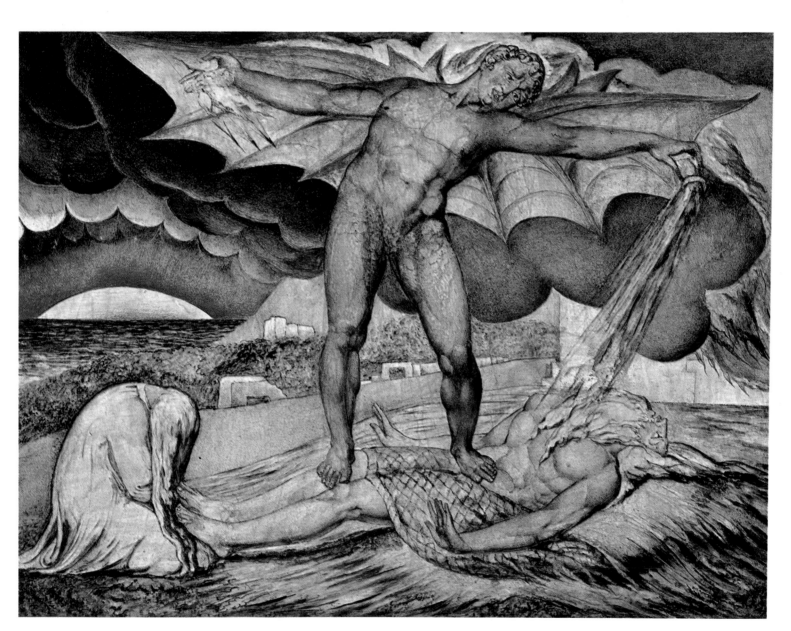

Satan Smiting Job with Sore Boils, tempera on wood, c. 1826–27

So went Satan forth from the presence of the Lord, and smote Job with sore boils from the sole of his foot unto his crown.

Job 2:7

The prophet Samuel, pointing downward with both hands, is about to tell Saul that on the next day his armies will be defeated by the Philistines and he and his three sons killed in battle. The squatting posture of the Witch of Endor, and the expression of open-mouthed horror on her face, closely resemble those of Bromion in *Visions of the Daughters of Albion* (see page 49), who also looks as if he had just seen a ghost.

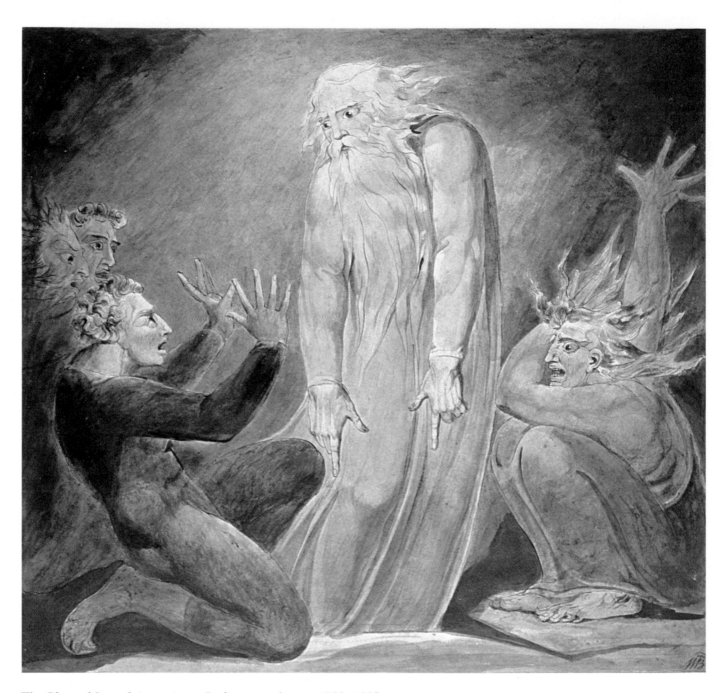

The Ghost of Samuel Appearing to Saul, watercolor, c. 1800–1805

And Saul disguised himself . . . and he went, and two men with him, and they came to the woman [the Witch of Endor] by night: and he said, I pray thee, divine unto me by the familiar spirit, and bring me him up, whom I shall name unto thee. . . . Then said the woman, Whom shall I bring up unto thee? And he said, Bring me up Samuel. And when the woman saw Samuel, she cried with a loud voice. . . . And the king said unto her, Be not afraid: for what sawest thou? And the woman said unto Saul, I saw gods ascending out of the earth. And he said unto her, What form is he of? And she said, An old man cometh up; and he is covered with a mantle. And Saul perceived that it was Samuel, and he stooped with his face to the ground, and bowed himself.

I Samuel 28:8–14

During the years 1825–27, Blake made 102 watercolor sketches as well as seven line engravings to illustrate *The Divine Comedy*. The translations of Dante that accompany the pictures selected here are by Thomas Okey and J. A. Carlyle, from the Temple Classics edition published in 1899–1901.

Dante intended the "four creatures" —man, lion, ox, and eagle—to represent the evangelists Matthew, Mark, Luke, and John; the "six wings," the six types of law ordained by God; the "eyes," knowledge of past and future;

the "two wheels," the Old and the New Testament; the "three ladies," Faith (white), Hope (green), and Charity (red); and the gryphon and Beatrice, Christ and the Church.

But Blake, who believed that Dante "for Tyrannical Purposes . . . made This World the Foundation of All & the Goddess Nature Mistress," has completely altered this symbolism, depicting instead the subjection of the Poetic Genius (Dante) to the malign Female Will (Beatrice), personified by him as Rahab. Beatrice's green wreath

has thus become a gold crown, the wheels of her car have turned into a vortex. The central figure in white points to a book with her left hand while looking backward, indicating that she and her sisters at the left are the repressive and retrospective muses of pagan Greece, the daughters of Memory; and the four evangelists, whose heads appear among the peacock eyes of the six wings, have been transformed into Blake's Four Zoas.

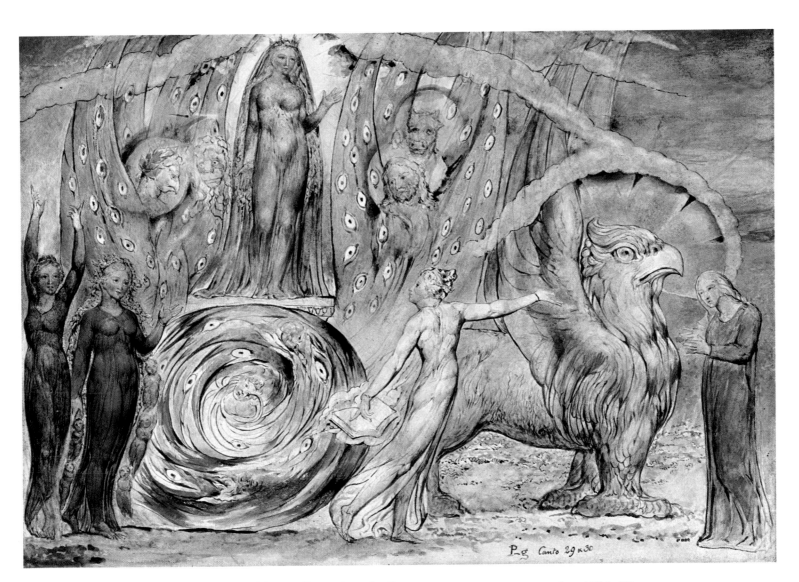

Beatrice Addressing Dante from the Car, THE DIVINE COMEDY, watercolor, 1824–27

Even as star follows star in the heavens, four creatures came after them, each one crowned with green leaves. Everyone was plumed with six wings, the plumes full of eyes. . . . The space within the four of them contained a car triumphal, upon two wheels, which came drawn at the neck of a gryphon. . . . Three ladies came dancing in a round by the right wheel; one so red that hardly would she be noted in the fire; the next was as if her flesh and bone had been made of emerald; the third seemed new-fallen snow. . . . Olive-crowned over a white veil, a lady appeared to me, clad, under a green mantle, with hue of living flame. . . . "Look at me well; verily am I, verily am I Beatrice. . . ."

Purgatorio, XXIX:91–126; XXX:31–33, 73

The writing sinner is Nicholas III, of the Orsini family, who held the keys from 1277 to 1280. Virgil is clasping Dante to protect him from the pope's rage, for Nicholas had mistaken Dante for another corrupt prelate, Boniface VIII, doomed to replace him in the hole—which was reserved, apparently, for only one simoniacal pope at a time.

The simple yet powerful figure-8 design sweeps about and concentrates within its loops the reciprocal actions in both parts of the picture. Blake's technical mastery as a watercolorist, which enabled him to superimpose thin layers of paint and so create forms as solid as they are luminously transparent, has sometimes been compared to Cézanne's.

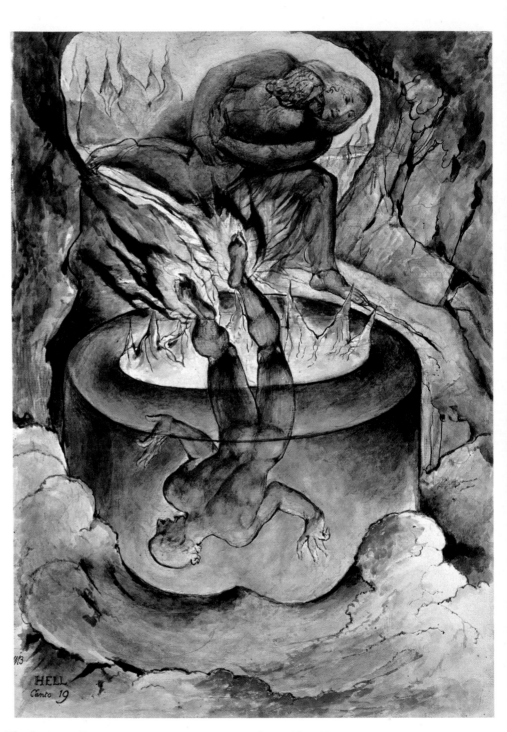

The Simoniac Pope, THE DIVINE COMEDY, watercolor, 1824–27

I saw the livid stone, on the sides and on the bottom, full of holes, all of one breadth; and each was round. . . . From the mouth of each emerged a sinner's feet, and legs up to the calf; and the rest remained within. . . . "Master! who is that who writhes himself, quivering more than all his fellows," I said, "and sucked by ruddier flame?"

Inferno, XIX:13–33

Upon being summoned, Paolo and Francesca leave the band of carnal sinners. Francesca then tells of the fatal day when she committed adultery with Paolo, the younger brother of her husband, the Lord of Rimini, who surprised the pair in the act and stabbed them. Her words so distressed Dante (seen lying prostrate upon the embankment) that he "fainted with pity . . . and fell as a dead body falls." Within the bright circle above Virgil's head, Paolo and Francesca are envisioned in their first and last embrace. Under the Blakean dispensation, however, the condemned lovers are being swept by the whirlwind not only out of the picture but out of the Sea of Time and Space as well, thereby escaping the wrath of Old Nobodaddy.

One victim, depicted in an upsidedown cruciform position, has crashed upon the bank close to Dante's feet. (See page 132.)

Sir Kenneth Clark has called this picture "one of the finest things Blake ever did, where the quasi-Mannerist nudes are made into a gigantic romanesque ornament. The so-called Celtic rhythm is unmistakable."

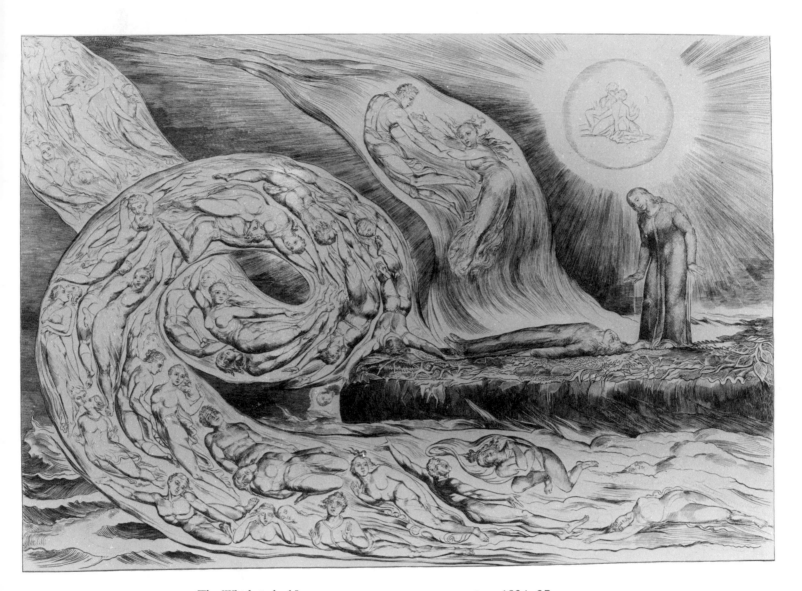

The Whirlwind of Lovers, THE DIVINE COMEDY, engraving, 1824–27

I came into a place void of all light, which bellows like the sea in tempest, when it is combatted by warring winds. The hellish storm, which never rests, leads the spirits with its sweep; whirling, and smiting it vexes them. . . . I learned that to such torment are doomed the carnal sinners, who subject reason to lust. . . . I began: "Poet, willingly would I speak with those two [Paolo and Francesca] that go together, and seem so light upon the wind."

Inferno, V:28–75

This grotesque metamorphosis takes place in the seventh bowge of Dante's Eighth Circle of Hell, the bowge of thieves. Since thieves make no distinction between their own property and that of others while alive, so in death their own bodies are joined with those of serpents and become indistinguishable from them. The two thieves at the right, looking on in horror at the scene, later suffer the same fate.

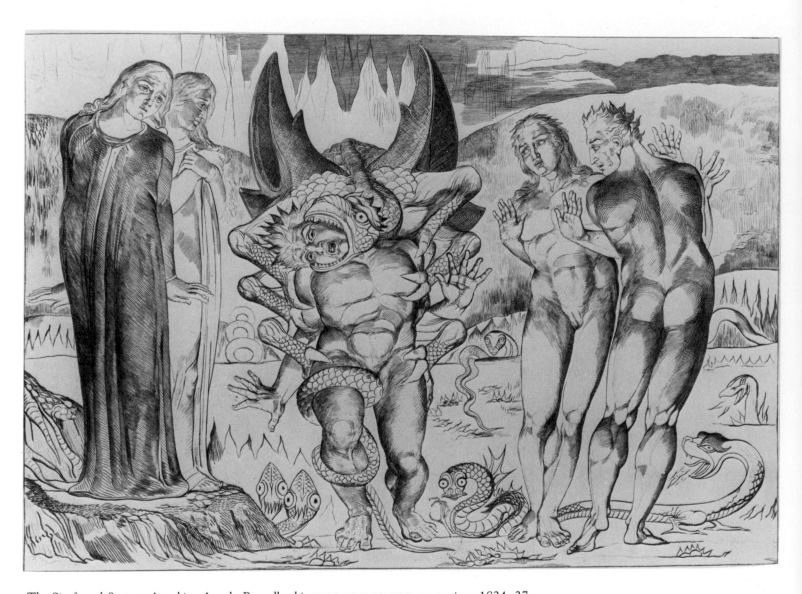

The Six-footed Serpent Attacking Agnolo Brunelleschi, THE DIVINE COMEDY, engraving, 1824–27

While I kept gazing on them, lo! a serpent with six feet darts up in front of one, and fastens itself all upon him. With its middle feet it clasped his belly, with the anterior it seized his arms; then fixed its teeth in both his cheeks. The hinder feet it stretched along his thighs; and put its tail between the two, and bent it upwards on his loins behind. Ivy was never so rooted to a tree, as round the other's limbs the hideous monster entwined its own . . . neither the one, nor the other, now seemed what it was at first. . . .

Inferno, XXV:49–63

The voice crying out is that of Pier del Vigne, a minister of the Emperor Frederick II of Germany. After being accused of betraying his master, then blinded and imprisoned, he committed suicide in 1249. The half-human Harpies, symbolizing the mindless will to destruction, make their nests in the half-human trees of the self-destroyers, who have become rooted in themselves for eternity.

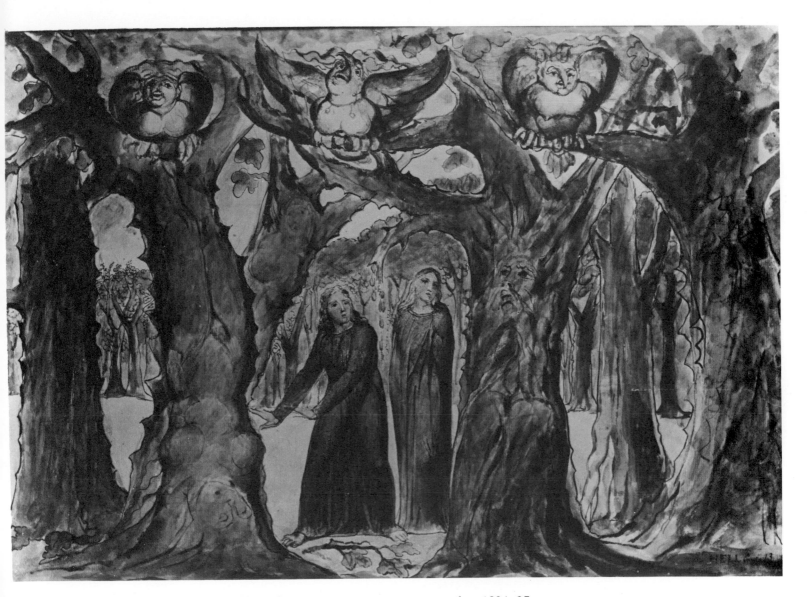

The Wood of the Self-Murderers, THE DIVINE COMEDY, watercolor, 1824–27

Not green the foliage, but of color dusky; not smooth the branches, but gnarled and warped; apples none were there, but withered sticks with poison. . . . Here the unseemly Harpies make their nest. . . . Wide wings they have, and necks and faces human, feet with claws, and their large belly feathered; they make rueful cries on the strange trees. . . . Then I stretched my hand a little forward, and plucked a branchlet from a great thorn; and the trunk of it cried, "Why dost thou rend me? Hast thou no breath of pity? Men we were, and now are turned to trees."

Inferno, XIII:4–36

115

To the four poets mentioned by Dante—Homer, Horace, Ovid and Lucan—Blake has added a nameless fifth, apparently to equate them with the five senses. As such they would be incapable of rising to the spirituality of the Bible. In the scene, which takes place in Limbo, Blake has depicted them as tiny figures standing in the obscurity of a thick grove of oaks, unaware of the divine radiance all about them.

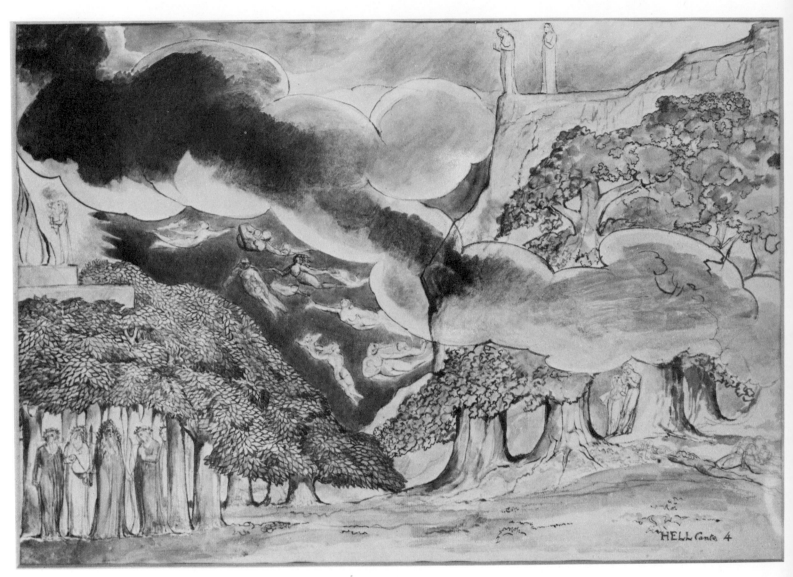

Homer and the Ancient Poets, THE DIVINE COMEDY, watercolor, 1824–27

We ceased not to go . . . but passed the wood . . . of crowded spirits. Meanwhile, a voice was heard by me: "Honour the great Poet! His shade returns that was departed." After the voice had paused, and was silent, I saw four great shadows come to us; they had an aspect neither sad nor joyful.

Inferno, IV:64–66, 79–84

Caiaphas, the high priest of Jerusalem at the time of the Crucifixion, was yoked together with Pontius Pilate by Blake to personify the unholy and hypocritical alliance of Church and State against the teachings of Christ. In the illustration, the devils who escorted Virgil and Dante to this bowge, and from whom they have just escaped, are shown flying off in a rage.

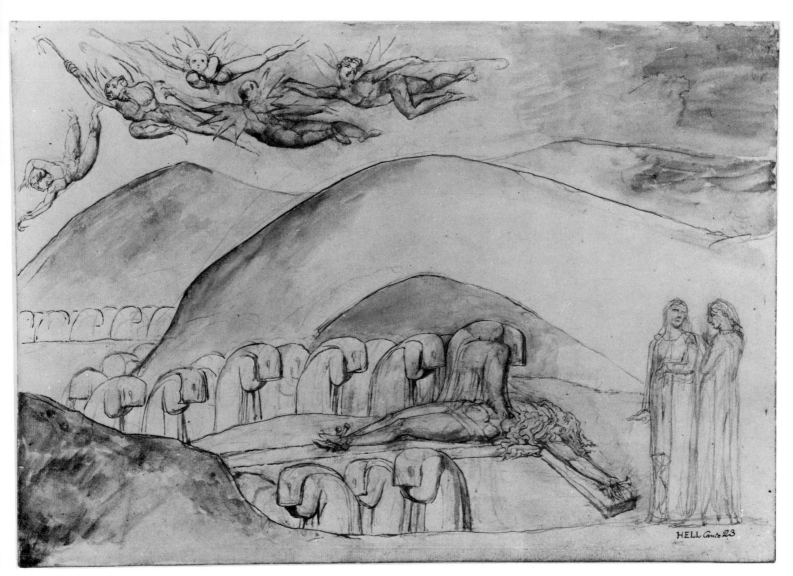

Caiaphas and the Hypocrites, THE DIVINE COMEDY, watercolor, 1824–27

There beneath we found a painted people, who were going round with steps exceeding slow, weeping, and in their look tired and overcome. They had cloaks on, with deep hoods before their eyes. . . . Outward they are gilded so that it dazzles, but within all lead O weary mantle for eternity! To my eyes came one [Caiaphas], cross-fixed in the ground with three stakes . . . and Friar Catalano . . . [one of the hypocrites], who perceived this, said to me: "That confixed one, on whom thou gazest, counselled the Pharisees that it was expedient to put one man to tortures for the people."

Inferno, XXIII:58–67, 110–117

The great feud in Florence between the Guelphs and Ghibellines, which began as a family quarrel, is supposed to have been instigated by Mosca dei Lamberti's fatal remark calling for the murder of a young nobleman who had jilted his fiancée; while Bertrand de Born, the Provençal poet and courtier, was instrumental in fomenting a war between King Henry II of England and his son Prince Henry. In the center of the picture, with his back turned, stands the avenging demon who, just as the Schismatics divided kingdoms and families on earth, now severs their limbs in hell with his sword.

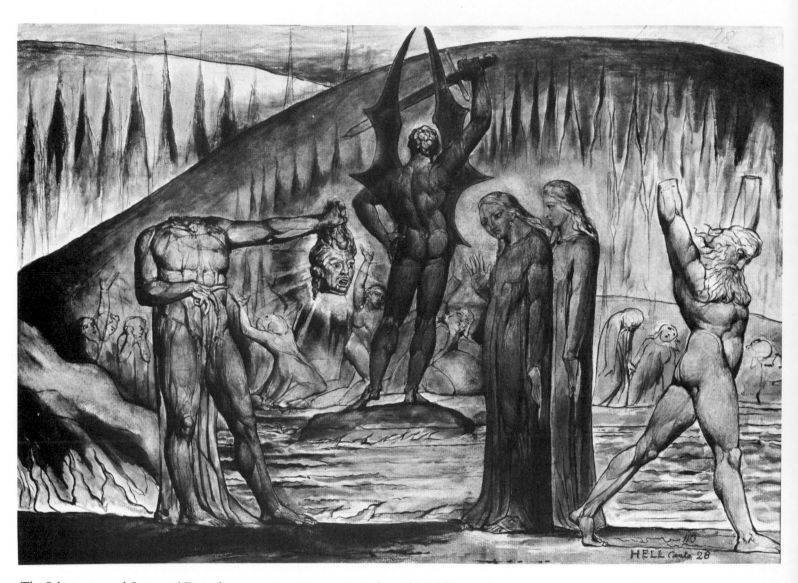

The Schismatics and Sowers of Discord, THE DIVINE COMEDY, watercolor, 1824–27

And one who had both hands cut off, raising the stumps through the dim air so that their blood defiled his face, said: "Thou wilt recollect the Mosca, too, ah me! who said, 'A thing done has an end!' which was the seed of evil to the Tuscan people.". . . Certainly I saw, and still seem to see it, a trunk [Bertrand de Born] going without a head, as the others of that dismal herd were going. And it was holding by the hair the severed head, swinging in his hand like a lantern. . . .

Inferno, XXVIII:103–22

Though Dante makes no distinction in the sex of the thieves, all the figures in Blake's illustration are apparently female. He may have intended to show the malign Female Will, which imposes itself upon the male through serpentine guile, as in turn being punished by serpents.

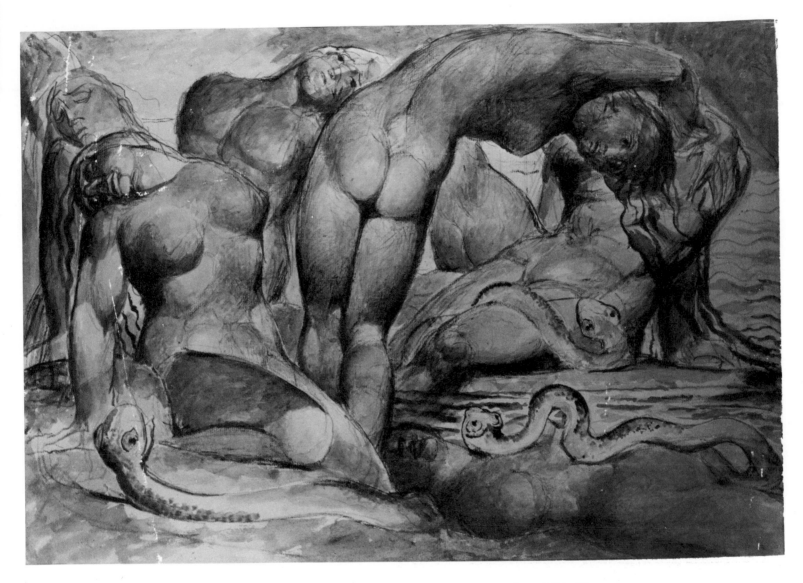

The Punishment of the Thieves, THE DIVINE COMEDY, watercolor, 1824–27

We went down the bridge, at the head where it joins with the eighth bank; and then the chasm was manifest to me: and I saw within it a fearful throng of serpents, and of so strange a look, that even now the recollection scares my blood. . . . Amid this cruel and most dismal swarm were people running, naked and terrified. . . . They had their hands tied behind with serpents; these through their loins fixed the tail and the head, and were coiled in knots before.

Inferno, XXIV:79–96

These five glum giants are the five senses sunk in materialism. Though debased and restricted, the senses still remained according to Blake "the chief inlets of Soul in this age." In *The Marriage of Heaven and Hell* he wrote: "The Giants who formed this world into its sensual existence, and now seem to live in it in chains, are in truth the causes of its life & the sources of all activity. . . ."

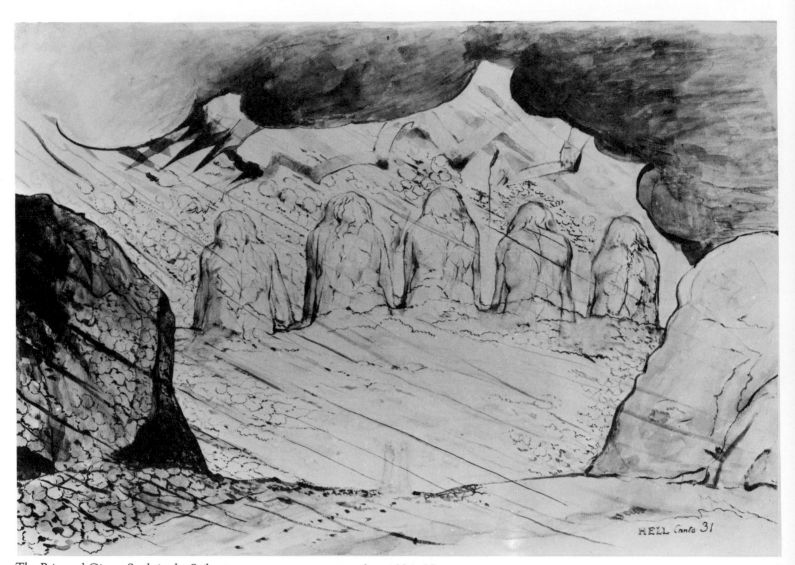

The Primeval Giants Sunk in the Soil, THE DIVINE COMEDY, watercolor, 1824–27

Shortwhile had I kept my head turned in that direction, when I seemed to see many lofty towers; whereat I: "Master! say, what town is this?" And he to me: "Because thou traversest the darkness too far off, it follows that thou errest in thy imagining. . . . Ere we go farther, that the reality may seem less strange to thee, know, they are not towers, but Giants; and are in the well, around its bank, from the navel downwards all of them."

Inferno, XXXI:19–33

A "Memorandum" by Blake written in 1807 describes the method by which this picture was produced: "To Woodcut on Pewter: lay a ground on the Plate & smoke it as for Etching; then trace your outlines, and beginning with the spots of light on each object with an oval pointed needle scrape off the ground as a direction for your graver. . . ."

In 1824, when Blake was nearly sixty-seven, he began a series of illustrations in watercolors for Bunyan's Baptist allegory, *The Pilgrim's Progress*. That same year he acquired a group of young and admiring disciples, dubbed the "Shoreham Ancients," who formed a charmed circle around the poet. The members of this group, chief among them the artists Samuel Palmer, George Richmond, and Edward Calvert, would refer among themselves to the house in which Blake lived at the time as "The House of the Interpreter."

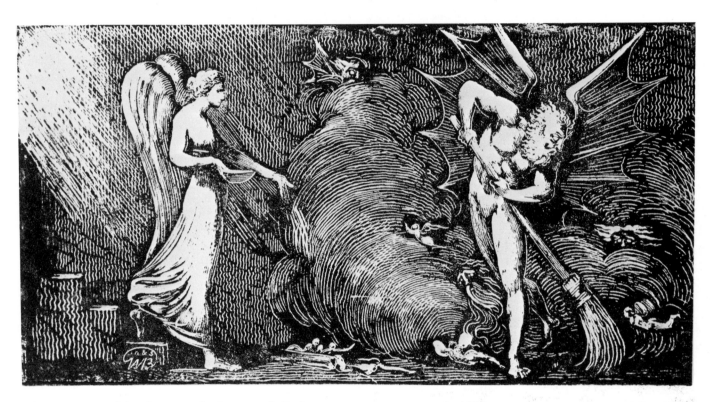

Man Sweeping the Interpreter's Parlor, engraving on pewter, c. 1822

Then he took him by the hand, and led him into a very large parlour that was full of dust, because never swept; the which, after he had reviewed a little while, the Interpreter called for a man to sweep: now when he began to sweep, the dust began so abundantly to fly about, that Christian had almost therewith been choked. Then said the Interpreter to a damsel that stood by, Bring hither water, and sprinkle the room; the which when she had done, it was swept and cleansed with pleasure.

Then said Christian, What means this?

The Interpreter answered, This parlour is the heart of a man that was never sanctified by the sweet grace of the gospel; the dust is his original sin, and inward corruptions, that have defiled the whole man. He that began to sweep at first is the law; but she that brought water, and did sprinkle it, is the Gospel. . . . This is to show thee, that the Law instead of cleansing the heart (by its working) from sin, doth revive, put strength into, and increase it in the soul, even as it doth discover and forbid it; for it doth not give power to subdue it.

John Bunyan's *The Pilgrim's Progress*, Part I:48

Around 1819 Blake became acquainted with John Varley, a well-known watercolor painter as well as a devotee of astrology and the occult, to whom he was introduced by one of Varley's former pupils, the artist John Linnell. "Varley believed in the reality of Blake's visions," declared Linnell, "more than even Blake himself." Blake, on the other hand, could not share Varley's enthusiasm for astrology, since that would have meant accepting, in the fixed glare of the stars, a universal and unalterable fate decreed for mankind by Urizen, "Prince of the Starry Wheels."

During the years 1819–21, Blake, Varley, and Linnell would hold regular visitation hours from 9 to 5 A.M., during which any spirits who might choose to appear would be interviewed by Blake and have their portraits sketched. At times there were so many, Varley wrote, that they would crowd and jostle each other for a place in his vision.

The almost perfect egghead of the spirit in the above drawing, his symmetrical yet oddly disproportionate features, and the enormous slanty eyes thro' which he seems to be gazing at us with otherworldly intelligence, would cast him as the Man from Outer Space in any science fiction movie. But that strange brachiate growth in the middle of his forehead—is it hair? an amulet? branching veins? or what?

Blake's lines from "The Human Abstract" (see page 37) on The Tree of Mystery may provide a clue:

The Gods of the earth and sea
Sought thro' Nature to find this
 Tree;
But their search was all in vain:
There grows one in the Human
 Brain.

The inscription below, probably by John Varley, reads: "Imagination of a man who Mr. Blake has recd. instruction in Painting &c from."

The Man Who Taught Blake Painting, pencil drawing, c. 1819

According to John Varley, who must have been so informed by Blake, this is "the very individual task-master whom Moses slew in Egypt." The step-by-step steeply ascending and descending pyramidal features of this character, with his blunted nose as apex, suggest that Blake must have intended his portrait as a caricature. The inscription below and the date are in Varley's handwriting.

The Man Who Built the Pyramids,
pencil drawing, c. 1819

With his hooded, inward-looking eyes far withdrawn behind the sensual and sharply protruding nose, Solomon's expression in this portrait is as inscrutable as Blake's attitude toward him was equivocal. In a letter written in 1799 (to Dr. Trusler), he referred to Solomon as among the "wisest of the ancients," along with Moses, Aesop, Homer, and Plato; but in 1820, beneath an illustration of Milton's *L'Allegro*, "Mirth and Her Companions," he wrote: "Solomon says, 'Vanity of Vanities, all is Vanity,' & What can be Foolisher than this?"

That bludgeon of a face, clenched like a fist in defiance, belongs to the tribal chieftain who led the ancient Britons in their resistance to the Roman legions during the years 43–51 A.D. Captured and taken with his family to Rome, he made a patriotic and unyielding speech before the Emperor Claudius. The children of Caractacus, after being converted to Christianity while in Rome, later returned to their native land to preach the gospel.

This saucy wench, according to legend, claimed to have been rudely strumpeted by one of the collectors of the hated poll-tax during the reign of Richard II. Her father, after slaying the tax collector, then took command of the great peasant rebellion of 1381 that bears his name. As Blake has envisioned her, she must at least have partly provoked, and perhaps even welcomed, the assault.

Solomon, pencil drawing, c. 1819

Caractacus, pencil drawing, c. 1819

Wat Tyler's Daughter, pencil drawing,
c. 1819

Head and Mouth of a Flea, BLAKE-VARLEY SKETCHBOOK, pencil drawing, c. 1819

In his *Zodiacal Physiognomy*, Varley wrote: "I felt convinced by his mode of proceeding that he had a real image before him, for he left off and began on another part of the paper to make a separate drawing of the mouth of the Flea. . . ."

John Varley, who attended the séance at which this most famous of all Blake's apparitions appeared, spoke of it long afterwards to the biographer Alan Cunningham:

> I called on him one evening, and found Blake more than usually excited. He told me he had seen a wonderful thing—the ghost of a flea. . . . He looked earnestly into a corner of the room, and then said, here he is—reach me my things—I shall keep my eye on him. There he comes! his eager tongue whisking out of his mouth, a cup in his hand to hold blood, and covered with a scaly skin of gold and green;—as he described him so he drew him.

Present at the same time, however, though perhaps unknown even to Blake, was the ghostly memory of still another flea: one first observed by the early English microscopist Robert Hooke, and depicted in an engraving in his *Micrographia*, published in 1665.

Hooke's corporeal flea (as noted in *Micrographia*) was enclosed within a "curiously polish'd suit of sable Armour, neatly jointed"; and the "tongue or sucker," as well, was perceived "to slip in and out." Moreover, that "cup in his hand to hold blood" (according to Varley) turns out to have been the aperture of Hooke's microscope. It is as if the Ghost, a hundred and fifty years later, had come back from the spirit world to peer with amazement into the "magic speculum" by which it was first examined post mortem on earth.

Robert Hooke's microscope

Upon the proscenium of a narrow stage, curtained off on either side and open to the night sky, the Ghost appears to be mincing by on tiptoe, in a somnambule trance, while gazing into a bowl-shaped object held in his left hand. A huge shooting star cuts diagonally across, lighting up his scaly features and glowing phosphorescently upon his eye. On the floor between his legs, barely discernible, lies the tiny corpse (perhaps his own) of a once lively, leaping, biting, and bloodsucking flea; while on the right the curtain, shaped like a gigantic leg, drops flat-footedly down to the floor, as if another and still more monstrous apparition were stalking behind him.

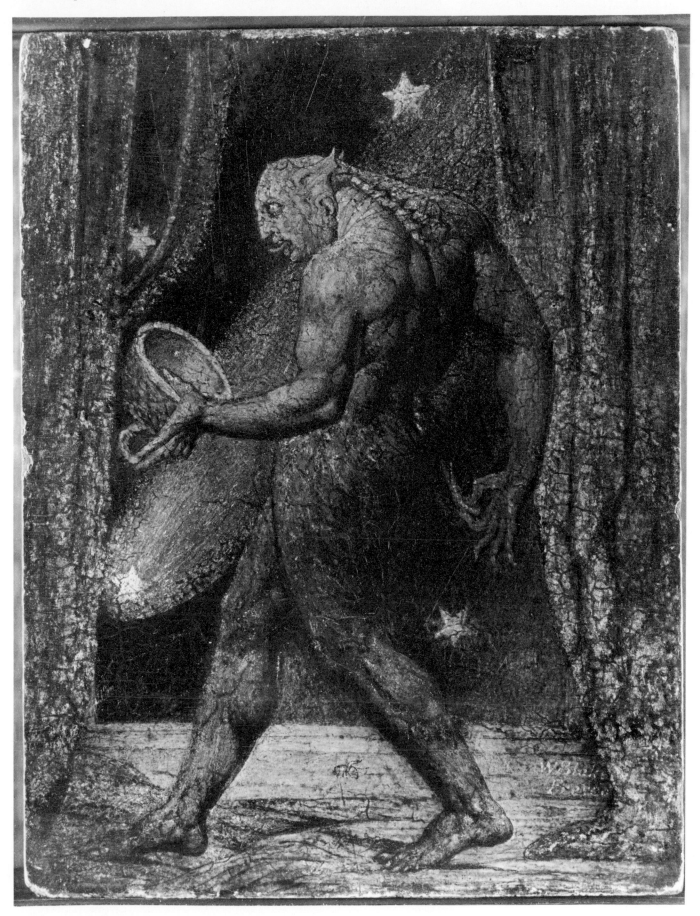

The Ghost of a Flea, tempera on panel, c. 1819

125

In 1820 Blake made seventeen wood engravings—the first he ever attempted in that medium—to illustrate Ambrose Phillips's translation of Virgil's *First Eclogue* for a school edition of Virgil, edited by Dr. Robert Thornton. Upon seeing them, Thornton wished to have the designs recut by a professional wood engraver, but was persuaded not to do so by the artist John Linnell. The blocks, however, were trimmed down and otherwise mutilated by the printers to fit the pages of the book. In only eight instances do proofs remain of the engravings in their original state, and these we reproduce here.

THENOT: *Sure thou in hapless hour of time wast born,*
When blightning mildews spoil the rising corn,
Or when the moon, by wizard charm'd, foreshows,
Blood-stain'd in foul eclipse, impending woes.

THENOT: *Nor fox, nor wolf, nor rot among our sheep:*
From these good shepherd's care his flock may keep.

COLINET: *Untoward lads, the wanton imps of spite,*
Make mock of all the ditties I indite.

COLINET: *The damp, cold greensward for my nightly bed,*
And some slant willow's trunk to rest my head.

THENOT: *See Lightfoot; he shall tend them close; and I*
'Tween whiles across the plain will glance mine eye.

COLINET: *The riven trunk feels not the approach of spring;*
Nor birds among the leafless branches sing.
Ill-fated tree! and more ill-fated I!

COLINET: *Thine ewes will wander; and the heedless lambs,*
In loud complaints require their absent dams.

COLINET: *Unhappy hour! when fresh in youthful bud*
I left, Sabrina fair, thy silvery flood.
A fond desire strange lands and swains to know.

127

Blake's mystical bond with the prophet and patriarch Enoch, who "walked with God: and he was not; for God took him" (Genesis 5:24), was reaffirmed in 1821 when the pseudepigraphical *Book of Enoch*, discovered in Abyssinia in 1773 by the Scottish explorer James Bruce, was first translated into English. For it Blake made several drawings, most likely with the intention of illustrating the whole work.

In the illustration below, two of the sons of heaven, with what appear to be enormous snaky phalluses winding in and out of starry rays, are approaching a daughter of man. She seems both appalled and enthralled by the visitation, reaching up and down with her arms to touch them, as if to make sure they are real.

An angel descends from heaven *(on the opposite page)* to whisper of sinful practices into the willing ear of a daughter of man.

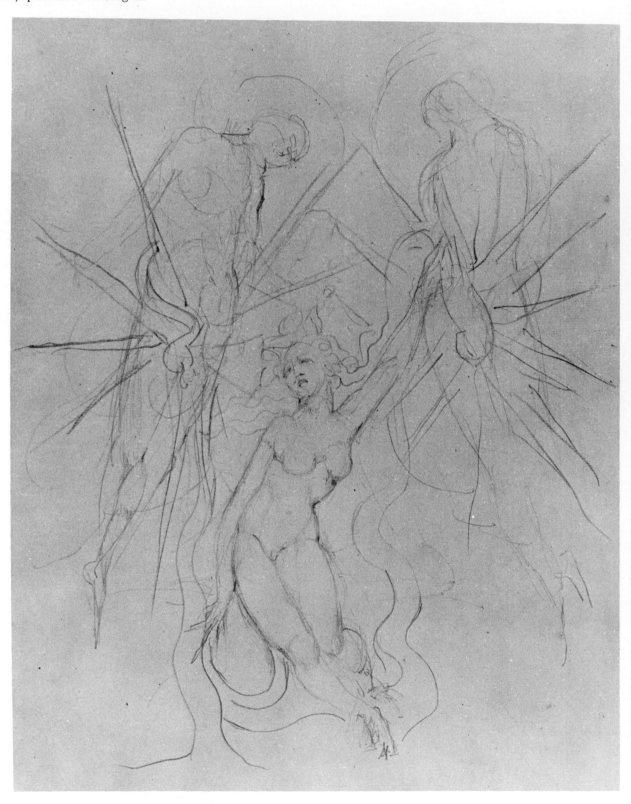

Two Angels Descending, THE BOOK OF ENOCH, pencil drawing, c. 1822

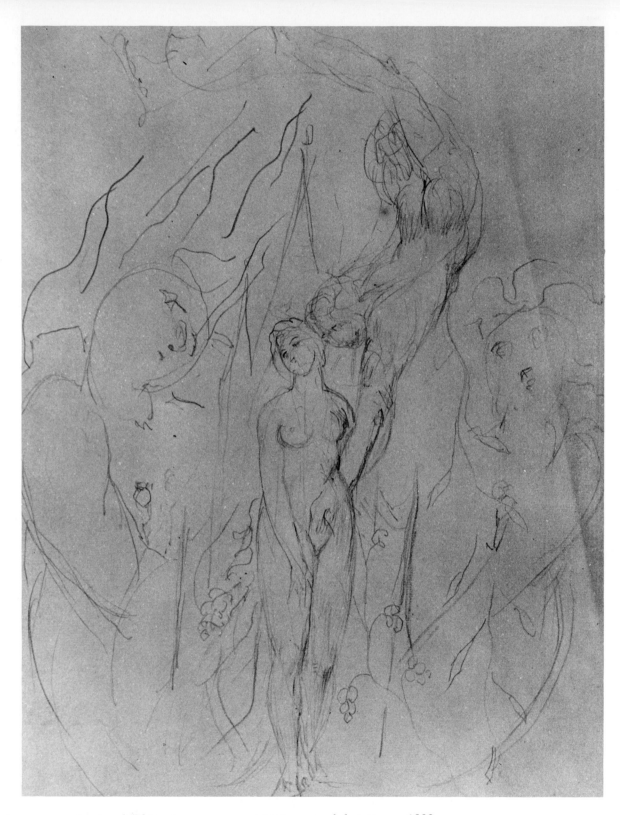

An Angel Whispering, THE BOOK OF ENOCH, pencil drawing, c. 1822

It happened after the sons of men had multiplied in those days that daughters were born to them, elegant and beautiful. And when the angels, the sons of heaven, beheld them, they became enamored of them, saying to each other, "Come, let us select for ourselves wives from the progeny of men, and let us beget children " . . . Then they took wives, each choosing for himself; whom they began to approach, and with whom they cohabited, teaching them sorcery, incantations, and the dividing of roots and trees. And the women conceiving brought forth giants, whose stature was each three hundred cubits. These devoured all which the labour of men produced, until it became impossible to feed them; when they turned themselves against men in order to devour them; and began to injure birds, beasts, reptiles, fishes, to eat their flesh after one another and to drink their blood. . . .

The Book of Enoch, VII–VIII, trans. by Richard Lawrence

Two of the already corrupted daughters of man are triumphantly brandishing weapons above a corpse in the foreground. The floating figure at the left is covered with scales, perhaps to indicate that she has taken on the dragonish appearance of the man-devouring Female Will. (See *Dragon Forms*, page 100.)

Depraved Daughters of Man, THE BOOK OF ENOCH, pencil drawing, c. 1822

Around 1820 Blake did a series of twenty-one watercolors illustrating and interpreting The Book of Job; and three years later, after being commissioned by the artist John Linnell, he undertook to engrave the set. With the addition of the title page, his *Illustrations of The Book of Job,* published in 1825, contained twenty-two plates in all, as many as there are letters in the Hebrew alphabet.

Blake divided the twenty-one illustrations into three cycles of seven (corresponding to the seven "eyes of the Lord" mentioned in Zech. 4:10 and also in Rev. 5:6), which he named in his prophetic books as: Lucifer, Molech, Elohim, Shaddai, Pahad, Jehovah, and Jesus. In his gradual emergence from innocence through experience into spiritual enlightenment, Job sees himself through each of these "eyes" in succession. Further, as Joseph Wicksteed has shown, Blake's left-right symbolism, important for understanding his work as a whole, is especially so for the *Illustrations of The Book of Job.* "I intreat then," Blake wrote in his *A Vision of the Last Judgment* (1810), "that the Spectator will attend to the Hands & Feet, to the Lineaments of the Countenances; they are all descriptive of Character, & not a line is drawn without intention, & that most discriminate & particular."

The quotations from Job and the outline engravings in the margins were added by Blake only after the illustrations themselves were completed. "This decision," declares Ruthven Todd, "turned the series from being just an important part of his life's work into a creation of almost unique grandeur."

This study most closely resembles Job depicted in plate 14 (see page 137), where he is looking upward and inward as "all the Sons of God shouted for joy."

Head of Job, pencil drawing, c. 1823

Job's tempestuous rage against his children, rising in his mind, becomes "a great wind" with which Satan blows their house down.

Everything in the picture seems precariously balanced, toppling or about to topple, yet the triangular composition, with the squatting Satan at the apex, is firmly based upon the outstretched figure of the concubine beneath. She has her feet upon a timbrel and her left hand upon a lyre. To her right, one of Job's sons has fallen upside down (his genitals thus being elevated above his head and heart), and his extended arms, in a cruciform position, form a smaller triangle. The eldest son, poised with his left foot upon a stump, attempts to save his child, whom he has placed upon his left shoulder, while with his right hand he is assisting its mother.

In the margin are depicted flames, scorpions, and the half-concealed coils of a serpent.

Plate 3, THE BOOK OF JOB, engraving, 1825

This scene, which does not occur in the Bible, is Blake's own interpolation.

Job is shown handing half a loaf to a crippled beggar, but with his left hand, as an obligatory deed of charity. In his poem "The Human Abstract" from *Songs of Experience*, Blake wrote:

Pity would be no more,
If we did not make somebody Poor:

And Mercy no more could be,
If all were as happy as we.

The two angels on either side seem unimpressed. Behind Job and his wife is a Druidic dolmen, symbolizing primitive natural religion that sacrifices man to the Law. The swooping Satan above, who has penetrated the cloud barrier that separates the spiritual and phenomenal worlds, is about to pour a vial of fiery guilt upon his head; and the seraphs observing this act recoil in horror. Seated upon his throne, a listless and faineant deity clutches a book (of Law) in his right hand, while letting a scroll (of Mercy) dangle from his left.

The margins are filled with flames and thorny briars, while the scaly serpent of plate 3, *on the opposite page,* has now fully emerged.

Plate 5, THE BOOK OF JOB, engraving, 1825

133

The accusing fingers, like thirty writhing snakes, belong to Job's "comforters," Eliphaz, Bildad, and Zophar. His wife, self-contradicted by doubt, looks up at Job in perplexity and appeals to him to defend himself; but Job, remaining steadfast, shows his guiltless open palms and raises his eyes toward heaven.

In the margin two angels, weighed down by chains, are struggling to rise above the frame of the picture; while at the bottom are a cuckoo (of slander), a snake (of guile) with a forked tongue, and a hoot owl (of derision) clutching a rodent.

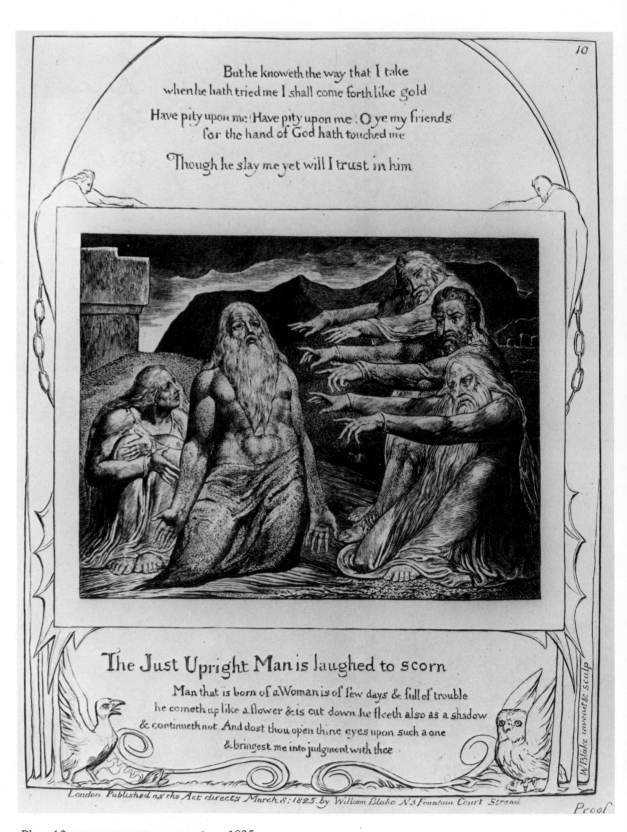

Plate 10, THE BOOK OF JOB, engraving, 1825

134

Entwined with the serpent of material-ism, a malevolent deity points with his right hand toward the twin stone tab-lets of the Law behind him, with his left toward the pit of hell beneath. Demons have emerged from the pit and attempt to drag Job down with them into the flames. The Urizenic lightning flash-ing about is repeated in the chevron designs upon Job's mat. Job, however, has just observed that the God he has always worshiped, the God of Justice, has a cloven left foot, and in reality is Satan the Accuser. (See pages 57 and 59.)

In the margin, rising upward in wisps of smoke, are Job's thoughts, as recorded in Scripture, as well as Blake's comments upon them.

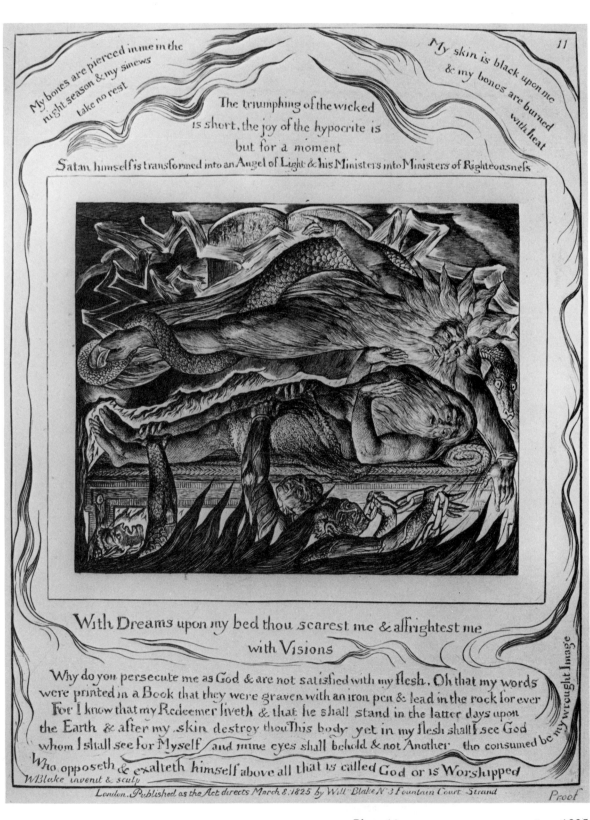

Plate 11, THE BOOK OF JOB, engraving, 1825

Advancing with left foot forward while pointing upward with his left hand toward the starry heavens, the youthful Elihu now enters the scene to assert that God's works as well as his ways are beyond human understanding. Job's wife, with hands clasped in anguish and her face sunk between her knees, seems stricken by his words; the three friends, confounded and silent; but Job himself, seated with his right foot somewhat forward, appears deep in contemplation. His expression is now no longer despairing but almost hopeful.

The sleeping figure in the lower margin, representing Job's dormant humanity, lies with his left hand upon a scroll rooted in the ground. Swarms of angels rising from the bottom to the top of the picture and beyond are attempting to awaken him.

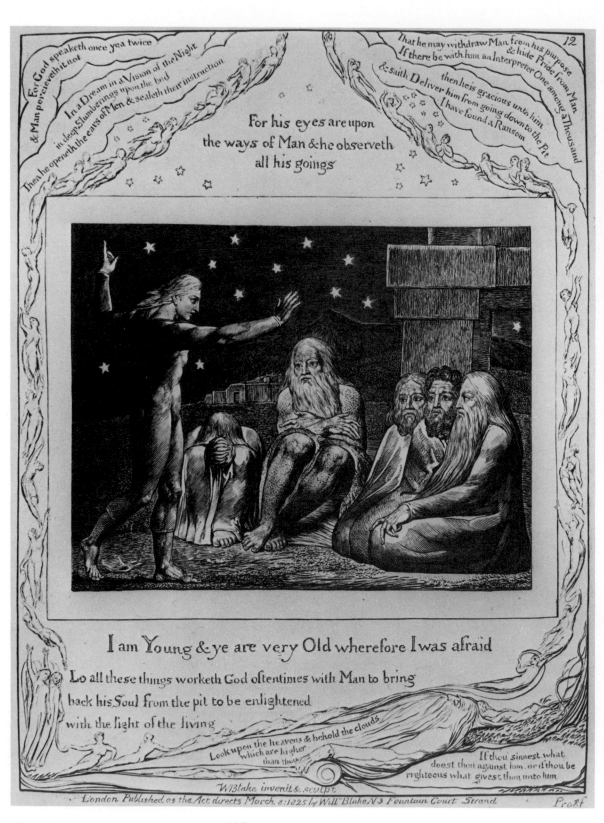

Plate 12, THE BOOK OF JOB, engraving, 1825

Blake's "Four Zoas," the fourfold soul of man, are represented in this picture: Tharmas (the physical body); Urizen (the intellect); Luvah (the emotions); and Urthona (the spirit). At the bottom, enclosed within a thick cloud barrier, are Job, his wife, and his three friends, all gazing upward with radiant faces; to the left is the sun god Apollo, attempting to push back the shadows and widen the realm of light; on the other side is the moon goddess Diana, riding the dragons of emotion; at the top stand the spiritual sons of God, their crisscrossed arms extending outside the picture on either side, as if to indicate that the realm of the spirit is limitless. All four are centered in the true God of the Divine Imagination.

The margins at the sides depict the six days of creation. In the bottom margin is Leviathan (or Nature) engulfed in the Sea of Time and Space; and next to Leviathan, a worm (of death) has coiled itself about a corpse in a shroud.

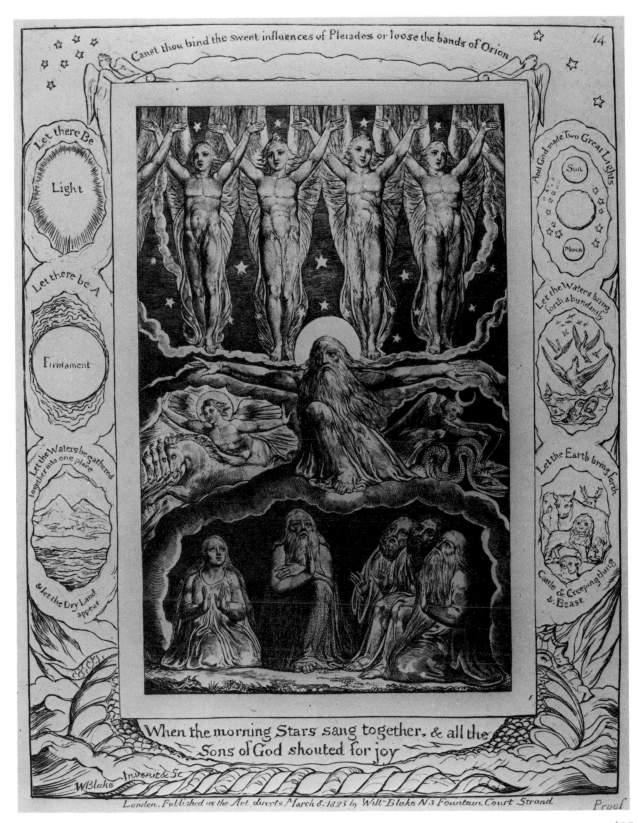

Plate 14, THE BOOK OF JOB, engraving, 1825

INDEX